# THE *End* OF *Reading*

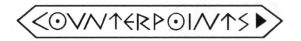

# Studies in the
# Postmodern Theory of Education

Shirley Steinberg
*General Editor*

Vol. 394

PETER LANG
New York • Washington, D.C./Baltimore • Bern
Frankfurt • Berlin • Brussels • Vienna • Oxford

# DAVID TREND

# THE *End* OF *Reading*

## From Gutenberg to *Grand Theft Auto*

PETER LANG
New York • Washington, D.C./Baltimore • Bern
Frankfurt • Berlin • Brussels • Vienna • Oxford

**Library of Congress Cataloging-in-Publication Data**

Trend, David.
The end of reading: from Gutenberg to Grand Theft Auto /
David Trend.
p. cm. — (Counterpoints: studies in the postmodern
theory of education; 394)
Includes bibliographical references and index.
1. Literacy—Social aspects. 2. Popular culture. 3. Computers
and literacy. 4. Postmodernism and education. I. Title.
LC149.T74   302.2′244—dc22   2010008626
ISBN 978-1-4331-1016-0 (hardcover)
ISBN 978-1-4331-1015-3 (paperback)
ISSN 1058-1634

Bibliographic information published by **Die Deutsche Nationalbibliothek**.
**Die Deutsche Nationalbibliothek** lists this publication in the "Deutsche
Nationalbibliografie"; detailed bibliographic data is available
on the Internet at http://dnb.d-nb.de/.

The paper in this book meets the guidelines for permanence and durability
of the Committee on Production Guidelines for Book Longevity
of the Council of Library Resources.

# CONTENTS

# THE END OF READING

BIG CHANGES have been taking place in reading in recent years. While American society has become more visual and digital, the general state of literacy in America is in crisis, with educators and public officials worried about falling educational standards, the rising influence of popular culture, and growing numbers of non-English-speaking immigrants. But how justified are these worries? *The End of Reading: From Gutenberg to Grand Theft Auto* is titled provocatively to address current debates about the state of literacy in the United States and around the globe. By focusing on "reading" this book takes a serious look at public literacy, but chooses not to blame the familiar scapegoats. Instead, *The End of Reading* proposes that in a diverse and rapidly changing society, we need to embrace multiple definitions of what it means to be a literate person.

These new definitions of literacy require an inclusive approach to "reading," which validates the many languages and forms of communication that define a democratic society in the contemporary age. Embracing these diverse forms of reading entails a recognition of differences in the origins, forms, contexts, and cognitive processes of expression and reception. This broadened perspective requires us to look beyond established paradigms of media and cultural studies—though these remain crucial—and examine the sources of language, the field of perception, and the history of visual expression. Put another way, this means looking past disciplines of education and

media studies to also consider recent scholarship in anthropology, art history, linguistics, and psychology, among other areas.

As the digital revolution has made media part of everyday life, the way we take in information about our world has changed. Messages, entertainment, and learning come to us from our phones, televisions, and laptops in a variety of visual and aural formats. Some of them arrive as written texts, some present themselves through images and sounds, others combine all of these elements. *The End of Reading* acknowledges our culture's reliance on reading as a central vehicle of communication, recognizing that literacy is the cornerstone of learning. At the same time, *The End of Reading* talks about the many new forms of communication that have grown up around reading and the importance of those new media forms. In older discussions this might suggest a call for "media literacy." But in today's world that isn't enough. Simply saying that people are entranced by movies or influenced by the nightly news doesn't suffice. After all, mainstream media critics like Jon Stewart, Bill O'Reilly, and Rachel Maddow are already there any time you need them. But in today's communications infovrese we are charting new territory. Advances in interactive entertainment, social networking, mobile communication, texting, video sharing, "quality television," and the ubiquity of iPods—all of these things show us that people now face a world where one form of "reading" really isn't enough.

The age-old divide between the word and the image plays a big role current literacy debates. This separation of language from visual expression has shaped cultures across time, providing coherence to our thinking and expression, but also generating controversy over the influence of words and pictures. *The End of Reading: From Gutenberg to Grand Theft Auto* examines the long standing opposition of language and vision in human culture. The book explores the pre-historic origins of language as well as ways that people develop language abilities in childhood. *The End of Reading* similarly looks at humanity's earliest non-linguistic picture-making inclinations and traces their parallel development with speaking and writing. Following these trajectories to the present day, the book offers a diverse approach to literacy compatible with evolving discourses in technology, multiculturalism, and gender and disability studies. In personal terms, *The*

*End of Reading* is informed by the struggles with the written word I've observed in my own child. Like many other facets of development, reading accrues to kids at different rates—and a surprising number of children these days experience delays in this process. As I've observed difficulties in literacy development in my own family and others, I continue to wonder how our kids are going to do in a world that requires reading while it is increasingly made to seem irrelevant. Each chapter begins with an anecdote about a fictional child named Emily, developed from my general observations as a parent.

The *End of Reading* stakes out territory in three areas: education, media, and technology. In terms of education, the book discusses the trend common to both talk-radio alarmists and honestly concerned citizens to blame schools and teachers for declines in reading and public literacy.[1] It's an understandable reaction if one looks at the problem without much scrutiny. Why wouldn't one think that the fault lies in the one institution that's supposed to be teaching little Johnny to read? The flaw in this reasoning is part of what makes the whole issue so difficult to grasp. No single institution is entirely at fault and no one component of a child's experience (or an adult's experience) can fully correct the situation. Besides, K-12 education in the United States is extraordinarily complicated by the local character of school governance and funding, which results in little consistency in what is taught and creates great disparities in school quality. Important rejoinders to the assault on schools and teachers emerged from progressive traditions espoused by early thinkers like John Dewey and later focused in the field of critical pedagogy developed by Paulo Freire, as well as feminist and multicultural educators.[2]

Owing much to the traditions of critical pedagogy, *The End of Reading* emerged from my ongoing interest in the everyday things that occupy people's lives and often define them as human beings. In recent decades critical pedagogy's commonsense address of ordinary experience has brought it close to the media literacy field and its literature. In its engagement with media, the critical dimensions of The *End of Reading* would position it with such classic works on the media industries as Ben Bagdikian's *The Media Monopoly* (1983). Yet, *The End of Reading* also embraces contemporary thinking that credits viewers with good judgment, thus assuming a more even-handed view. Tak-

ing care not to romanticize "the beholder's share," *The End of Reading* concludes that intellectual and popular culture need to come together in a technologically diverse and multicultural society.[3] *The End of Reading* also seeks to expand the existing discourse on media literacy by discussing visual culture in artistic, anthropological, and neuroscientific terms.

It's important to remember that until relatively recently, technology was regarded as a debased or simply non-essential category of academic inquiry, addressed by relatively isolated figures like Marshall McLuhan and Raymond Williams.[4] As small computers became consumer goods in the 1990s, the discourse on technology grew robustly. Notable early examples include Donna Haraway's, "A Manifesto for Cyborgs" (1985), Manual Castells' *The Informational City* (1989), George Landow's *Hypertext: The Convergence of Critical Theory and Technology* (1991), and Howard Rheingold's *The Virtual Community* (1993)—each interrogating technology in a specific area.[5] *The End of Reading* pays homage to such important works, but strikes a different chord in applying such critiques to fundamental issues of vision and expression throughout human history and across a range of non-technological disciplines.

*The End of Reading* reflects the evolution of my writing interests over the last three decades. With an early inclination toward visual studies, I worked from 1980 to 1995 for *Afterimage: The Journal of Media Arts and Cultural Criticism,* which publishes articles and essays by figures in photography, film studies, and media theory.[6] Actively engaged with the New York media art community during those years, I wrote news stories, reviews, and critical articles on photography, film, and video, as well as institutional critiques of organizations ranging from the American Film Institute to the National Endowment for the Arts. Moving to California in the early 1990s, I assumed the editorship of *Socialist Review* and was introduced to the intellectual legacy of the American New Left.[7] At this time I also met Henry Giroux and discovered critical pedagogy. As these influences commingled, I came to recognize that artists and media producers were, in essence, teachers, in their efforts to communicate and inform. Thinking about education, I began writing about the creative aspects of teaching that might define educators as artists. My book *Cultural*

*Pedagogy* (Bergin & Garvey, 1992) emerged from this synthesis of ideas and helped in bringing the fields of critical pedagogy and art/media studies together.[8] This work was followed by a number of books on education, media, politics, and technology.

*The End of Reading* was written for general non-fiction readers and students interested in current debates over literacy, popular culture, and education. The work is informed by the kind of teaching I do, which for much of the past 15 years has involved large undergraduate classes of hundreds of students. In what I say and write, I work continually to find ways to make my ideas accessible and understandable. This book seeks to be conversational, yet direct, conceived and written as an integrated and sequentially presented work, rather than a selection of essays. It follows a loosely chronological progression that begins with historical background, assesses recent and current ideas, and concludes with future projections. Each of its six chapters has three subdivisions, which are further divided into smaller units titled to inform readers about exactly what is being discussed.

Chapter One, entitled "The Disappearing Word," lays out the paradox of reading in today's world. Reading is critical to learning and success, but in so many places it seems unnecessary. We read for information and functioning without thinking very much about it. Can we say that reading is a "natural" skill? New research tells us that pre-historic humans were more inclined to making pictures than words. Educators now agree that written language is more learned than instinctual. But Western civilization has always favored reading over seeing. Chapter Two, "The Crisis in Public Literacy," looks at reasons to be concerned about reading in America. There are plenty of such reasons, but immigration isn't one of them. Most newcomers learn to read as soon as they can. And while many people worry about educational decline, the real problem is that many schools in poor communities don't get the money they need. When self-righteous politicians advocate budget cuts to failing schools, they fail to acknowledge that many such schools already get less money than their successful counterparts.

Chapter Three, "The Rise of Media Culture," talks about what's taking the place of reading in people's lives. It's no secret that we are

now an "information society" in which visual media, the internet, and computer games dominate our culture. The further we go, the more ingrained technology becomes in our everyday experience and our ways of knowing ourselves and our world. How do we address these changes? Is this transformation good, or bad, or both? Chapter Four, "When Machines Do the Reading," examines in greater depth the implications of life informed more by media than words. There's no mistaking the innate skills in media literacy that people possess, especially the younger of us. In fact, it can be said that many people "read" media with the kind of proficiency they have with print. But with so much at stake in the new information economy, media needs to become a bigger part of education. *The End of Reading* winds up with Chapter Five, "The Future of Reading," concluding that the time has arrived to equally value written and media literacy. As information technology increasingly becomes our means of communicating and learning about the world, reading and seeing should be seen as equivalent. This will not signal the death of the printed word, but certainly the end of reading *as we know it*.

## NOTES

1.  Key works in these early criticisms of schools and teachers include Alan Bloom, *The Closing of the American Mind* (New York: Simon & Schuster, 1987); E.D Hirsch, Jr., *Cultural Literacy: What Every American Needs to Know* (New York: Vintage, 1988); Diane Ravitch, *The Troubled Crusade: American Education, 1945–1980* (New York: Basic Books, 1985).
2.  John Dewey, *Democracy and Education: An Introduction to the Philosophy of Education* (1917) (New York: Gardners Books, 2007); Paulo Freire, *Pedagogy of the Oppressed*, 30th Anniversary Edition (New York: Continuum, 2000);    Henry A. Giroux, *Teachers as Intellectuals: Toward a Critical Pedagogy of Learning* (South Hadley, MA: Bergin & Garvey, 1988); Peter McLaren, *Life in Schools: An Introduction to Critical Pedagogy in the Foundations of Education*, 5th Edition (Allyn & Bacon, 2006); Joe L. Kincheloe, *Toward a Critical Politics of Teacher Thinking: Mapping the Postmodern* (South Hadley, MA: Bergin and Garvey, 1993); Carol Gilligan, *In a Different Voice* (Cambridge: Harvard University Press, 1982); Lather, Patti, "Feminist Perspectives on Empowering Research Methodologies," *Women's Studies International Forum* 11, no. 6 (1988) 569–581; James A. Banks, *Multicultural Education, Transformative Knowledge, and Action* (New York: Teachers College Press, 1995); bell hooks, *Teaching to Transgress: Education As the Practice of Freedom* (New York: Routledge 1994); Christine Sleeter, ed., *Empowerment through Multicultural Education* (Albany: State University of New York Press, 1991); Joe Kincheloe and Shirley Steinberg, *Changing Multiculturalism: New Times, New Curriculum* (London: Open University Press, 1997).

3.  The somewhat obscure expression "the beholder's share" is important to these discussions in offering early evidence in art history of what literary theorists would later term "reader-response" theory. See, E. H. Gombrich, *Art and Illusion: A Study in the Psychology of Visual Perception* (Princeton: Princeton, 1960).

4.  Marshall McLuhan, The Gutenberg Galaxy: The Making of Typographic Man (Toronto: Toronto, 1962); Marshall McLuhan, Understanding Media: The Extensions of Man (New York: McGraw Hill, 1964);Raymond Williams, Television: Technology and Cultural Form (New York: Schocken, 1975).

5.  Donna Haraway, "A Manifesto for Cyborgs: Science, Technology, and Socialist Feminism," *Socialist Review* 80, vol. 15, 2 (March, 1985) pp. 65–107; Manual Castells, *The Informational City: Information Technology, Economic Restructuring, and the Urban Regional Process* (Oxford, UK & Cambridge, MA: Blackwell, 1989); George Landow, *Hypertext: The Convergence of Critical Theory and Technology* (Baltimore and London: Johns Hopkins, 1991); Howard Rheingold, *The Virtual Community: Homesteading on the Electronic Frontier* (Perseus, 1993). See also, N. Katherine Hales, "The Seduction of Cyberspace" Verena Andermatt Conley, et al., eds., *Rethinking Technologies* (Minneapolis, Minnesota, 1993) pp. 13–28; Felix Guattari, "Machinic Heterogenesis," in *Rethinking Technologies*, pp. 42–58.

6.  See Grant Kester, ed., *Art, Activism, and Oppositionality: Essays from* Afterimage (Durham, NC: Duke, 1998).

7.  See Socialist Review Collective, *Unfinished Business: Twenty Years of Socialist Review* (London: Verso, 1991).

8.  David Trend, *Cultural Pedagogy: Art/Education/Politics* (South Hadley, MA: Bergin & Garvey, 1992).

# THE DISAPPEARING WORD

## Growing Up in a Wordless World

AS I'M THINKING about this book, my eight-year old daughter is mad at me in what has now become a familiar pattern. We haven't had an argument and she hasn't misbehaved in any way. Emily is frustrated because I've told her she needs to read a book. Or try to read a book. We're again at an impasse because reading is difficult for Emily and she's starting to hate it. This is really out of character for her. In just about every other aspect of her life, Emily is engaged, positive, and quick to learn—in other words a happy, intelligent, and altogether "normal" kid. But she has this mysterious problem with the written word, and it has started me thinking about reading in our culture. The real source of Emily's frustration is that in most of her life she doesn't need reading. The world she experiences is driven by images, media, and interactive technologies—all so inviting and easy to access that learning to read feels like a conspiracy invented by grown-ups and school. And I'm beginning to think the kid may have a point.

When I imagine myself in Emily's shoes I know this reading business is tough. I'm not talking about peer pressure, competition, or jibes from friends who can read the *Farmville* directions that she can't always decipher. It's the more subtle experience that Emily has when part of her world looks like a jumble of hieroglyphics. It is a life partly cut off from a language that most of us have long taken for granted, a

universe of signage so ubiquitous that it envelopes us like the air we breath.

The specialists my spouse and I have consulted tell us that Emily's reading problem is not especially unusual. In fact, the American Academy of Family Physicians now estimates that as many as one in five children have "significant difficulty" in this area.[1] Such children eventually catch up with their peers, but it takes early intervention and a lot of work. Typical reading operates when eyes take in the raw visual data of letter and word shapes and match them with remembered patterns of familiar utterances. Emily has no problem with the remembered utterance part, and in fact has sophisticated vocabulary and grammar abilities for her age.  But there's a disconnect in her processing between what is seen and what is recognized. It's comforting for us to know that figures like Agatha Christie, John F. Kennedy, and Walt Disney faced similar challenges and did just fine in life.  But what isn't comforting is the fact that literacy levels in the general population among both children and adults are falling. Could something be happening in the broader society that makes this situation worse?

The stark reality is that reading problems in American schools have skyrocketed in recent years, sending educators and policymakers nationwide into a panic. Verbal SAT scores have dropped for several decades, with our tenth graders now ranking fifteenth in reading among twenty-seven countries.[2] More ominously, literacy levels in the adult population are also dropping at historically unprecedented rates. By current estimates, one in seven American adults— approximately 32 million people—can't read a newspaper.[3] These findings come from the U.S. Department of Education's most recent "National Assessment of Adult Literacy," a survey that measures reading rates as far down as county levels.  According to Sheida White, a researcher at the department, a growing number of citizens simply "cannot read paragraphs or sentences that are connected."[4] This means that many Americans are saddled with such low literacy skills that it would be tough to read anything more challenging than a children's picture book or to understand a medication's side effects listed on a pill bottle.

THE DISAPPEARING WORD   11

*The New American Illiteracy*
This drop in American literacy rates is hardly a secret. Neither are the scapegoats: *rising immigration, failing schools,* and *popular culture.* While each of these presumed culprits indeed plays a role in the nation's literacy crisis, the root causes of the problem lie deeper. Despite the anti-immigrant stance of headline-hungry politicians and talk-radio fanatics, the nation's population of newcomers does not seek to subvert our common language any more than gays and lesbians want to destroy the institution of marriage. Throughout the history of the United States people have arrived from non-English speaking countries and remarkably put themselves through the difficult process of adapting to a strange culture. The self-propelled transformation so inherent to the assimilation process gets forgotten by self-righteous reactionaries who have lost touch with their own immigrant roots. This in no way denies that English proficiency among immigrants is disturbingly low. But it is essential to understand that the desire for learning and language acquisition among theses groups is more intense than in any other demographic.

Visit nearly any community college or public high school in America and you'll find English as a second language (ESL) classes packed with people clamoring to learn the language essential to participation in society. But if you listen to commentators like Michael Savage and Jay Severen (the latter of whom recently referred to Mexican Americans as "criminalians") you get the impression that hoards of people are crossing U.S. borders intent on making Martha Stewart carry on in Spanish. It just isn't true—and it makes no logical sense. People come to America now for the same simple reason that they always have. They want to join something that seems to be working—so they can improve their lives. If the xenophobes ever took the time to actually converse with a new immigrant family, they'd find that learning English is what newcomers want to do most because you need language to do practically everything.

*Blaming Schools Again*
The intense desire among immigrants to learn English is almost never mentioned in mainstream media. Instead you hear endless critiques of the American educational system, where beating up on schools has become the country's favorite blood sport. These criticisms find voice

across the ideological spectrum. Attacks from conservatives date to the 1980s, most notoriously to a study from the Reagan-era U.S. Department of Education entitled *A Nation at Risk*, ominously proclaiming that America's "once unchallenged preeminence in commerce, industry, science, and technological innovation is being overtaken by competitors throughout the world."[5] *A Nation at Risk* blamed rising trade deficits on failing schools, asserting that "the educational foundations of our society are presently being eroded by a rising tide of mediocrity that threatens our very future as a Nation and a people."[6] Attacks on schools have persisted ever since, undergirded by a political program critical of progressive education, multiculturalism, and anything funded with public money.

Liberals offer their own answers for plummeting reading and math scores. Inspired by figures like Jonathan Kozol, liberals blame spending inequities for destroying schools. To Kozol, disparities in educational funding affect urban communities of color most severely. He writes that "people don't have any idea of how deeply segregated our schools have become. Public policy has pretty much eradicated the dream of Martin Luther King."[7] Liberals also fault traditional test-oriented teaching methods and public policies that benefit private schools.

With so much blame to go around, one might expect a revolution in the making in public education. No such luck. The much bally-hooed No Child Left Behind (NCLB) Act, enacted by Congress in 2001 and championed by *both* George W. Bush and Edward Kennedy, mandated standardized reading and math tests, goals for public school performance, and consequences for failure. Names of problem schools were published in local newspapers, parents were allowed to bail out, and chaos ensued overall. Some claimed that test scores went up in the narrowly defined measures the law required. Others argued that minority children suffered as NCLB poured billions into voucher options and corporate coffers. At the end of the day not very much changed in the great American literacy crisis.

The numbers are revealing. Despite some recent advances, reading scores among Latinos and Chicanos fall 25 points lower than whites, while scores of African Americans lie below by nearly 30 points. Not that whites are doing that well either. Over half of them

(in fact, 59 percent) don't read at a proficient level, while Hispanics and blacks fail at rates of 88 and 85 percent, respectively.[8] So, while immigrants and minorities struggle because they speak another language or go to poor schools, the problem seems to be broader in nature. This leads to inevitable debates over popular culture and suspicions that television and computer games are "dumbing down" our society.

*The Media Made Me Do It*
The demographic bubble of baby-boomer parents has pushed concerns about educational achievement to the forefront of public consciousness. Joining the legions of worried parents, one doesn't have to look far to find concerned educators and accusatory experts bemoaning the polluting influence of media on junior's unspoiled mind. If only we could keep him away from *Sponge Bob* and *Super Mario* or pry the Wii controller out of his hands, the little guy would cuddle up with a good book—maybe, if we are lucky, a literary classic like *Harry Potter* or *Twilight*. But no, he'd rather wallow in dreck. In fact, it seems his mind feeds on it, burrowing ever more deeply into the morass of mind candy that grows at an exponential rate on cable television and the gaping maw of the online entertainment infoverse. This seemingly primal fear among parents has a history dating to the early years of television, when, in 1961, newly–named Federal Communications Commission (FCC) chair Newton Minnow declared TV to constitute a "vast wasteland." The simple phrase went down in history, obliterating the rest of a speech in which Minnow also said that "When television is good, nothing—not the theater, not the magazines or newspapers—nothing is better."[9]

Since those years an enormous academic subculture has grown to feed public paranoia about popular culture. But it's a lazy crowd in intellectual terms. With a universe of parent groups, news organizations, and public officials anxious about what kids are learning, anyone with an academic title can concoct a study "proving" some deleterious effect from *Transformers* or *Grand Theft Auto*. Recent evidence has shown that the damage done by this stuff is minimal, short-lived, or non-existent in the minds of most people—young and old.[10] The only problem that media violence actually causes is a view of the world as a dangerous place, which is no laughing matter. The 24-hour

news cycle of cable television feeds the nation an endless diet of killings and mayhem, leading the average citizen to believe that we need police and military protection far out of proportion to any actual threat. Rates of crime have dropped in all categories during the past 30 years, but media coverage of killings has gone up by 600 percent.[11]

Fears about media are nothing new. In historical terms, people always have worried about violence and sexuality in storytelling, forgetting that these two elements have driven narratives as fundamental to human culture as Greek and Hindu mythology, Aztec and Samurai legend, the Bible and the Koran. Violence is especially embedded in the type of stories Western civilization tells itself. Literary works of the Middle Ages like Dante's *Inferno* (1302) and Chaucer's *Canterbury Tales* (1386-1400) were riddled with detailed descriptions of violent assault and death. Familiar plays of William Shakespeare like *Hamlet* (1607) and *Macbeth* (1606) relied heavily on patricide, fratricide, suicide, and plain old murder to drive their plots. In their day, Shakespearean works were the cultural equivalent to *Desperate Housewives* and *CSI*. Everybody saw them, from the illiterate "groundlings" who sat on the floor of the public theater to the educated elites who attended plays in Queen Elizabeth's court.

The printing press took storytelling beyond the stage. By the 17th century, over 1,000 print shops were operating in Europe. As printing improved over the next century, "true crime" books began recounting felonious acts and the brutal punishments that awaited those apprehended. The books satisfied a hunger for gore and provided warnings for potential offenders. The introduction of plate lithography in 1801 made possible the mass production of books, pamphlets, and broadsides. In the United States, *The National Police Gazette*, first published in 1833, arose to satisfy the public hunger for stories of violent crime. History has demonstrated that periodic "moral panics" over media seem to parallel the development of new communication technologies and the social changes they enable.

Violence was the centerpiece of early movies. Thomas Edison demonstrated the new technology in 1895 with his Kinetoscope film *The Execution of Mary, Queen of Scots*, a 30-second clip of a beheading. Movies of boxing matches proved to be a sensation. The immediate success of *The Corbett-Fitzsimmons Fight* (1896) gave it the dubious dis-

tinction of being one of the first films to evoke the ire of anti-media violence critics, a sentiment that led to a ban of prizefighting movies in 1912. Like today's effects-laden action films, graphic depictions in movies like Sigmund Lubin's *Chinese Massacring Christians* (1900) or George Méliès *The Last Days of Anne Boleyn* (1905) were used to help show off the features of the moving image. Early movies were especially popular among new immigrant populations in emerging urban centers. The visual language of film made proficiency in English irrelevant to those audiences.

But soon entertainment technologies would do something far more significant for audiences with limited literacy. Through the 1920s motion pictures were silent and viewers were required to read written captions of dialogue. Up to this point, movies had enjoyed great popularity, but they still remained a secondary form of entertainment, largely due to their lack of sound. As evidence of this fact, many silent films were originally used as "chasers" in the more popular vaudeville shows. Warner Brothers introduced "talking pictures" in 1926—eliminating the need for audiences to read. Movie sound unleashed the power of photographic realism.

*Reading and Seeing*
Since its inception in the 1840s the photograph had been radically changing society. Before photography the printed page conveyed information through written stories and laborious attempts at realistic depiction through drawings and engravings. These pre-photographic media required tremendous effort from both the sender and receivers of information. Reading is a linear medium—meaning that data is communicated one word at a time, in a rule-bound sequence, line-by-line. Reading comprehension takes skill, concentration, and, most of all, time. By contrast, a photograph delivers its entire message all at once. Sounds good, doesn't it? But the ease with which photographs convey information has gotten them into trouble throughout their history. Think media violence, pornography, propaganda, "trick" photography and special effects, manipulated news coverage, "telegenic" politicians—the list goes on. It all has to do with the deceptive simplicity of pictures and power of visual meaning—which creates anxiety about what images can do. When we look at a picture, we don't always understand why we respond to it. Written language gives us a

way to capture ideas—literally pinning them down on paper—for examination word-by-word. But pictures are wild. They defy written description. They require a new vocabulary and syntax—if you can even define them in such terms. This problem of translation drove linguists like Roland Barthes and Jacques Derrida crazy, as they struggled to stretch literary paradigms around visual ideas.[12] The best Plato could do was to explain the whole mess as a metaphor of things and copies of things.[13] As a result we tend to trust writing as somehow more reliable than pictures.

These difficulties in pinning down the way images make meaning lie at the heart of society's ambivalence toward visual intelligence. We need new paradigms to explain how vision informs us. A remarkable coalescence of thinking among evolutionary psychologists, neurobiologists, communication theorists, media educators, and technologists has begun to piece together a new picture of the human mind. This emerging paradigm, sometimes described as a "whole brain" model, traces our patterns of perception, understanding, and communication to pre-historic times in order to understand how the mind is wired, how it has evolved through genetic mutation, and how culture has imprinted its communicative processes.

Researchers have discovered that written language is but one of many possible modes of communication of which the brain is capable—and that other languages of images, sounds, and other sensations either exist or lie dormant, waiting to be awakened by human invention. Evidence of these non-linguistic forms of communication can be traced from the earliest *homosapien* cave paintings to the ubiquitous *YouTube* videos of our current moment. These pathways around reading are rooted in our genes and our history—and it's time to recognize their significance and potential. One doesn't need to be a brain scientist to reach this conclusion. New modes of communication in our current digital era are rapidly replacing old print paradigms. Today's young people need to possess new multimedia literacies.

## Reading Against the Grain

Reading isn't natural. This simple statement flies in the face of practically everything educators tell us about language acquisition and literacy. But it's true. Reading is a form of communication that has been systematically privileged over other forms of information exchange—and those other forms of communication have been discounted, discouraged, and delegitmized. Many people learn and more effectively remember stories that they hear; others respond more to pictures than to words.  But these forms of aural and visual literacy ultimately are trumped by the written word in Western culture. And it makes sense in terms of socialization—that is, in terms of teaching children how to adapt to the existing social order.  Written language is the lingua franca of functioning in society.

Children begin to learn to read in a seemingly automatic process following their acquisition of spoken language. Whether we teach our children to read using traditional "whole language" methods (i.e., "See Spot run."), or whether we break the words down into smaller sounds like speech through a "phonics" approach (i.e., "S/ee Sp/o/t r/u/n"), most kids readily pick up early reading skills in pre-school or kindergarten. Learning experts tell us that regardless of native intelligence, reading ability inevitably accrues, sometimes as early as three or four years of age, or sometimes, like with my daughter Emily, at a later age. But it always kicks in—as it must—because reading is essential not just for picking out a juice box or a Lego, but for all subsequent learning about the world.

Reading is so ingrained in our culture that many people believe it is a natural part of growing up—that children somehow automatically make the transition from speaking to reading. Most of us can remember our first adventures in the written world. For me it came around age four as I was squirting mustard on a hamburger patty and I remember asking, "Mommy, did I write a word?" I can still recall my mother scrutinizing the gloppy mess and kindly answering, "Yes David, you wrote your name."

But I still stand on the statement that reading is not natural—that it is a social convention adapted by Western civilization at the expense of other forms of communication. To understand the situation,

one needs to examine the pre-history of writing itself, to areas of anthropology and evolutionary psychology, which have been the site of fascinating research in recent years. The great breakthrough in human evolution took place 30,000 years ago, when "Homo Sapien" ("knowing human") culture evolved from a more animalistic state of being. Homo Sapiens differed from other early humans in their ability to speak words, or what were originally differentiated grunts or sounds referring to things like sticks or water.[14]

Experts disagree on how spoken language actually got started. Some neurobiologists think it came from a genetic mutation that gave people the physical ability to articulate word-like sounds. But if that was the case people would have started speaking 100,000 years ago—which they did not. Anthropologists have another idea—that at some point people simply discovered that an utterance could correspond to a thing in the world and that the utterance/thing connection helped them survive. Evidence of this kind of activity from bone points, harpoon heads, and other tools dating to 50,000-70,000 years ago places early signs of language in the regions of the African continent along the Nile River, where humans had gone to be near water in an time of draught.[15] Late in this era early language-bearing groups would begin to migrate from Africa into Europe and Asia.

What is the connection between early language and humanity's first tools? The initial primitive utterances represented something very important: the emergence of a symbolic consciousness. At first, a grunt or a click of the tongue would have a meaning—or what linguists call signification. Later these huffs, clicks, or other sounds would become systemized, remembered, and shared. Spoken language would come into existence and enable prehistoric humans to work together to hunt, gather, and eventually cultivate crops and livestock to keep them alive.[16] This process of developing a symbolic consciousness is what differentiates human beings from animals.

And the difference is clear brain-wise. Famous experiments have been conducted in which paint brushes have been put into the hands of chimps.[17] The furry guys like to paint, or so it seems, and they make patterns on canvases in a consistent manner. The problem is that the chimps just can't stop painting. Unless one of the observing "scientists" removes the canvas, the monkey messes the whole thing

up. And chimps never go back to look at their work. It just doesn't matter. In the animalistic mind the act of painting is simply another thing done in the present with no lasting significance—no mental link to anything else. But something in the human brain creates the link, remembers the significance, and forges the symbolic meaning that makes language and picture-making possible.

This symbolic thinking manifest in early humans also showed itself the physical world. At first a bent stick stood in for a bird and a scratch in the dirt was the trail of a hunter, but later images of animals and people appeared on cave walls and probably lots of other places lost though the ravages of time. The cave paintings found in Altamira (Spain) and Lascaux (France), produced 30,000-40,000 years ago, were protected from the elements. These first physical expressions of the human mind were pictures and figures of animals and people. There is now a broad academic consensus that the emergence of these renderings is partly what allowed Homo Sapiens to advance beyond more primitive Neanderthal culture. Written language didn't appear till much later, about 5,000 years ago. This means that for much of the early development of the creatures we now consider modern humans, communication was pictorial and aural rather than written.

Fast-forward to the present day. For a long time claims of "visual literacy" had little academic validity. Mostly they came from anecdotal observations from educators who saw that media could hold kids' attention and teach them thing books couldn't. But there really wasn't much science to back up the visual literacy idea. Of course, the entertainment and advertising fields didn't need scientific research to know that special effects and dazzling visuals captured customer attention. Madison Avenue had for decades known that images and jingles were much more potent ways than written explanations for luring buyers, especially youngsters.

*Looking to Neuroscience*
The understanding of visual literacy has advanced dramatically in the past decade, due to research in brain science and evolutionary psychology. For one thing, neurobiologists have discovered preferences for visual images hard-wired into our brains, which have little to do with written language. These pre-linguistic preferences are tricky to find because language exerts such a powerful "governing function"

over much of the brain does. After all, we "think" in words from a very early age. But there's a lot going on in the non-linguistic parts of the brain, which helps us navigate the world.

A model of partitioned brain functions was advanced in the 1960s by psychobiologist Roger W. Sperry, who later received the Nobel Prize for his work. Sperry said that the human mind had regions corresponding to two very different ways of thinking. In his words, each hemisphere is "indeed a conscious system in its own right, perceiving, thinking, remembering, reasoning, willing, and emoting," and that both "may be conscious simultaneously in different, even in mutually conflicting, mental experiences."[18] Sperry envisioned a region on the left side of the brain that is *verbal* and processes information in an analytical and sequential way, looking first at the pieces then putting them together to get the whole. He described a right brain that is *visual* and processes information in an intuitive and simultaneous way, looking first at the whole picture then the details.

Then left/right brain scholarship found its way into mainstream culture, notably through a 1979 book by Dr. Betty Edwards, *Drawing on the Right Side of the Brain*.[19] Edwards popularized the idea that people fell into camps as either left-brain rationalists or left-brain creative types. The book urged people to cultivate their right-brain capabilities through artistic activities. *Drawing on the Right Side of the Brain* achieved a cult-like popularity, with one reviewer describing it as "not only a book about drawing, it is a book about living."[20]

Recent brain research found that things weren't quite as simple as a clear left/right dichotomy, since regions of the brain constantly work together. Using Magnetic Resonance Imaging (MRI) and other technologies, brain researchers also now know that the brain has a front/back design. The front of the brain, known as the frontal cortex, controls language, cognitive behavior, personality, and social behavior. The back of the brain processes sight and imagery, in the visual cortex. In both humans and monkeys, the visual cortex has six layers, each of which process a unique mix of optical information. Different layers deal with items like spatial orientation, color vision, motion perception, and the recognition of patterns and even things like faces. The bottom line is that linguistic and visual intelligence can be attrib-

uted to different parts of the brain, but that the "whole brain" works together to get us through the day.

*Child Development and Human Evolution*
In the context of the whole brain, we can't simply separate visual literacy from the rest of our thinking. All the visual cortex really does is process data into raw perception. The frontal cognitive part of the brain assigns meaning to a scene or tells us that we are looking at the refrigerator. The same holds true for language. We are not born with the ability to understand words or say them—let alone read them. In the 50 or so recorded cases of children raised "in the wild" by animals, it's been clear that without human contact we have no language or picture making skills.[21] We learn these things from the people around us. The development of "visual thinking" in children follows a curious path that in some ways confirms what we know about our Homo Sapien ancestors.

Artwork by very young children appears to follow quite predictable patterns that remain constant across different cultures.[22] Psychologist Jean Piaget observed in the 1960s that when four-year-olds are asked to draw people or familiar things, they invariably produce images with similar characteristics. Certain things are greatly exaggerated (people with big heads are common), scale or proportion are ignored, visible parts of what is being drawn are excluded, other items get added from the child's memory.[23] In short, the pictures seem to be less about producing an accurate image of a thing seen than they are about rendering a mental image—a conceptual interpretation—of the depicted person or object. Houses are the size of people, dogs fly like birds, and mommy is distorted to be bigger than daddy.

Piaget's big contribution to the study of children lay in his formulation of "developmental stages" in the growing mind. Piaget told us that children are not simply pint-sized adults who reach maturity when they consume enough knowledge. Children actually perceive and understand the world in evolving ways as their brains grow through a sequence of stages. Little kids in the process of acquiring visual intelligence don't yet know that a picture they draw of a duck is actually supposed to look like a real duck. Instead they make the quite remarkable leap of drawing the duck according to a bird picture in their minds—maybe with giant eyeballs and purple wings. A little

later kids learn to correct their weird pictures into recognizable copies of reality and the wonderful world of childhood fantasy gets squashed. This is one reason why progressive art educators now no longer ask the question, "What is it a picture of?" but instead query, "Tell me about this picture."

Drawings by young children confirm that we are symbol makers––that human beings are defined by their ability to make mental images that stand in for real things. But are we the only animals that do this? It turns out that we are not. Recent research by UC San Diego neuroscientist V.S. Ramashadran has shown that creatures as primitive as birds (that some evolutionists say are the only living remnant of dinosaur species) have abilities to recognize visually abstract versions of things critical to their survival. Baby seagulls are drawn to the red beak of the mother bird that brings them food. But in captivity the little birds will choose a red Popsicle stick over a beige one. In fact, they will chase a red Popsicle stick if it moves.

Similar things happen with other birds. Male cat-birds will beautify their nests in ways to attract female birds who respond to certain colors and textures. In other words, certain visual forms are hard-wired into the minds of these creatures, which make them respond in particular ways. Most experts think that preferences for things like the red Popsicle stick are genetic mutations of the sort Charles Darwin described in his theories of evolution. Way back in history, baby seagulls who could recognize their mother's red beak survived and those who could not fell by the wayside.

But human infants are not baby seagulls. Do people manifest any similar hardwired visual preferences? In the field of archeology there is a tiny statue that has drawn much attention in the last few years. It is a four inch-high statue of a woman discovered in the small town of Willendorf, Austria. The tiny figure was carved 25,000 years ago. It apparently held great significance because it was carefully carried from place to place by the nomadic tribe that made it. The so-called "Venus of Willendorf" is an odd-looking statuette because its proportions of the female body are highly exaggerated—with an oversized head, huge breasts, and a bulging tummy.

This is to say that the statuette depicts not so much a "real" woman as does a mental image of a woman, with imagined features

reflecting fertility and plenty to eat. In later history, cultures on nearly every continent would make similar "earth mother" renderings as they struggled through periods of low birth rates and hunger. Evolutionary psychologists believe that human visual preferences for fantasized images of the body reflect powerful survival instincts imprinted in our pre-linguistic brains.

This pre-historic impulse to see and possess an idealized body presaged what we now consider "beauty." Survival instincts hardwired in the human brain made some depictions of people more desirable than others. The strangely unrealistic depictions corresponded to what viewers wanted, not what they actually saw. Thus began the human fixation on certain body parts, which remains with us today. This trajectory is easily traced by art historians through the stylized renderings of Egyptian tomb builders, Grecian and Early Roman sculptors, and bodily renderings in Asia, the African sub-continent, the Americas, and elsewhere in Europe. Over time the human impulse to render mental images into "art" has driven our aesthetic sensibilities, our desires for what we consider "good looking" people, and our yearnings for the things we want to have. We navigate the world through our sensory intelligence, like the baby seagull drawn to the red Popsicle stick. Advertisers have learned, more by marketing evidence than by any theory, that people will respond to certain colors, shapes, textures, and images over others—and that's what compels us to buy.

Innate human preferences for certain images explain part of the story of visual intelligence, but not all of it—because there is no getting around the centrality of written language in human consciousness. Words on a page are not a "natural" part of human existence, at least not in a historical sense. To appreciate this we must look to the origins of writing. There is no scientific doubt that Homo Sapien culture evolved into modern humankind by making pictures on rocks, cave walls, and burial sites. From an early stage images reveal a departure from "realism" in favor of abstraction like that of children's drawings. In part this simplification of rendering might be explained as a kind of shorthand for the sake of efficiency. But consistencies in the ways the shorthand developed show that the early mark-makers followed specific principles based on design elements they saw as important.

Precursors to writing are found in little bits of clay or stone "tokens" fashioned 9,000 years ago in the "Fertile Crescent" of land running from the Eastern Mediterranean region through the Western territory of current–day Iraq. Made habitable by water from the Tigris and Euphrates rivers, the so-called "cradle of civilization" also functioned as the channel for early migration from Africa into Eurasia. The earliest "counting tokens" inscribed with simple lines, crosses, and stripes, are attributed to the emerging Sumerian culture of Mesopotamia. With the innovation of a wedge-shaped stylus, markings got a little more detailed in depicting fundamental concepts like a hand or the sun—as these ideographs first began to serve as stand-ins for spoken words and formed the writing system to be known as cuneiform.[24]

About 5,000 years ago people began stringing little symbols and pictures into sequences to form early alphabets. Here again, the human capacity for abstraction mixes imagination with observation in fabricating imagery. As the first pictographic alphabet developed in Egypt, humans often appeared with heads or limbs from other animals, especially if those depicted held power or royal status. In regal tombs, such as that of Ramses IV in the Valley of the Kings near Luxor, thousands of hieroglyphics show remarkable—and remarkably unrealistic—stylistic consistency. Each delicately rendered figure appears in profile, but always with two eyes facing forward. As described by Nigel Spivey, "The artists who used this image of the body were not concerned with the actual appearance of a human being, but something like a dictionary definition ('Two legs, two arms, stands upright, etc.'). The shape of the human body in Egyptian art was in this sense determined not by any direct observation—certainly not in a drawing life class—but rather by a mental image."[25]

By 3,500 years ago the Egyptians had condensed their pictograms into a basic alphabet of 30 signs looking like crosses, hooks, snakes, and stick-people. Language historians believe that the Egyptian alphabet gave birth to the writing systems of the Phoenicians, Greeks, and Romans.[26] But pictographic writing seemed to sprout up all over the world around this time. In China people began carving ideographs into tortoise shells, known as "oracle bones," during this period.[27] By some accounts, the Chinese used as many as 5,000 individ-

ual signs in this early writing. In the Americas, ancient Mayan cultures living in cloudless desert environments were fascinated by astronomy and knew how the sun could make things live or die. The Mayans developed elaborate calendars based on the stars and a religious system to go with them, articulated in hieroglyphic writing showing geometric renderings of people, gods, and objects. In the Indus Valleys of what is now northwestern India and Pakistan, the Harappa people produced a kind of written code based on short sequences of symbols that no one has ever quite figured out. Some accounts date Harappa trident and diamond shaped symbols to as early as 5,500 years ago.[28]

*The Birth of Reading*
The history of reading really begins with paper. As early as 3,000 BC, the ancient Egyptians had scratched hieroglyphics on large compressed leaves of the papyrus plant. A bit later the early Romans began writing on parchment made from the skins of sheep, goats, and cattle—and parchment was widely used in Europe through the 1300s. But parchment was expensive to produce and its irregular surface quality made it unsuitable for making mechanical duplicates. Then came paper from China, where technicians in the court of Emperor Ts'ai Lun first began to spread hemp pulp mixed with rice starch on cloth sieves in the first century AD. Papermaking technology spread to Korea, Tibet, Persia, India. But things really began to speed up about 500 years ago. It largely had to do with the development of printing. While the invention of the moveable metal-type printing press generally is attributed to German Johannes Gutenberg in the 1400s, the Chinese had been printing with moveable clay type four centuries earlier. But Gutenberg's technology had the backing of a powerful social institution that Chinese printing did not: the Catholic Church. Initially Gutenberg mass-produced papal "indulgences," which were little slips sold by the church to wealthy people as pardons for their sins. But Gutenberg's big market turned out to

be bibles, which before the printing press took as long as 20 years to copy by hand.

The effect of Gutenberg's invention went far beyond religious indoctrination, however. As Marshall McLuhan eloquently explained in his book *The Gutenberg Galaxy*, the printing press set in motion what remains perhaps the greatest social transformation in the past two millennia—the spread of literacy on a mass scale.[29] And with growing literacy, intellectual discourse and nationalistic sentiment flourished. Simply put, with the spread of printed ideas it was less possible for people to be isolated into pockets of ignorance, superstition, or manipulation. And as printed ideas gained currency among large populations, the idea of belonging to a community or nation no longer was defined by geography boundaries like rivers or mountains, or, for that matter, by local demagogues. An explosion in reading took place around the world in the centuries following the invention of the printing press. Initially driven by the church, publishing soon became a secular affair, as governments recognized the importance of books in advancing knowledge and as a public hungry for information bought pamphlets and broadsides (single sheets of stories or news). The increased consumption of reading materials of all sorts was one of the key features of what we now term the Enlightenment or "The Age of Reason"—a period beginning in the 1600s in which a range of modern ideas and institutions emerged, from individual rights to modern nation-state.

## From Gutenberg to *Grand Theft Auto*

*The Print Divide*
There have been two great eras in the evolution of reading. One was marked by the explosion of reading that occurred in the Enlightenment era beginning approximately 500 years ago, which separated language from visual communication. The second great

moment came with the exponential growth of personal comput-
ing and network technologies that began in the mid-1990s. The
so-called "digital era" transformed society's relationship to read-
ing by rendering it equivalent to visual information. Today read-
ing exists as a vital—yet partial—component of the communica-
tions toolbox people need in a digital world of movies, television,
the World Wide Web, and interactive media. Print and visual
communication are converging in the new digital era to demand
new definitions of what it means to be a literate person.

Enlightenment thinking is well-known for the philosophical
division of human existence into two realms—mind and body—
thanks to the rascal of renaissance thinking, Rene Descartes.[30]
The Cartesian "split" of human consciousness into two domains
governed philosophical thinking for centuries, neatly approxi-
mating dualisms like good against evil, humanity versus nature,
and progress over inertia. Descartes didn't actually invent the
mind/body divide, which can be traced to ancient Greece and
India. But the idea really took hold in an Enlightenment Age of
systemic thinking. This binary thinking justified both bad and
good behavior, underpinning the spread of colonialism, capital-
ism, and democracy. But more importantly for this discussion,
the Cartesian mind/body split helped divide the word and the
image.

The social history of art has unequivocally documented the
way the Enlightenment drew a line between written knowledge
and visual intelligence.[31] Before the revolution of literacy in
Europe in the early 1500s, Michelangelo was known as one of the
era's greatest communicators through his commissioned artworks
illustrating stories from the Bible. People would simply look at
his renderings because most of them didn't read. The Catholic
church made much of this, especially when it came to depictions
of Christ, through what has been termed "optical communion," or
communing with the holy spirit by gazing at it.[32] But within
200 years people began to practice religion using Bibles, as read-
ing the gospels eclipsed viewing them in pictures. Of

course, hand-written illuminated manuscripts had existed, which kept words and images together. But they took so much effort to make that only churches or rich people had them.

With printed Bibles, larger numbers of people had access to written texts conveying both a specificity and an immediacy that paintings and sculptures could not. Before long reading became the coin of the realm. Meanwhile artworks morphed from being the television of the medieval age into rarified roles as signatures of wealth, recordings of aristocratic family history, or testimonies of faith. The point is that visual and written thinking began to veer apart—and people's views of artists changed as well. Once figures fully embraced by medieval society as the "seers" in the social order, artists became outmoded by the written word and exoticized by mainstream culture. Whereas Leonardo Da Vinci was regarded as an artist, scholar, and scientist—within a few hundred years artists were seen more as eccentric "visionaries," sometimes endowed with magical creativity, but usually not reasoned or logical thinkers. And certainly not writers.

During the 500 years in which Enlightenment thinking ruled philosophy, the divide between the word and the picture widened, with reading establishing itself as the essential currency of personal communication, academic scholarship, and legal discourse. In English the fundamental appearance of the printed alphabet has remained the same through the present. As the written word gained currency, the visual image suffered. The once dominant vehicle of communication in the pre-Enlightenment era ultimately was devalued and distrusted in the age of reason. To many people visual imagery became synonymous with propaganda and, eventually, with marketing. This latter commercial link was hardly neutral. By the 20th century, educators and child advocates began arguing that overexposure to visual media actually destroyed the minds of youngsters or other impressionable groups. As discussed above, movies were suspected from their earliest days of polluting the minds of the urban poor. It's no different today. Take this, for example, from educational psychologist Jane M. Healy, who regularly is featured on the *Today Show, Nightline, Good Morning America, CNN,* and *NPR.* "We know that experience shapes the networks and pathways that constitute the physical structures of our brains. So, while children who spend time reading will develop

'book minds,' child development experts tell us that brains of young-
sters who spend lots of time in front of a TV set may be expected to
develop differently."[33] To Healy, "television, video games, and other
components of popular culture compromise our children's ability to
concentrate and to absorb and analyze information." In fact, "even
supposedly educational shows like *Sesame Street*—develop 'habits of
mind' that place children at a disadvantage in school."[34] So there you
have it: the up-to-date version of media as vast-wasteland-mind-
candy-chewing-gum-for-the-mind-couch-potato to argument. A pow-
erful cohort of educators still tells us that watching stuff on a screen
rots your mind.

The problem with this pop-culture reading-is-everything argu-
ment is that philosophy demolished the credibility of the Enlighten-
ment project at the end of the last millennium. The rise "postmodern"
thinking in the 1980s academic circles may have been too esoteric for
most people to fully appreciate, but post modernism's general dis-
trust of institutional authority and given "truths" trickled down to the
popular zeitgeist.[35] Nobody living in the real world believes anymore
that everything can be divided into categories of good-versus-bad or
black-and-white. Comedians making fun of such stuffed-shirt think-
ing have moved from the margins of public discourse to the center.
Jon Stewart's *The Daily Show* won two Peabody Awards and a dozen
Emmys for its "fake news" poking holes in the story lines of political
figures. Life is simply more complicated than George W. Bush's "Axis
of Evil."[36] If we learned anything from that presidency, it was that
America's program of "progress" and "freedom" also could foster
division and destruction.

Ongoing assaults on Enlightenment mind/body thinking con-
tinue from across the intellectual spectrum. Single-consciousness
thinkers, known as "monists," have for a long time argued that the
human psyche can't really be spilt in two, except as an idea.[37] To mo-
nists there is really only one whole person. Most religions frown on
the mind/body split on similar grounds. At the other extreme, iden-
tity theory has argued that both dualism and monism have it wrong,
since we are always made up of many "selves" deriving from factors
like personal experience, temperament, genealogy, gender, and age.
Meanwhile, even broader resistance abounds against Enlightenment
autocratic and rule-bound thinking. Call it street smarts, native intel-

ligence, or the rebellious nature of youth culture—but the public zeit-geist seems to be brimming with antiauthoritarianism. Young people, who in masses prefer fake news to the establishment's illegal wars, are supporting a huge home-grown culture of "Indy" music, *YouTube* videos, and the blogosphere.

The mind/body divide also fails scientifically. Neurobiology has shown that in actuality the brain is an organ of cells exchanging electrical energy to perform many distinct functions—not simply two. In the 1990s Harvard psychologist Howard Gardner proposed a theory of mind that gained great currency, especially in debates over the word/picture dichotomy. In his classic work *Frames of Mind: The Theory of Multiple Intelligences*, Gardner proposed eight discrete brain functions associated with different ways of being in the world: verbal-linguistic, visual-spatial, logical-mathematical, musical, naturalistic, bodily-kinesthetic, interpersonal, and intrapersonal.

> In the heyday of the psychometric and behaviorist eras, it was generally believed that intelligence was a single entity that was inherited; and that human beings - initially a blank slate - could be trained to learn anything, provided that it was presented in an appropriate way. Nowadays an increasing number of researchers believe precisely the opposite; that there exists a multitude of intelligences, quite independent of each other; that each intelligence has its own strengths and constraints.[38]

Gardner's ideas had a profound effect on the field of education, where it helped explain why different kids seem to have an easier time in some subjects. To Gardner, people are simply differently inclined—some more musical, spatial, logical, etc. Teachers finally could explain why students with academic difficulties might thrive as painters or clarinet players. Which gets us back to the word/picture dichotomy. Multiple intelligence tells us that you can't simply write off an entire domain of visual perception rooted in the pre-historic mind of humanity. If one looks at our society it's clear that most people really depend on their visual intelligence to learn, work, and enjoy themselves. As this embrace of visual culture was sweeping public consciousness at the end of the 20th century, a far larger cultural and material change was taking place. A technological tsunami would sweep over society, transforming our institutions and everyday lives.

*The Digital Reunion*

The dawn of the digital era marked the biggest change in our relationship to language since the invention of the printing press. The rise of personal computing, networked communication, and other technologies at the turn of the millennium coincided with the death of Enlightenment thinking that separated the word from the image. On one hand the world is accommodating non-readers as never before simply for practical reasons. At Disneyland, my daughter Emily is identified by her electronic fingerprint and she buys drinks by pressing pictures on vending machines. Young people now make *YouTube* videos like crazy, communicate face-to-face through laptop cameras, and the Nintendo Wii lets them navigate a game with a wave of the hand. In my life, the bank machine now reads the checks I deposit, a voice in my car tells me where to turn when I get lost, and I don't need to touch my phone to use it. College students let the Amazon Kindle read back to them the term papers they've just composed. In a sweeping sense, something is happening to the way we communicate and function in daily life. Language is being taken over by images as experience itself becomes increasingly visual.

Two forces are at work in the virtual transformation of the word and image. One is the ever-advancing "push" of technology, which in its essence, functions to expand the capabilities of human beings. The other is the equally powerful "pull" of human society to find more efficient and accessible means to communicate and get things done. The usurping of communication by images and media is neither good nor bad. It's a simple fact of life. Clearly, this change does much for the nation's growing non-English-speaking demographic as well as certain disabled populations. If the ultimate purpose of language is to convey knowledge and empower people, then the image-based society of the future actually might possess more wisdom than in the past.

For today's young people the word and the image exist on an equal footing—in part because visual imagery simply bests writing in certain areas. Let's look at entertainment with an open mind. New movie releases are now driven increasingly by special effects and digital chicanery, taking over the screen with explosions, flying characters, and creatures, as well as entire environments that morph and change in fantasized realities. It's been observed by more than one

movie critic that many films make no logical sense—that they simply present a sequence of cinematic experiences. But this criticism really misses the point. It fails to explain the fact that the top grossing films of all time share one common theme: they all take their audiences into astonishingly complex imaginary worlds, which could not be rendered in "realistic" visual representation. The ten most highly attended movies ever are: *Titanic* (1997), *The Dark Knight* (2008), *Star Wars IV* (1977), *Shrek 2* (2004), *E.T.* (1982), *Star Wars I* (1999), *Pirates of the Caribbean: Dead Man's Chest* (2006), *Spider-Man 2* (2002), *Star Wars III* (2005), and *Lord of the Rings: Return of the King* (2003). One of the reasons why movie theaters continue to thrive even in difficult economic times lies in the immersive character of the theatrical film experience. People in movie theaters lose their corporeal selves in the darkness of the theater. Owing to technological advancements like Dolby Sound, Imax Screens, digital projection, and 3-D production, movies now maximize the immersive experience that originally drew audiences at the medium's inception.

But let's not forget television. In the last two decades the depth and complexity of TV has grown dramatically in what many media scholars call the age of "quality television." HBO's *The Sopranos*, which was launched in 1999, frequently is cited as the series that raised the bar for commercial TV to a level previously associated with PBS. The new quality TV distinguishes itself with complex plots, ensemble casts, and long-term story lines in such series as *Twin Peaks, ER, Six Feet Under, Lost, Oz, The Wire, Battlestar Galactica, Deadwood, True Blood,* and *Fringe*. Often catering to self-selecting cable-TV audiences, the new quality television has been called by some an emerging medium of "visual literature."[39]

Computer games offer an even more powerful immersive experience, driven by the visceral pull of interactivity. More than a simple matter of engaging participants in "play," the best games allow audiences to inhabit virtual worlds. I would challenge any "educational expert" who denigrates the world of electronic culture to pick up an X-Box or PlayStation controller and give it a try. What they'd find is that navigating a virtual world is incredibly difficult and complicated. A first-time game player is like an infant learning to crawl. You have

to learn to move and navigate before you can even think about speaking or interacting. Most adults are helpless in such an environment.

Of course, it's vital to acknowledge that this great push and pull of digital technology hinges on the availability of the gadgets and services that make it happen—which all comes at a price. The widening chasm between rich and poor in the United States and around the world remains one of the most underreported stories of the great economic downturn. If there is a split in contemporary society, it is no longer between readers and non-readers. It lies between technology haves and have-nots. While half the population of the U.S. remains unconnected to the internet, America has eight times as many internet users as Africa.[40] Clearly, for those fortunate enough to have the latest toys of modern communication, a remarkable confluence has taken place between the word and the image. They are both omnipresent in our lives at every level of existence. Vision informs language and vice versa as never before in human history. There is nothing lazy or weak about using one's visual capacities to navigate the world these days.

But don't worry about the written word. While illiteracy remains a serious problem in some countries, the United Nations estimates that 80 percent of world's population is able to read and write a simple sentence.[41] The U.N. stresses the vital role of literacy in the "ability to identify, understand, interpret, create, communicate, compute and use printed and written materials associated with varying contexts. Literacy involves a continuum of learning to enable an individual to achieve his or her goals, to develop his or her knowledge and potential, and to participate fully in the wider society."[42]

In our digital age more people are reading and writing than ever before—thanks to e-mail and other advancing social networking technologies like Twitter. Kids are actually clamoring to write so that they can instant-message or text their friends through laptops and phones. And yes, books continue to provide their own powerful kind of immersion in a story—and they offer a unique kind of detailed experience. In fact, recent research carried out by the National Endowment for the Arts (NEA) has show that in the midst of all of the new-fangled technological distractions, people are actually reading more books in recent years.[43] In 2009 the NEA reported that for the first time in the history of its reading surveys—conducted five times since 1982—the overall rate at which adults read literature (novels and

short stories, plays, or poems) rose by 7 percent. Young adults show the biggest jump in reading, with 18-24 year olds having seen the biggest increase—9 percent since 2002. The racial/ethnic breakdown is significant, with overall reading jumping 20 percent among Latinos, 15 percent among African Americans, and 8 percent among whites.

Why is this increase in reading happening? A lot of the credit seems to go to technology. A whopping 84 percent of Americans get a portion of their material from the internet, largely from downloaded books. Approximately 15 percent do their reading online. These findings fly in the face of the criticisms and fears of pious experts bemoaning the dumbing-down of American society by popular culture and media technology. Rather, the research confirms what the business community has known ever since the dot-com boom of the 1990s—that we are increasingly becoming an information society made up of "knowledge workers" and consumers. The linguistic world of reading and the visual world of media are not competitive or mutually exclusive domains. The word and the image are inextricably intertwined in the information order of the 21$^{st}$ century.

*The End of Reading* does not argue for the elimination of the written word in our society. But it does insist on the end of reading *as we know it*. Living in the digital era demands a new kind of literacy that is both language and vision based. The computer industry saw this coming in the 1990s when it began giving hardware to schools. And while I'm no big fan of Adam Smith, the "invisible hand of capitalism" really does pull the strings in the society in which we live.[44] Vision drives the biggest commodity of the 21$^{st}$ century: information. Being cognizant of how pictures, sounds, and even tactile sensations tell us things is essential to our individual and collective lives. Right now, this is a very touchy matter in schools—and reading education is the ground zero of the debate. In our highly technological and increasingly visual society, is it okay if Johnny—or my daughter Emily--can't read?

## NOTES

1. S. Sutton Hamilton and Frances P. Glascoe, "Evaluation of Children with Reading Difficulties," *American Family Physician*, 74, no. 12 (Dec. 15, 2006) p. 1.

2. E.D. Hirsch, Jr. *The Knowledge Deficit* (New York: Houghton Mifflin, 2006) p. 1.
3. Gregg Toppo, "Literacy Study: 1 in 7 U.S. Adults Are unable to Read this Story," *USA Today*, 1/8/09. Internet reference. http://www.usatoday.com/news/education/2009-01-08-adult-literacy_N.htm Accessed July 6, 2009.
4. Ibid.
5. National Commission on Education, *A Nation at Risk: The Imperative for Educational Reform* (Washington, DC: US Department of Education, 1983). n.p.
6. Ibid.
7. Jonathan Kozol, *Savage Inequalities: Children in America's Schools* (New York: Harper Perennial, 1992) p. 3.
8. *The Knowledge Deficit*, p. 3.
9. Newton Minnow, "Television and the Public Interest" (Washington, DC: Federal Communications Commission) Internet reference. www.fcc.gov. Accessed July 24, 2009.
10. See David Trend, *The Myth of Media Violence: A Critical Introduction* (Malden, MA: Blackwell, 2007) and Jonathan L. Freedman, *Media Violence and Its Effects on Aggression: Assessing the Scientific Evidence* (Toronto: University of Toronto, 2002).
11. *The Myth of Media Violence*, p. 27.
12. Many literary theorists have sought to provide explanations for the ways visual imagery functions. Most have been practitioners in the linguistic field of semiotics—or the study of signs and their meanings. Emerging from scholarship begun in the latter half of the 18th century by Charles Sanders Pierce and Ferdinand de Saussure, semiotics grew from desires to rationally explain the operations of language in a quasi-scientific fashion. Barthes, Derrida, and others in this field sought to bring linguistic principles to the understanding of images, specifically photographs—although Barthes famously applied his principles to the "reading" of all manner of objects, images, and experiences.
13. Plato explained his theory of representation through "The Allegory of the Cave" in his book *The Republic*. In Plato's story he imagines a group of people who have lived chained in a cave all of their lives, facing a blank wall. The people watch shadows projected on the wall by things passing in front of a fire behind them, and begin to ascribe forms to these shadows. According to Plato, the shadows are as close as the prisoners get to seeing reality through this "copy" of the world outside. He then explains how the philosopher is freed from the cave and comes to understand that the shadows on the wall are not constitutive of reality at all. In his "theory of forms" Plato later says that even the objects we experience in our lives, like chairs and tables, are but copies of "ideal" mental images of the objects.
14. William Noble and Iain Davidson, *Human Evolution: Language and Mind: A Psychological and Archaeological Inquiry* (New York: Cambridge, 1996).
15. Steve Olson, *Mapping Human History: Genes, Race, and Our Common Origins* (Boston and New York: Mariner Books, 2002), p. 88.
16. Denis Dutton, *The Art Instinct: Beauty, Pleasure & Human Evolution* (New York: Bloomsbury, 2009).
17. *How Art Made the World: A Journey through the Origins of Human Creativity* (New York: Basic Books, 2005), pp. 11–12.
18. Roger Wolcott Sperry, "Lateral specialization in the surgically separated hemispheres." In: F. Schmitt and F. Worden, eds., *Third Neurosciences Study Program* (Cambridge: MIT Press, 1974) p. 5.
19. Betty Edwards, *Drawing on the Right Side of the Brain* (New York, Penguin, 1979).
20. Helen South, "Drawing on the Right Side of the Brain: Full Review" *About.com* Internet reference http://drawsketch.about.com/od/suppliesbooks/fr/draw_right_side.htm. Accessed July 18, 2009.

21. *How Art Made the World,* p. 15
22. Ben-Ami Scharfstein, *Art Without Borders: A Philosophical Exploration of Art and Humanity* (Chicago: Chicago, 2009).
23. Jean Piaget, *Play, Dreams and Imitation in Childhood* (New York: Norton, 1962).
24. C. B. F. Walker, *Cuneiform: Reading the Past* (Berkeley: California, 1987).
25. *How Art Made the World,* p. 63.
26. Donald P. Ryan, "The Archaeological Analysis of Inscribed Egyptian Funerary Cones," *Varia Aegyptiaca* 4, no. 2 (1988): 165-170.
27. Michael Loewe and Edward L. Shaugnhnessy, *The Cambridge History of Ancient China: From the Origins of Civilization to 221. B.C* (Cambridge: Cambridge University Press, 1999).
28. David Whitehouse, "'Earliest Writing' Found," *BBC Online Network* (May 4, 1999). Internet reference. http://news.bbc.co.uk/2/hi/science/nature/334517.stm. Accessed July 19, 2009.
29. Marshall McLuhan, *The Gutenberg Galaxy: The Making of Typographic Man* (Toronto: Toronto, 1962). McLuhan credits William Ivins with many insights into the role of written language in human culture. See William M. Ivins, Jr., *Prints and Visual Communication* (Cambridge, MA: MIT, 1969).
30. In the 1600s French philosopher and mathematician Rene Descartes asserted that the body works like a machine, that it has the material properties of extension and motion, which follow the laws of physics. The mind (or soul), on the other hand, was described as a nonmaterial entity that lacks extension and motion, and does not follow the laws of physics. Descartes argued that the mind controls the body, but that the body can also influence the otherwise rational mind. This dualism, adapted from ancient Greek philosophy, eventually was challenged in the 19th and 20th centuries by "structuralists" who said that the mind and body could not be neatly separated. The philosophical fields of structuralism and semiotics sought an integrated theory of the mind, primarily by analyzing the functions of language and "sign systems."
31. Janet Wolff, *The Social Production of Art* (New York: NYU, 1993).
32. Martin Kemp. ed., *The Oxford History of Western Art* (Oxford: Oxford, 2000). p. 139.
33. Jane M. Healy, "Kid's Brains Must Be Different..." Excerpt from *Endangered Minds* (New York: Touchstone, 1990). Internet reference. http://www.enotalone.com/article/5607.html. Accessed July 22, 2009.
34. "Kid's Brains Must Be Different..."
35. Postmodernism emerged in the 20th century as its proponents challenged then-dominant structures and assumptions of philosophy. Specifically critical of phenomenology and structuralism, early postmodern philosophers include Jean Baudrillard, Jean-François Lyotard, Jacques Derrida, and Michel Foucault. These thinkers asserted that all knowledge and philosophical ideas are conceived by human beings who can never be fully conscious of their own biases and preconceptions. As a consequence, all philosophy is always someone's point of view and some vested interest behind that viewpoint. Foucault in particular argued that this kind of biased thinking masquerading as "objectivity" has the effect of reproducing authority and the "power" of dominant groups in society.
36. "Axis of Evil" is a term coined by United States President George W. Bush in his State of the Union Address on January 29, 2002, in order to describe governments that he accused of helping terrorism and seeking weapons of mass destruction. President Bush named Iran, Iraq and North Korea in his speech.
37. Monism is the philosophical view that there is unity in a given field of inquiry. Some monists argue that the universe is really just one thing, despite its many

appearances and diversities. Other monists support the view that there is one God, with many manifestations in different religions.

38. Howard Gardner, *Frames of Mind: The Theory of Multiple Intelligences* (New York, 1993) p. xxiii.

39. Janet McCabe and Kim Akass, *Quality TV: Contemporary American Television and Beyond* (London and New York: Tauris, 2009).

40. "The Digital Divide at a Glance," *World Summit on the Information Society* (New York: United Nations/International Telecommunications Union, 2005) Internet reference. http://www.itu.int/wsis/tunis/newsroom/stats/ Accessed July 23, 2009.

41. "Human Development Index," *The Economist* (2009). Internet reference. http://www.economist.com/screensaver/glossary.cfm. Accessed July 22, 2009.

42. UNESCO Education Sector, *The Plurality of Literacy and its implications for Policies and Programs: Position Paper*. (Paris: United National Educational, Scientific and Cultural Organization, 2004) p. 13.

43. All NEA reading statistics in this section from "More American Adults Read Literature According to New NEA Study," excerpting findings from *Reading on the Rise* (Washington, DC: National Endowment for the Arts, 2009). Internet reference. http://arts.endow.gov/news/news09/ReadingonRise.html. Accessed Aug. 1, 2009.

44. Adam Smith, *The Wealth of Nations* (London: Strahan and Cadell, 1776).

CHAPTER TWO

# THE CRISIS IN PUBLIC LITERACY

## The Demographic Blame Game

ALTHOUGH my daughter Emily struggles with reading, it doesn't seem to bother her very much. In fact, the only times it really causes her stress are when we sit her down to study reading or when she is forced to read in school. The rest of the time Emily effortlessly navigates her way through the day because so much of her world is visual or defined by multimedia technologies like YouTube or the Wii. This is part of the problem—for Emily inhabits a universe in which written language has become simply one among many ways communication takes place. Living as we do in Los Angeles, one frequently encounters people who have absolutely no fluency in English whatsoever. Yet these non-English speakers function and even thrive nevertheless. The learning experts we have consulted about Emily tell us that most kids who are late readers invariably catch up at some point—just as most non-English-speaking immigrants eventually learn the language. Still, we feel compelled to push our daughter to advance as quickly as possible—and it stresses her out. All of this raises questions in my mind about what it takes to *really communicate* in today's world of multiple communication forms and technologies.

After all, what is literacy? The answer to this question lies at the heart of *The End of Reading*. The quick response is that literacy is being able read and write. We think of basic literacy enabling a person to fill out a job application or understand the label of a cereal box. These seemingly simple applications of literacy point to its broader and

more significant meaning. Literacy enables a person to function in society—to make a living, to learn things in school, to buy needed items, etc. More specifically, most of the time we think of literacy as proficiency in written English. And the general tendency among native-born American citizens is never to question to centrality of written English in the social order or to consider the viability of alternatives.

*The End of Reading* argues that great transformations are taking place in literacy as we know it. For too long mainstream culture has ignored the importance of visual culture and the many ways we "read" the world through images, sounds, and other sensory data. At the same time, the great English-speaking majority in the U.S. has devalued and worried about the many Americans who get through their days speaking languages other than English. Some even argue the presence of "foreign" languages threatens the social cohesion to society that a common language provides. From this perspective there indeed is much to worry about since so many newcomers continue to arrive speaking their native languages.

*One Language or Many?*
While the U.S. does not have an "official" language, 82 percent of the population speaks English.[1] The variety of English spoken in the United States is known as American English; together with Canadian English it makes up the group of dialects known as North American English. In recent decades there have been several proposals to make English the U.S. national language in amendments to immigration reform bills, but none has succeeded. Spanish is the second most common language in the country, and is spoken by over 12 percent of the population.[2] The United States holds the world's fifth largest Spanish-speaking population, outnumbered only by Mexico, Spain, Argentina, and Colombia. Throughout the southwestern United States, long-established Spanish-speaking communities coexist with large numbers of more recent Spanish-speaking immigrants. Although many new Latin American immigrants are less than fluent in English, second-generation Hispanic Americans commonly speak English fluently, while only about half still speak Spanish.

Despite the attention to recent immigration from Central and Latin America, people of German ancestry make up the largest single ethnic group in the United States. The German language ranks fifth among languages spoken in the U.S. Similarly, Italian, Polish, and Greek are still widely spoken among populations descending from immigrants from those countries during the past 100 years, but these languages are dwindling as older generations pass away. Russian is also spoken by immigrant populations. Tagalog and Vietnamese have over one million speakers in the United States, almost entirely within recent immigrant populations. Both languages, along with Chinese, Japanese, and Korean, are now used in elections in Alaska, California, Hawaii, Illinois, New York, Texas, and Washington.[3] Some Native Americans still speak their native languages, but these populations are decreasing, and their languages are almost never widely used outside of reservations. All totaled, about 337 languages are spoken by the American population.

Remember, though, that we are talking about written and spoken languages only. Of great relevance to *The End of Reading* are the powerful forms of communication used by the vision and hearing impaired. Sign language and Braille give us important clues about ways human beings can function in the world without the "written'" word, as commonly understood. People with disabilities can teach us about the potentials of human beings communicating without conventional language. From the disabled we can take lessons about visual, aural, and tactile literacy—as well as the fascinating ways that adaptive technologies for the handicapped are leading the way in developing new forms of literacy. Perhaps more significantly, attention to disability culture can lead to a broader recognition that everyone is, in a sense, "differently abled." We all command a unique blend of physical, intellectual, and sensory capacities. Some of us face greater challenges than others. But in the end we all share the same desires to communicate, interact, and succeed in what we do.

Given the many languages spoken, written, signed, and read in the U.S., an important distinction is needed in any discussion of literacy in America. Ours is not so much a nation plagued by illiteracy, as it is a country struggling for universal competence in one language: English. Many stereotypes persist about the intelligence, character, and work-readiness of immigrants who lack English proficiency but

who possess quite competent literacy in their native languages. Contrary to popular opinion, most non-English speaking citizens and non-citizens are completely "literate" if we define literacy as the ability to communicate and function in a society. Again, the "invisible hand of capitalism" responds to this with bi-lingual advertising, store signage, and product packaging. And government responds as well with multilingual tax forms, health information, and other print and online materials.

Some advocate the benefits of a multilingual society, noting that in many nations around the world citizens routinely are schooled in more than one language. Besides promoting cultural diversity internally, multilingual nations can better tolerate immigrants and better understand people in other countries. One doesn't have to look far to see this principle in action. Canada is a nation of two languages, English and French. According to the Canada's Official Languages Act, the purposes of maintaining a bi-lingual society are to: "ensure respect for English and French as the official languages of Canada, and equal status, rights and privileges as to their use in federal institutions; set out the powers, duties and functions of federal institutions in the area of official languages; support the development of English and French linguistic minority communities, and encourage the full recognition and use of both English and French in Canadian society."[4] The majority of Francophones live in the province of Quebec, although there are also large French-speaking communities in Ontario and the Atlantic provinces, especially New Brunswick.

It might surprise some Americans to know that the literacy rate in Mexico is 92 percent. That's right, 92 percent as calculated by our own U.S. Central Intelligence Agency.[5] Much of Latin America reads at an 80 to 90 percent level. In Pakistan the literacy rate is 55 percent, in Sierra Leone it is 38 percent, in Afghanistan it is 28 percent.[6] U.S. literacy rates are calculated by a double standard. On one hand, American government officials proudly calculate the nation's literacy at 99 percent, referring to the number of people minimally competent in one language or another. On the other hand, the number of people literate in English is estimated at about 85 percent.[7] Contrary to what anti-immigrant groups say, this basic statistic of 15 percent of the

population lacking in "Basic Prose Literacy Skills" in English has remained relatively constant for the last 20 years.[8]

Several important conclusions can be drawn from these statistics and international comparisons. Perhaps the most significant of these is that the great "literacy crisis" in America is partly a myth. All but one percent of Americans can read and write, perhaps not in English, but in some language. Other bi-lingual or multi-lingual societies, such as Canada, show us that this is a perfectly workable situation if national and regional governments are willing to accept it. And thus far the United States—to its credit—has exercised restraint in declining to declare English the "official" national language. Moreover, the great fear among anti-immigrant groups that hoards of illiterates are streaming across the southern U.S. border is also a myth, since literacy in Central and Latin America is relatively high or in some cases very high. In Cuba the literacy rate is 99 percent and in Costa Rica it is 95 percent, for example.[9]

*"English Only" and the Anti-Immigrant Movement*
Of concern in *The End of Reading* is the persistent intolerance in America for languages other than standard written English—whether they are visual languages or foreign tongues. The United States remains unique in the world as the only major power comprised almost entirely of immigrant peoples. Of course, in a pre-historic sense the entire world evolved from the migratory patterns of Homo Sapien society. But most countries grew a native culture and a native language that stayed put. But in the case of the Americas, a relatively recent migration occurred as people from Europe, Asia, and Africa moved in—as they still do today. As a result, the nations of North and South America, and especially the United States, found themselves brimming with people speaking many different languages.

Efforts to narrow things down to one language in the U.S. date to the early 1800s. With the purchase of the Louisiana Territory from France in 1803, America found itself owning a huge territory that spoke French. When the Mexican-American War ended in 1848, the U.S. suddenly had a Spanish-speaking region. French language rights were abolished after the American Civil War. In 1868, the Indian Peace Commission recommended English-only schooling for the Native Americans. In 1878–79, the California constitution was rewritten:

"All laws of the State of California, and all official writings, and the executive, legislative, and judicial proceedings shall be conducted, preserved, and published in no other than the English language."[10] During World War I, there was a widespread campaign against the use of the German language in the U.S., including removing books in German from libraries.[11] Early in that conflict President Theodore Roosevelt famously declared that "We have room for but one language in this country, and that is the English language, for we intend to see that the crucible turns our people out as Americans, of American nationality, and not as dwellers in a polyglot boarding house."[12]

In more recent times, English Only movements have gained momentum on the premise that a coherent society requires a common language. This idea sits well with prejudices of anti-immigrant groups who believe that "foreigners" are fraying the fabric of American society with their different customs, beliefs, and languages. The fundamental argument that a shared language shores up national identity has been criticized by linguists, who point to the many nations that comfortably accommodate different tongues. The Linguistic Society of America passed a resolution in 1986–87 opposing "'English only' measures on the grounds that they are based on misconceptions about the role of a common language in establishing political unity, and that they are inconsistent with basic American traditions of linguistic tolerance."[13]

These arguments do little to alter the familiar refrain in American society, "Why don't they just learn to speak English?" Strictly speaking this is not a partisan view. One often hears liberals making the same complaint as conservatives like Rush Limbaugh or Anne Coulter—about the gardener or the guy parking cars. Hey, learn English. Barely ever considered is the glaring fact that most of those yakking about non-English speakers themselves speak only one language. Along with this thinking is the belief that in the good old days immigrants learned English immediately and unproblem-matically.

Recent studies show that Germans in Wisconsin in the 1900s and their descendants remained monolingual decades after immigration had ceased.[14] Data from the 1910 Census—supported by evidence from newspapers and court records—indicates that German continued to be a primary language, with many second and third-

generation immigrants still monolingual as adults. Understanding this history can help inform contemporary debates about language and assimilation—and help dismantle the myth that successful immigrant groups of yesterday owed their prosperity to an immediate, voluntary shift to English.

While many Americans can't seem to tolerate non-English speakers, they themselves are resistant to learning other languages. Americans immigrating to places where English is not the main language often have difficulty becoming bi-lingual. Some Americans learn the local language, but many simply do not. In international terms, you find that in general Americans have the narrowest range of linguistic competence.

With so much attention paid in the U.S. to the English skills of immigrants, especially those from Central and Latin America, very little research has been done about the native literacies (in languages such as Spanish or Portuguese) of entering immigrants. A few things are clear, however. We know that the general level of literacy in Latin America is notably high. This is because citizens and governments alike recognize the importance of literacy. And immigrants from these nations bring their commitment to reading and learning with them. According to a recent survey by the Pew Charitable Trusts, "Hispanics by a large margin believe that immigrants have to speak English to be part of American society and even more so that that English should be taught to children of immigrants."[15] In addition, immigrant families rely on their children's English competence in what is termed "language brokering"—or translating between Spanish and English for their parents.

*Difference as a Problem or an Asset*
Much of the great national debate over literacy and immigration really boils down to entrenched disputes over cultural sameness and difference. People who think being different from the majority constitutes a problem say that society should be working toward a common set of beliefs and standards, with the assumption that cultural sameness is the basis for social coherence, stability, and the minimization of disagreements. From this perspective society needs common laws, consistent values, shared cultural icons, and, most of all, a common language. Proponents of sameness see difference as a prob-

lem, and they claim that national unity depends on a firm set of standards to which everyone should subscribe. Outsiders need to adopt mainstream idea and ways of speaking via assimilation.

In this thinking, assimilationists claim that separating citizens by such categories as ethnicity, race, or religion—or by allowing immigrant groups to speak their native languages—can harm the very groups they seek to assist. By tolerating differences between these groups and the majority in this way, the government may foster resentment towards them by the majority. In this view, tolerance actually makes the immigrant group resist mainstream culture. Assimilationists suggest that if a society makes a full effort to incorporate immigrants into the mainstream, immigrants will naturally work to reciprocate the gesture and adopt new customs. Through this process, it is argued, national unity is retained. The assimilationist view has held sway in most school programs, and it is what "English Only" advocates now press in literacy debates. Its ethos dates to the early days of the republic, as typified in the words of eighteenth century French immigrant, Hector St. John de Crevecoeur: "He is American, who, leaving behind him all his ancient prejudices and manners, receives new ones from the new mode of life he has embraced, the new government he obeys, and the new rank he holds . . . Here individuals of all nations are melted into a new race of man."[16]

Proponents of cultural and linguistic difference as an asset argue that diversity is a source of social vitality, dynamism, and continual change. Supporters of cultural difference believe in valuing different perspectives. Within this logic people have different histories and they are inherently individualistic. Making everyone the same is tyrannical and anti-democratic. People don't need to surrender their identities. Different people need different amounts and kinds of resources. The problem isn't whether one agrees or disagrees with one side or another on these issues. It has to do with the fact in a democracy people are allowed to live together with different views on issues—and presumably different ways of expressing those views. What is "normal" or correct to one group of people may not be so to another. Historically, American society has maintained a commitment to values of tolerance, individual liberty, a diversity of opinion. As a nation primarily composed of immigrants, Americans by definition

constitute a heterogeneous people.  This diversity contributes to complexity and ultimately to the intelligence of our society.

In the colonial era, nations like England, France, and Spain (among numerous others) imposed their languages on the nations they colonized. Such acts of linguistic control made explicit the military and economic domination that colonizers exerted over the nations they subjugated. In India, Hong Kong, and numerous African colonies, the British justified the imposition of their language on the basis of efficiency and political expedience. Not only would one language simplify communication in commerce and government, but a single imposed language might eradicate antagonisms within regions where numerous native languages and dialects existed. Rarely did the process of linguistic reconfiguration go smoothly. Yet in nations like India the process eventually made facility in English synonymous with upward mobility and success. Today there are more English speakers in India than in Great Britain. Not everyone is pleased with this outcome. To many the long imposition of English culture has meant a devaluing of preexisting regional culture and a loss of self-respect. This issue of cultural devaluation is succinctly articulated in a videotape by artist Meena Nanji entitled *It Is a Crime* (1997).[17] The videotape connects the issue of spoken/written English with filmic representations and stereotypes generated by English and American media. The tape presents a montage of Indian men as crazed mystics, Indian women as voluptuous temptresses, and the nation of India itself as an exotic tourist destination. The tape takes its name from a poem by Shanti Mootoo, which also provides a script that is projected over the film footage. The first line reads: "It is a crime that I should have to  use your language to tell you how I feel that you have taken mine from me."

*Immigration and American Possibility*
Language plays a crucial role in our understandings of ourselves and our place in the world. Debates over English and its relationship to U.S. immigration have always been with us and show no signs of going away. As a concept, immigration has a history and a theoretical explanation. Immigration in the way we understand it today began with the emergence of modern nation-states and the establishment of borders, laws, political systems, and self-contained economies—that

took precedence over tribal or geographic factors that held people to-gether. Scholars like Benedict Anderson have argued that communi-cation technologies like the printing press first allowed people to see themselves as citizens of distinct nations because it allowed people to share the same stories and news. Anderson famously termed this me-dia-produced sense of togetherness "the imagined community."[18]

With the idea of the nation came the "citizen," defined in the dic-tionary as a "member of a state or nation who owes allegiance to its government and is entitled to its protection."[19] And from citizenship grew powerful "insider" versus "outsider" mentalities. People immi-grate for all kinds of reasons all around the world, but not in the numbers one would think. These days approximately 200 million people move from one country to another each year—or about 3 per-cent of the world's population.[20] This means that roughly one of every thirty-five persons in the world is a migrant. According to the Inter-national Organization for Migration (IOM), the rest of us mostly stay where we are.

One theory about immigration uses a "push/pull" principle like the model discussed  earlier in this book regarding technology. Peo-ple are pushed to move from their native lands by poor wages, politi-cal instability, religious persecution, and natural disasters like floods. The pull exerted from destination countries may involve economic or educational opportunity, safety from coercion, or the presence of family members who have already immigrated. One of the largest immigrations in U.S. history was non-voluntary, as 10 million Afri-cans (10 percent of the total African population) were forcibly relo-cated during the 1700s and 1800s to the United States in the slave trade. In the 20th century large migrations to America resulted from wars (World Wars I & II, Vietnam), political takeovers (such as the expansion of the Soviet Bloc in Europe in the 1950s and 1960s), and ethnic cleansing campaigns (the Nazi Holocaust, Rwanda, Bosnia and Herzegovina genocides).

Today immigration to the U.S. is regulated by a quota system al-lowing set numbers of immigrants per year from any given country. Since 2000, immigration to the United States has run at about 1,000,000 people per year, with Mexico leading as an immigration source. The next three largest immigrant contributors to the U.S are

China, India, and the Philippines.[21] Given this history, immigration remains a cornerstone of American identity and has been celebrated as such—despite the misgivings of anti-immigration groups. The Statue of Liberty that overlooks the New York immigration portal on Ellis Island bears an often-quoted poem by Emma Lazarus entitled "The New Colossus," which reads in part: "Give me your tired, your poor, your huddled masses yearning to breathe free, the wretched refuse of your teeming shore. Send these, the homeless, tempest-tost to me, I lift my lamp beside the golden door!"[22]

Think about language and immigration to the United States. What does it mean from the newcomer's perspective? People who choose to relocate to another country are making a leap, a courageous leap, to a better future. Sometimes immigration occurs for political or family reasons, but usually there is an economic motivation, a basic survival instinct, perhaps, or maybe the old American dream. But several things are generally true about people who immigrate. They typically are people of strength, motivation, and a bit of courage—willing to make the leap across geography, culture, and often language for the possibility of a better future. These are people with the energy and wherewithal to leave one situation and expend the necessary effort to start again. Simply put, immigrants tend to be among the more competent and socially connected members of their national population—not the dysfunctional, service-needy, or criminal demographic that they sometimes are portrayed to be.

In the future immigration will define American society by the sheer number of people it will add to the U.S census. Recent surveys by the Pew Research Center show that the population of the U.S. will rise to 438 million by 2050 from the current 296 million.[23] Of the 117 million people added to the population, 67 million will be immigrants and 50 million will be their U.S.-born children or grandchildren. Get ready anti-immigrationists. This means that nearly one in five Americans will be an immigrant in 2050, compared with one in eight in 2005. By 2025, the immigrant, or foreign-born, share of the population will surpass the peak during the last great wave of immigration a century ago.

This defining role of immigration in national growth builds on the pattern of recent decades, during which immigrants and their offspring born in the U.S. accounted for most of the nation's population

increase. This is because the average number of births to U.S.-born parents dropped before leveling off in the past few years. The Latino population, already the nation's largest minority group, will triple in size and will account for most of the nation's population increase from 2005 through 2050. Also worth noting, the nation's elderly population will more than double in size from 2005 through 2050, as the baby boom generation enters its sunset years. Conversely, the number of working-age Americans and children will shrink as a share of the total population.

What does all of this say about literacy? Immigration projections provide further evidence of the coming end of reading as we know it. By this I mean the end of intolerance toward people who lack normative English proficiency. In the future, growing portions of the U.S. population will be perfectly literate, but in languages other than English. Over time the newcomers will acquire English literacy, as evidence has shown. But mainstream American society will move toward bi-lingualism. The bending toward bi-lingualism will be a good thing, too, because it will signal a further trend toward multiple literacies. The changing demographics of the American population will help to loosen the grip of written English as the only form of communication that matters. The result will be an opening up of the communications sphere and an overall improvement in the way people actually exchange information.

Given the nation's changing ethnic and racial demographics, new definitions of what counts as literacy have a dual purpose. Education in multiple ways of communicating can prepare "readers" to engage diverse communities around diverse media forms. As immigration continues to alter America's population demographics, an explosion in new media forms continues to change the communications landscape. New and more diverse understandings of literacy can prepare our society for both of these changes.

## THE INVISIBLE FAILURE OF EDUCATION

Education is the engine of the American dream and it remains one of the most emotional issues in public opinion. Discussions about education inevitably evoke the image of the innocent child, full of poten-

tial, our hope for the future, the legacy of us all. And it's undeniably true that education is tremendously important in promoting the intellectual advancement of the nation, ensuring that we have a competent workforce, and helping to bring newcomers up to speed. But one structural reality is often understated or simply not mentioned in discussions of education. It is that schooling is a local matter politically, economically, and even in intellectual terms.

Americans want to control the schools their kids attend, whether public or private. And they care so much about this that they never have allowed federal or state governments to interfere very much in the way schools work. Basically, people living in wealthy areas want good schools for their kids. Others living in religiously inclined communities want schools that reflect their values. In today's highly mobile society, many people actually choose the neighborhoods and communities where they live according to school quality. The system feeds on itself as wealthier communities yielding higher local property taxes for schools attract more and more families who can afford them. It's a fine system, except if you happen to be poor. Then it works in reverse. Maybe you live in an inner city with crappy schools and falling property values. With less tax income, the schools just get worse, but you can't afford to move out. So you're stuck in a system in which educational inequity widens. This is the reality of American education today. But there remains a dream of what education might accomplish.

*Education and the American Dream*
Throughout U.S. history schools have sought to drive upward mobility through basic knowledge transmission, skill building, assimilation training, and literacy education. The image of the American immigrant family sending junior off to school each day to become the family's first American college graduate has almost become its own stereotype. After all, education is the great equalizer of a democratic meritocracy. In principle, everyone is free to go and learn—and then accomplish as much as ambition dictates. In a meritocracy it's not supposed to matter if you had rich parents, family connections, influential friends—or if you were white, male, and heterosexual. In America everybody gets a free education, at least through high school and sort of through community college. And there are lots of cheap

state colleges with grants, loan programs, and student jobs. So every-body gets a fair shot at a middle class future. Just look at Bill Clinton and Barack Obama, who both grew up poor and became presidents. Well it all works well in theory.

The great spokesperson for the educational American dream was John Dewey, who wrote the book *Democracy and Education* in the midst of the huge wave of industrial-era immigration in the early decades of the 20th century.[24] Dewey didn't invent the idea of educational opportunism, which in and of itself is a common sense principle championed by America's founders. But Dewey wrote about education with an eloquence and enthusiasm that resonated powerfully in the emergent institution of public school. Dewey's book came into print a year before mandatory schooling became the national standard in 1918. For much of the prior century, education had been a highly localized affair, often available only to those who could afford it. But with the shift from an agrarian economy, the growth of cities, and the immigrant influx—proponents of government-sponsored education argued that "common schooling" could bring people of different backgrounds together and thus combat alienation, poverty, and crime. Dewey underscored the link between schooling and participatory government, arguing that "What nutrition and reproduction are to physiological life, education is to social life. This education consists primarily in transmission through communication. Communication is a process of sharing experience till it becomes a common possession."[25]

But Dewey promoted more than ordinary communication in education. In fact, he famously criticized conventional schooling of his day for the way it simply transmitted information to students in a one-directional and authoritarian way. Dewey recognized that both education and democracy hinge on respect between teachers and students, leaders and citizens—that balanced "communication" is what makes both systems work. For schools in particular Dewey argued that traditional education was too concerned with delivering knowledge, and not enough with understanding students' actual experiences.

Dewey was the most famous proponent of hands-on learning or experiential education, which is related to, but not synonymous with,

experiential learning. Dewey went on to influence much of what is today known as "progressive" schooling. Underpinning this trend in education was a belief that certain "natural" learning styles had become subverted by institutionalized education. Important in the context of *The End of Reading*, a distinction was drawn between the formalized, rule-bound, and quantified education that industrial worker-oriented schooling was offering—and a less-formal model premised on spontaneity and the quality of experience.

Here Dewey was following the thinking of 18th century philosopher Jean Jacques Rousseau. In Rousseau's view, educators shouldn't worry so much about imparting information and concepts, but rather should develop character and moral sense in young people, so that they grow into self-conscious and ethical beings. Rousseau's hypothetical boy, Émile, was raised in the countryside, which, to Rousseau was more natural and healthy than an urban environment.[26] Rousseau felt that children learn right and wrong through experiencing the consequences of their acts rather than through physical punishment. He was one of the first to advocate developmentally appropriate education—and his description of the stages of child development mirrors his conception of the evolution of culture.

Progressive education as advocated by Dewey drove reform efforts in the 1960s and 1970s to make learning more accessible to minority students. With its emphasis on student experience and dialogue, progressive education gained momentum as other theorists threw support behind it. Brazilian expatriate Paulo Freire gave progressive education a more explicitly political bent by arguing that school played a powerful role in teaching students about their place in the world.[27] To Freire the teacher/student relationship shaped young people's attitudes toward authority, often overtly telling them to obey teachers to get good grades much as workers obey their bosses to get paid. This thinking fit perfectly with the goals of the American civil rights movement that gained momentum from the 1950s through the 1970s. The movement argued that women and minorities often had been marginalized by traditional education. New student-centered, "emancipatory" models of schooling could reverse the damage. At this time, schools often found themselves at the center of anti-segregation efforts. The famous legal case of *Brown v. Board of Education of Topeka, KS*, resulted in a landmark decision of the U.S.

Supreme Court in 1954, which declared that state laws establishing separate public schools for black and white students denied African American children equal educational opportunities. In a similar action, Congress in 1972 passed Title IX banning federal funding for any school program that discriminated against students based on their gender.

## Blaming Schools Again

Educational reform changed what was taught in schools and how it was taught. Besides rewriting books to include previously excluded groups, emphasis was shifted away from teaching methods that favored children who entered school with advantages in subjects like reading. Rather than exclusively teaching conventional whole language reading, many schools adopted phonics to help students more easily transition from speech to the written word. More significantly, traditional subjects like English, history, math, and science would share space with studies of topics like art, media, ethnic-culture, and the role of women in society. In this sense education's prior emphasis on transmitting "traditional" knowledge was broadened to include learning from the "contemporary" world. Regrettably, this departure from traditional school curricula would result in declines in standardized test scores by the 1980s.

Conservative critics jumped on the opportunity to accuse progressive education of failing to teach young people critically needed knowledge. Liberals countered that the progressive school movement had encouraged more students from different backgrounds to go to school and keep attending. Test scores may have declined, progressives argued, but the overall education of the American population had risen. Regrettably, the liberal argument couldn't get much political traction. Test scores of U.S. students were dropping in comparison to those in other nations. The American fiscal turmoil of the 2000s allowed conservatives to rekindle arguments from the bad economic times of the late 1970s and 1980s. Back in those days it was argued that America had lost its competitive edge because it had become too educationally complacent. Catering to minorities and offering student-centered courses in things like art and cooking had watered down the school curriculum.

Led by people like Alan Bloom, Dinesh D'Souza, Eric Donald Hirsch, and Diane Ravitch—critics of progressive education argued that schools had gone overboard in trying to be too "democratic" and responsive to everyone. These voices said there were certain traditional canons of knowledge that citizens needed to master, and American students weren't getting them. Some critics focused on K-12 schools, while others leveled their charges against higher education. Bloom's now-classic *The Closing of the American Mind* asserted that many U.S. universities had lost their bearings and, as the book's title suggests, had fallen into a narrow-minded liberal group-think. Bloom wrote that "Professors of these schools simply would not and could not talk about anything important, and they themselves do not represent a philosophic life for the students."[28] Hirsch remains one of the most strident critics of progressive education in elementary and secondary schools. He got a lot of attention during the Reagan years with his book *Cultural Literacy: What Every American Needs to Know.* The book's fundamental premise was that American young people lacked the fundamental knowledge necessary to function as citizens or to succeed in life. Hirsch famously cited interviews with young people who couldn't conjure up what he considered important facts. In the first chapter of *Cultural Literacy* one reads, "I have not yet found one single student in Los Angeles, in either college or high school, who could tell me the years when World War II was fought. Only two could even approximately identify Thomas Jefferson. Only one could place the date of the Declaration of Independence."[29]

Both Bloom's and Hirsch's books became instant bestsellers as the nation was swept with a wave of paranoia about schools. Teachers received much of the blame, with conservatives making accusations, not only of liberal bias in curriculum, but of professional laziness. Critics claimed that schools lacked accountability, professional standards, and that lousy teaching was being protected by unions and tenure practices. The economic turmoil of recent years rekindled public suspicions about schools. The regime of President George W. Bush refused to consider that poor educational outcomes among the nation's underclass might be related to economic or social inequity. So it introduced a project called "No Child left Behind" (NCLB) to fix the schools. And who could argue with the basic idea of improving education for underachievers "left behind"? The concept gained bi-

partisan support in Congress. Figures like Hirsch again came to the forefront in suggesting that schools simply weren't doing their jobs. The title of Hirsch's 2007 book says it all: *The Knowledge Deficit: Closing the Shocking Education Gap for American Children.*[30] As Hirsch writes:

> The Public sees that something is badly amiss in the education of our young people. Employers now often need to rely on immigrants from Asia and Eastern Europe to do the math that our own high school graduates cannot do. We score low among developed nations in international comparisons of science, math, and reading. This news is in fact more alarming than most people realize, since our students perform relatively worse on international comparisons the longer they stay in our schools.[31]

Hirsch goes on to point out that by 10th grade, American students rank 15th among 35 countries surveyed. He concludes that our young people increasingly are being set up for failure in the global economy. Hirsch identifies progressive education as the "deadly enemy" of educational success and recommends a time-tested (and I do mean "tested") program of back-to-basics teaching.

Visible figures like Hirsch were important in this movement because the federal government's role is in reality rather limited. Remember that most schools are governed and paid for by the communities where their students live. Good schools in affluent suburbs don't need federal money very much, but in poor urban and rural communities it's a different story. So federal policies to tighten curricula and financially punish bad schools affected some areas more than others. People like Hirsch helped sell the idea of educational reform. The combined effect of NCLB legislation and cultural fearmongering about falling test scores turned the tide against progressive education in the 2000s—and the battle is still being fought. Meanwhile public education has been in turmoil. Some regions report positive momentum in test scores, but the legitimacy of such scores for measuring real benefits to students has been challenged. Elsewhere the return to traditional schooling has been accused of damaging education for minorities and the poor.

NCLB was scheduled for reauthorization in 2007, but the effort was stalled for years due to disagreements between liberal and conservative interests over its effectiveness. To find a middle ground in

the debates, churches entered the fray in 2009. A coalition of minis-
tries coordinated by the United Church of Christ  (UCC) issued a
"2010 Message on Public Education" suggesting that the federal gov-
ernment should use its leverage in shaping public education but that
the government must "recognize that it is immoral to demand equal
outcomes on standardized tests without equalizing the resources that
create the opportunity to learn" and "improve vulnerable public
schools and turn away from blaming teachers," while addressing
"economic and social issues outside the school day that impair
learning."[32] The UCC statement is significant in pointing out that
educational failure has three components: *what schools teach, what we
spend on schools, what takes place outside of school.* Much of the discus-
sion above has focused on debates over what gets taught and how.
But as in any complex issue, liberal or conservative teaching methods
alone do not make or break educational success. Quite understanda-
bly, anxious parents and public officials under pressure search for
easily stated solutions for problems. In some instances a single fix
might indeed work. But just as often school failure results from a
complex array of interrelated issues or structural flaws in institutional
design. Terribly old-fashioned teaching methods can yield positive
outcomes in well-funded schools where parents support their chil-
dren's efforts and expect them to succeed. It also must be acknowl-
edged that "throwing money at the problem" may not work at a
school with burnt-out teachers and families in economic distress.
Teaching, school funding, and a child's overall environment all need
to be considered in discussion of school failure and *The End of Read-
ing.*

## STILL SEPARATE, STILL UNEQUAL

When researchers, reformers, and educators examine how students
perform in our public schools, they consistently find that some
groups seem to be served better by schools than others. According to
the Education Equality Project, African American and Latino fourth
graders fall nearly three years behind their white and Asian counter-
parts.[33]  Less than two-thirds of African American and Latino stu-
dents finish high school, with African American students graduating

at 55 percent, Latinos at 58 percent, and their white counterparts at 78 percent. Only 9 percent of students in Tier 1 colleges (the 146 most selective schools) were from the bottom half of income distribution. By comparison, 70 percent of people in the top 10 percent income bracket have at least a bachelor's degree. These huge differences in academic performance between students from different economic circumstances and racial/ethnic backgrounds have been termed the "achievement gap."

These statistical disparities are not disputed by conservatives or liberals. They the simple facts of structural inequalities in the United States. Figures from the Congressional Budget Office show that the gap between rich and poor Americans has widened dramatically in the past 30 years. By the 1990s the wealthiest one percent of the population made 23 times what the bottom fifth did. By 2006 that number had tripled to 73 times earnings.   According to Arloc Sherman of the Center for Budget and Priorities, this shows "a greater income concentration at the top than at any time since 1929."[34] Family income correlates directly to how kids do in school. This effect is most pronounced with young children. Research from the U.S. Department of Education tells us, for example, that four-year-olds are more likely to struggle in school if their families fall below the poverty line, their parents lack a high school education, or English is not the primary language at home. Children obviously can't do well in school if they are hungry, tired, or going home to a family in financial stress. The government recognized the importance of the out-of-school environment in the 1960s when it funded Project Head Start programs in schools and non-profits to provide three to five-year-olds with food, medical check-ups, and learning support. Later Head Start was expanded to help even younger children, as evidence mounted about the growing importance of children's first few years in their later development. The successful non-profit organization Zero-to-Three was founded in 1977 to support the healthy development and well-being of infants, toddlers and their families.

Economic inequities in the school population are one thing. But school funding disparities are even more striking. As a political matter, school funding varies dramatically from state to state and district to district, with more liberal regions supporting schools more gener-

ously. On average, the nation's public school districts spend $8,500 per student. New York and New Jersey average $14,000 per student in K-12 grades, with Connecticut and Vermont allocating about $12,000. In fact, seven of the highest spending states were in the Northeast. By comparison, Arizona, Mississippi, Oklahoma, and Utah spent $5,000-$7,000 per student. The ten states with the lowest expenditures per student are in the West or South. But because school funding is a local matter, the biggest disparities are found at the district level. The per-pupil cost of a public education in Oregon ranges from a low of $6,000 in the Sherwood School District near Portland to $33,000 in Eastern Oregon's Juntura School District.[35]

These local school funding disparities receive little news coverage because they are structural budgetary matters that change little from year to year. It took Jonathan Kozol to travel the country and examine firsthand the consequences of spending disparities. In his book *Savage Inequalities* Kozol pointed to school districts in inner cities receiving as little as 20 percent of the money as schools in their neighboring suburbs of Baltimore, Chicago, Detroit, New York, and Philadelphia. As Kozol later wrote,

> Many Americans who live far from our major cities and who have no first-hand knowledge of the realities to be found in urban public schools seem to have the rather vague and general impression that the great extremes of racial isolation that were matters of grave national significance some thirty-five or forty years ago have gradually but steadily diminished in more recent years. The truth, unhappily, is that the trend, for well over a decade now, has been precisely the reverse. Schools that were already deeply segregated twenty-five or thirty years ago are no less segregated now, while thousands of other schools around the country that had been integrated either voluntarily or by the force of law have since been rapidly resegregating.[36]

This is where "reading" gets political. What the high-minded alarmists bemoaning the nation's crashing literacy rates don't see is that poor kids have the deck stacked against them when it comes to learning to read. Aside from debates over "basic skills" versus "natural learning" lie more profound problems of kids growing up in impoverished environments and then being jammed into overcrowded classrooms. But when you add race to the equation, the problem is even more stunning. Illiteracy in the African American community

and lack of English fluency in the Latino/Chicano community are not accidents of nature or indications of unwillingness to learn. They are the inevitable consequence of an educational system that starves the poor of resources, especially in communities of color. The implications go beyond the classroom. If the American dream promises hope and opportunity, what message does the American Educational Nightmare send?

Poor academic performance has a direct and serious impact on a student's adult life. Dropouts are more likely to become and stay jobless. They make dramatically lower lifetime earnings and are far more likely to be incarcerated. College graduates earn 73 percent more than high school graduates during their lifetimes. To many experts these outcomes prove that our public education system is consistently failing certain children and drastically reducing their chances to compete and succeed as adults. But here's an even more sobering statistic. High school graduates on average live up to seven years longer than high school dropouts.[37]

Recognizing the reality of educational inequality helps counter perceptions that social problems like illiteracy have cultural origins. Misguided beliefs that certain populations lack the will or capacity for English proficiency derive from antiquated beliefs in differences in human nature. In today's multicultural society, it's rare to find anyone who believes in racial differences in intelligence.[38] But people like *Bell Curve* co-author Charles Murray continue to assert that certain cohorts of society are ill-suited for advanced learning and shouldn't be offered higher educational opportunities. In his most chilling work to date, *Real Education: Four Simple Truths for Bringing American Schools Back to Reality*, Murray argues that because half of all children fall below a statistical mid-point, too many people are going to college.[39] To Murray, only society's gifted upper half can make good use of a university education, so the below-average half should be herded into vocational training in the interest of efficiency. While Murray carefully explains that society needs the efforts of academic underachievers, his theorizing feeds the kind of prejudice that supports social stagnation and an acceptance of inequality as a given. It's a mentality that says that if people can't read, learn, or succeed in prevailing ways, society should write them off.

Winner-take-all attitudes like Murray's fly in the face of nearly 50 years of achievements in the name of educational accessibility and equity. The movement was launched famously in 1963 when Alabama Governor George Wallace stood at the door of Foster Auditorium at the University of Alabama in a symbolic attempt to block two African American students from enrolling at the school. On that historic day, a large contingent of national media looked on as Wallace took his position and state troopers surrounded the building. A call from President John F. Kennedy federalized the Alabama National Guard to help with the crisis. At the last minute, Wallace was persuaded to step aside and the two students were allowed to register for classes—with desegregation taking place in many schools and colleges in the months to follow. The events in Alabama became part of a broader movement to open public institutions to women, people of color, homosexuals, and the disabled. In doing so the nation reaffirmed its commitment to equality in opportunity and legal protection to all citizens regardless of who they were or where they came from.

The fact is that a college education has become the ticket to a promising future for most American young people. But the nature of college has changed significantly. The idealized image of a traditional four-year residential college is rapidly vanishing, as less than 30 percent of students now go this route. The economic crisis of the 2000s has been a major a factor in this shift. Most four-year institutions are reporting record low enrollments. While things are spiraling downward at these traditional colleges—where tuition and boarding costs at top schools like Harvard and Princeton can reach $50,000 per year—business is booming at two-year technical schools and community colleges. From 2000 to 2006, there was 10 percent growth in overall enrollment at two-year institutions, according to the most recent figures from the Department of Education. During the 2006-2007 academic year, 6.2 million students were enrolled in the country's 1,045 community colleges—accounting for 35 percent of all postsecondary enrollments that year, according to the National Center for Education Statistics. Moreover, many colleges are projecting increases of 10 percent in coming years.[40]

This ought to be good news for two-year institutions. But state-level funding cuts and faculty shortages are making it difficult for community colleges and technical schools to accommodate burgeon-

ing enrollment. Still, the cost differential between attending four-year institutions and community colleges is stunning. For example, tuition at Miami Dade Community College, the largest community college in the U.S., is $1,000 per semester for Florida residents. In marked contrast, tuition at the University of Florida—a public institution—is roughly $5,000 per year and a whopping $42,000 at the University of Miami, which is private.

The Obama administration has responded to this demand for two-year degrees with a dramatic ten-year federal funding plan. The American Graduation Initiative aims to nearly double the number of community college graduates by 2020, adding five-million new students to the current six-million Americans now enrolled in such institutions. The rationale is purely pragmatic. The "hard truth is that some of the jobs that have been lost in the auto industry and elsewhere won't be coming back. They are casualties of a changing economy," Obama said, adding that "even before this recession hit, we were faced with an economy that was simply not creating or sustaining enough new, well-paying jobs."[41]

Community colleges today play a vital role in addressing adult literacy in America. In the view of many policy analysts "community colleges are the best bet for long-term growth of the basic skills field, because those institutions already have a diversity of resources, a long track record of working with business and government on training issues, and, usually, strong support from state and local governments. They also allow the learner to avoid the stigma of 'going back to school' and provide a ready vehicle for transition from basic skills training to training and certification in specialized fields."[42]

The question of universal college education remains on the forefront of policy debates. Political pressure continues to increase from those who say too many or too few people are going to college. Some argue that society's expectation of college providing a person's educational capstone is misplaced and that K-12 schooling should do a better job. Others contend that everyone deserves as much education for as many years as their ambition dictates. Meanwhile, employers keep telling the educators that students aren't coming out of school with enough knowledge to be useful. Parents are fretting that their

children won't make the grade. And kids feel so left out of the conversation that they fantasize about being magicians or superheroes.

## NOTES

1. "Summary Tables on Language Use and English Ability," *The United States Census 2000* (Washington: DC: U.S. Census Bureau, 2001). Internet reference. http://www.census.gov/main/www/cen2000.html. Accessed Aug. 1, 2009.
2. "Selected Social Characteristics in the United States: 2007," *2007 American Community Survey 1-Year Estimates* (Washington: DC: U.S. Census Bureau, 2008). Internet reference. http://factfinder.census.gov. Accessed Aug. 1, 2009.
3. "Translations to Make Voting More Accessible to a Majority of Asian American Citizens," *EAC Issues Glossaries of Election Terms in Five Asian Languages* (Washington: DC: United States Election Assistance Commission, 2008). Internet reference. http://www.eac.gov/News/press/eac-issues-glossaries-of-election-terms-in-five-asian-languages/. Accessed Aug. 1, 2009.
4. "Canada Has Two Official Languages: English and French," *A Bilingual Nation* (Ottawa: Government of Canada, 2009). Internet reference. http://www.canadainternational.gc.ca/ci-ci/about-a_propos/bilingual-bilingue.aspx?lang=eng. Accessed Aug. 1, 2009.
5. CIA, *The World Factbook* (Washington, DC: Central Intelligence Agency, 2009). Internet reference. https://www.cia.gov/library/publications/the-world-factbook/. Accessed Aug. 1, 2009.
6. United Nations Statistic Division, "Indicators on Literacy," Social Indicators (New York: United Nations, 2009). Internet reference. http://unstats.un.org/unsd/demographic/products/socind/literacy.htm. Accessed. Aug. 1, 2009,
7. National Center for Educational Statistics, *State & County Estimates of Low Literacy* (Washington, DC: U.S. Department of Education, 2009). Internet reference. http://nces.ed.gov/naal/estimates/Overview.aspx. Accessed Aug. 2, 2009.
8. Ibid.
9. *The World Factbook.*
10. United States Indian Peace Commission, *Proceedings of the Great Peace Commission of 1867-1868* (Washington, DC: Institute for the Development of Indian Law, 1975).
11. James J. Martin, *An American Adventure in Bookburning in the Style of 1918* (Colorado Springs, CO: Ralph Myles Publisher, 1988).
12. Theodore Roosevelt, *Works* (Memorial ed., 1926), vol. XXIV (New York: Scribner's) p. 554.
13. Geoff Nunberg (December 28, 1986), Resolution: English Only, Linguistic Society of America. Internet reference. http://www.lsadc.org/info/lsa-res-english.cfm. Accessed Feb. 7, 2008.
14. Greg Laden, "When Do Immigrants Learn English? Likely, Not When You Think," *Science as Culture, Culture as Science* (April 13, 2009). Internet reference. http://scienceblogs.com/gregladen/2009/04/when_do_immigrants_learn_engli_2.php. Accessed Aug. 3, 2009.
15. Pew Hispanic Center, "Fact Sheet," *Hispanic Attitudes Toward Learning English* (July 7, 2006). Internet reference. http://pewhispanic.org/factsheets/factsheet.

php?FactsheetID=20. Accessed Sept. 18, 2009.

16. Hector St. John de Crevecoeur, *Letters From An American Farmer* (New York: Kessinger Publishing, 2004) p. 22.

17. Patricia R. Zimmermann, *States of Emergency: Documentaries, Wars, Democracies* (Minneapolis: Minnesota, 2000). p. 191.

18. Benedict Anderson, *Imagined Communities: Reflections on the Origins and Spread of Nationalism* (London and New York: Verso, 1983).

19. "Citizen," *Dicitonary.com*. Internet reference. http://dictionary.reference.com /browse/citizen. Accessed Aug 4, 2009.

20. International Organization for Migration, Internet reference. http://www. iom.int/jahia/jsp/index.jsp. Accessed. Aug. 4, 2009.

21. "United States: Top Ten Sending Countries, By Country of Birth, 1986 to 2006", (Washington, DC: Migration Policy Institute. 2007). Internet reference. http://www.migrationinformation.org/datahub/countrydata/data.cfm. Retrieved May 5, 2007.

22. Emma Lazarus, "The New Colossus," *Emma Lazarus: Selected Poems* (American Poets Project) (New York: Library of America, 2005).

23. All statistics in this section from, Jeffrey Passel and D'Vera Cohn, "Immigration to Play a Lead Role in Future US Growth", (Washington, DC: Pew Research Center, 2008) Internet reference. http://pewresearch.org/pubs/729/united-states-population-projections. Accessed Aug 5, 2009.

24. John Dewey, *Democracy and Education: An Introduction to the Philosophy of Education* (New York: W-L-C, 2009).

25. John Dewey, *Democracy and Education: An Introduction to the Philosophy of Education* (1917) (New York: Gardners Books, 2007).

26. Jean Jacques Rousseau, *Emile* (New York: Book Jungle, 2008).

27. Paulo Freire, *Pedagogy of the Oppressed* (New York: Continuum, 1970).

28. Allan Bloom, *The Closing of the American Mind* (New York: Simon & Schuster, 1987).

29. E.D. Hirsch, *Cultural Literacy: What Every American Needs to Know,* p. 6

30. E.D. Hirsch, *The Knowledge Deficit: Closing the Shocking Education Gap for American Children* (New York: Houghtlin Mifflin, 2007).

31. *The Knowledge Deficit,* p. 1.

32. Justice and Witness Ministries, "2010 Message on Public Education," *Rethinking No Child Left Behind* (Cleveland, OH: United Church of Christ, 2009). Internet reference. http://www.ucc.org. Accessed Aug. 9, 2009.

33. All statistics in this section from "What is the Achievement Gap?" (New York, NY: the Education Equality Project, 2009) Internet reference. http://www.educationequalityproject.org/ Accessed Aug. 9, 2009.

34. Ibid.

35. Anne Williams The per-pupil cost of a public education in Oregon" . Internet reference. http://www.encyclopedia.com/doc/1G1-96048923.html. Accessed Aug. 10, 2009

36. Jonathan Kozol, "Still Separate, Still Unequal: America's Educational Apartheid," *Harper's Magazine,* 311, no. 1864 (Sep. 1, 2005).

37. Statistics in this section are from Alliance for Excellent Education, "The High Cost of High School Dropouts: What the Nation Pays for Inadequate High Schools," *Issue Brief* (August 2009). Internet reference. http://www.all4ed.org/. Accessed Sept. 18, 2009.

38. Richard Herrnstein and Charles Murray, *The Bell Curve: Intelligence and Class Structure in American Life* (New York: The Free Press, 1996).

39. Richard Murray, *Real Education: Four Simple Truths for Bringing America's Schools Back to Reality* (New York: Three Rivers Press, 2009).

40. "The Community College Enrollment Boom" (Washington, DC: Inside Higher Ed, 2008). Internet reference. http://www.insidehighered.com. Accessed Aug. 12, 2009.
41. Dan Lothian, "Obama: Community colleges can help boost ailing economy," (Atlanta, GA: CNN, 2009) Internet reference. http://www.cnn.com/2009/POLITICS/07/14/obama.community.colleges/ Accessed Aug 12, 2009.
42. Forest Chisman, *Jump Start: The Federal Role in Adult Literacy: Final Report on The Project on Adult Literacy* (Southport, CT: Southport Institute for Policy Analysis, 1989) p. 12.

## Chapter Three

# THE RISE OF MEDIA CULTURE

## Visual Storytelling

IT'S HARD TO ignore the reality that movies, TV, and the internet have become the great teachers in contemporary society. With schools and written literacy in crisis, great volumes of knowledge are transmitted by entertainment and news media. Not long ago I was walking with my daughter Emily and a few of her friends through the Olvera Street section of Los Angeles, an area of Mexican shops and eating places set up near a restored Mission and Catholic Church. In a genuinely inquisitive manner, one of the kids said, "I have a question. What's with all of those crosses with a dead guy on them?" Adopting my pedagogical persona (and forgiving the cultural solipsism implicit in the question), I recounted the story of Jesus and the Crucifixion, to which the girl replied: "You mean that's a real story? I thought it was just something from South Park." Naturally I was somewhat taken aback that knowledge of such a sacred piece of Christian belief had come from a cynical cartoon. But I also was pleased that she had somehow absorbed a piece of history that her school had withheld in secular orthodoxy. But obviously, this anecdote speaks volumes about the way kids are getting their cultural literacy these days.

From a traditional perspective I suppose I've just described an educational disaster, a failure of school learning in providing core cultural literacy to elementary school kids. But if we follow this story a bit further we get to the heart of the matter of *real* literacy in the contemporary world. The point is that the child did indeed get the Jesus

story, but it came from the most unlikely of places. Though the knowledge came from a *South Park* episode, the crucifixion narrative got imprinted in her brain. I simply had to adjust the image to remove the clutter of comic baggage. The fact is that media surround us like the air we breathe. It's not so much a matter of whether we engage popular culture, as much as it is what we do with the material.

From a progressive educational perspective there is nothing wrong with learning from *South Park*. Dewey and those who followed him argued that a child's native curiosity and personal experience in exploring the world are much more important than a sociallyconstructed and hierarchical system of learning. The ideas of progressive education were taken up with great enthusiasm in the post-World War II explosion in television and movies. Amid fears that media consumption was simply "too easy" a form of garnering knowledge, progressives argued that fighting popular culture was a losing battle. The belief of media-as-teacher was perhaps no more stridently advocated than by Canadian theorist Marshall McLuhan, who suggested in 1966," The time is coming, if it is not already here, when children can learn far more, far faster in the outside world than within schoolhouse walls."[1]

Taking up the cause in the 1980s, progressive educators pointed to the emerging dichotomy between school knowledge and student-driven learning taking place in their homes. Most were careful not to condemn the school experience unequivocally, but rather to argue that experience outside school should be embraced as a useful supplement in educating the whole child. As stated by Henry A. Giroux, "This is not an argument against providing students with what some have called the 'Great Books' or any romantic celebration of popular culture," but instead a call to "expand rather than limit the potentialities that various students have to be literate."[2]

What is behind the apparent lure of visual media as a storytelling device? Perhaps the most powerful factor is the human desire for "realism," the attraction to images that mimic lived experience and tame it for the viewer's observation. Three factors are at play in this phenomenon: *memory, storytelling, and power*. The early cave paintings discussed in Chapter One held a fascination for their makers as a means of capturing experience in an image. Scholars speculate that

pre-historic images of animals and hunting excursions were copied on rock walls as a quasi-religious means of recreating the hunt so that it could be replicated. Early makers believed images could keep the successful hunt alive and ensure its return.[3] This fundamental idea of a record compelled early mark-makers to paint so that the memory of the event would not disappear. Human memory is frail and fleeting, but an image can help in remembering a moment and sharing it with others. Obviously, the concept of memory applies to subsequent image making. From stone talismans to Egyptian, Greek, and Etruscan statuary, the impulse is manifest to record and preserve ideas. In medieval and renaissance representation, one sees the desire to represent and historicize what society saw as important: religion and property. From tomb inscriptions and biblical stories to portraits of the powerful and their domains, sculpture and painting functioned as extensions of the mind. Through eras in which human life itself was short and fleeting, the permanence of stone and paint kept history alive.

In the great Age of Enlightenment science advanced the means of freezing reality. Italian architect Filippo Brunelleschi frequently receives credit for recognizing in the 1400s that our eyes triangulate distance in what had been termed "one point" or "renaissance perspective." Like many architects, Brunelleschi had struggled with how to make pictures of buildings look realistic. Brunelleschi and other architects recognized that if a person stands still and gazes into a landscape in space, the lines of buildings and other objects appear to converge at a single distant point. Drawings of buildings could be made following the same principle. With this basic discovery came one of the fundamental principles of artistic rendering still taught in drawing courses today.

But the urge to perfectly copy nature had been following another course that would eventually trump perspective rendering. It all had to do with discovering how to make an artificial eye. It was probably discovered by accident that a tiny hole in the wall of a darkened room could sometimes project an image of the outside world on the wall inside. Mentions of colored lights and strange reflections through apertures appear in early Chinese and Greek writing. Regardless of its origins, this primitive principle of pin-hole optics became recognized and later developed with lenses and mirrors to make images appear.

The so-called "camera obscura" grew in popularity well before the invention of photography, per se, as a curiosity and as a rendering aid for artists and portraitists. Leonardo Da Vinci used the camera obscura for his studies of geometry and physics. By the 17th century, renaissance painters like Johannes Vermeer were using similar devices called "camera lucidas" to make landscapes that looked positively photographic in the detail.

So there was a quite substantial history of "photo-graphic"—lens-derived—representation before the invention of photography itself. In this sense, photography is a perfect example of a technology waiting to happen. Societies all over the world were hungering for detailed pictures rendered in perfect perspective—and a means existed for making them. The trick was to find a way of saving these images of reality that didn't require copying them by hand. The history of photography generally credits Johan Schulze with recognizing in 1725 that the sun could darken silver salts, hence paving the way for Louis Daguerre and Henry Fox Talbot to perfect methods of fixing images on sheets of prepared metal or paper. By the mid-1800s the "mirror with a memory" was born. Of course, photography was a terribly messy and complicated process in its early years—requiring chemicals and wet plates to be prepared in complete darkness before an image could be brought into the daylight. But the powerful hunger for the photographic likeness welcomed the awkward technology with great enthusiasm.

Two developments would burst photography into the public consciousness—one private, one public. The *snapshot* and the *newspaper photograph* forever changed humanity's relationship with representation and reality, and in their evolving trajectories they have continued to do so ever since. In 1874, George Eastman became intrigued with photography, but found the process awkward. After three years of experimentation with gelatin emulsions, Eastman developed a dry photographic plate, and patented it in both Britain and the U.S. The effect was a sensation. With the marketing slogan, "You press the button, we do the rest," Eastman single-handedly made photography part of life for every American family. Suddenly, baby pictures, remembrances of grandma, records of where one lived or went on vacation—it was all available to everyone. Like a true heroic capitalist,

Eastman protected his copyrights with a vengeance and his "Kodak" cameras became universal commodities in American society for generations to come.

Meanwhile, photojournalism was becoming its own sensation. Initially painstakingly rendered as engravings, the first widely published news photographs were images of armed conflict. Pictures of the Crimean War between Russia and Turkey circulated in Europe during the 1850s, but American Civil War photojournalism really brought photography and the horrors of war to society as never before. During this time people began to believe in images and enjoy them—and be horrified by them.

But almost as soon as people began believing in the reality of photography, they also learned that reality could be manipulated. Mathew Brady is remembered as one of the great documentarians of the 19th century, capturing the real-life consequences of national conflict in his depictions of soldiers and their dead. But Brady also is remembered as one of the first photographers to doctor the scenes he photographed to make them more dramatic. Specifically, he and his helpers are known to have moved the dead bodies of Confederate soldiers around after the Battle of Gettysburg so that they would make a better picture. No doubt there was a bit of deception in the act. But Brady Studio workers had been perfectly accustomed to arranging and dressing up customers in Brady's portrait business. Just a few years earlier in 1858, Henry Peach Robinson launched the "special effects" industry in photography by creating the first photomontage in a picture of a woman dying of tuberculosis with family members artificially inserted into the frame. The fact is that in the 1860s no one had very much experience dealing with photography's presumed objectivity. Most other "journalistic" imagery of the day was rendered in drawings of events as they were remembered or recounted. In other words, the pictures were products of the mind rather than images of mechanical rendering.

It would be many years before people ever questioned the validity of photography. Expressions like "the camera never lies" captured photography's mystifying aura of authenticity. During the next century people would eventually lose their respect for photography, as its ability to copy reality became more widespread and taken for

granted. This shift in attitudes emerged as photography, radio, and movies grew as industries and the mass production of images became ingrained in everyday life. Of course, suspicion about the potential threats of mass-produced images dates to the 1800s, when stories and illustrations about crime and fighting had been fed to a readily consuming public through printed pamphlets, single-page broadsides, and early newspapers. But with the rise of industrialization and concentrated populations in cities in the early 1900s, mass production of commodities of all kinds grew—and the public was hungry for information and entertainment. As printing and motion picture technologies improved, so did demand for them. By the 1920s and 1930s photographic media had become staples of daily life.

## The Entertainment-Industrial Complex

During the 20th century media would grow to become one of Americas largest industries, eventually becoming the nation's most lucrative export. The steady growth of films, television, and subsequent forms of electronic entertainment would transform the United States from an industrial economy to an information economy. As early as 1929 more than 80 million people went to the movies every week, a level of consumption that held constant for two decades. These viewers were looking for comfortable, yet exotic, spaces of amusement apart from the routine of daily life. To answer the demand, movie impresarios like Sid Grauman in Los Angeles and S.L. "Roxy" Rothapfel in New York opened opulent theaters with names like the "Egyptian," the "Metropolitan," and the "Chinese."[4] This new form of public gathering performed an important social function as well for this newly established urban community. It provided a sense of identity and belonging with very specific nationalistic overtones. To Ella Shohat and Robert Stam, "the cinema's institutional ritual of gathering a community—spectators who share a region, language, and culture—homologizes, in a sense, the symbolic gathering of the nation."[5] Although it is important to resist overgeneralizing the effect of movies on different groups, the sheer number of people seeing films cannot be ignored. To the extent that movies were viewed on a regional and

national scale, some writers have suggested that these forms of entertainment actually helped divert public attention from domestic problems, serving to "neutralize the class struggle and transform class solidarity into national and racial solidarity."[6]

Not everyone was thrilled by the influence of the new media on the public mind. Criticisms of capitalism espoused in the late 19th century by Karl Marx and Fredrick Engels gained potency as factories and consumer culture grew. In the 1930s and 1940s Marxist thinkers of the Frankfurt School wrote of the manipulation of the "masses." Writers like Max Horkheimer and Theodore Adorno asserted that people were  powerless to resist the overwhelming forces of capitalism, its seductive ideology of consumption, and the continuous desire for more material goods.[7] Within this logic people became ensnared by an endless cycle of working and spending. To the Frankfurt School, the mass media played a central role in convincing people to accept the "false consciousness" that made them accept their oppressed lives without question.

As the U.S. faced economic crisis in the Great Depression of the 1930s, Hollywood itself took up critiques of capitalism. Influenced by leftist theater movements in New York City, Depression-era films began to appear which dramatized the tension between values of individualism and collective action. Led by Warner Brothers, the major studios hired East Coast writers who focused film industry attention on contemporary social and political issues like poverty, crime, and unemployment. Often basing movies on sensational newspaper stories of the day, Paramount established itself as the leading producer of gangster films like *Little Caesar* (1931) and *The Public Enemy* (1931). Typically these movies depicted young men and women who turned to crime after being abandoned by a greedy society. But like today, these criticisms of American capitalism did little to slow the public's yearning for a better life and all of the material trappings that went with it.  Complimenting stories about evil profiteers or criminals was a huge output of entertainment about the rich and powerful.

It's no secret that today mass media have taken over public life. According to the latest *Time Use Survey* from the U.S. Department of Labor, Americans over 15 years old spend 60 percent of their leisure time with TVs and computers—leaving less than two hours per day

for such things as socializing, reading, exercising, and thinking.[8] About 90 percent of the time spent with media goes to watching television. Several theories explain television's ability to attract and hold people's attention. Generally speaking, people find TV interesting—more so than other things they might be doing. It creates a world of engaging stories and stimulating imagery.

Perhaps more importantly, TV watching requires little effort and is easily accessible. In the 2000s the number of television sets in typical American homes (including the poorest ones) rose to 2.1, with more families owning color TVs than those with washing machines.[9] The average TV in the U.S. is turned on nearly seven hours per day.[10] In this context, one of the reasons people watch so much television has to do with its simple ubiquity. In relative terms, the price of television sets has been declining steadily since its wide scale introduction in the 1960s. Television literally has become a part of the home environment. Its presence and use have become naturalized and destigmatized. Rarely these days does one hear any mention of television as "mind candy" or "a vast wasteland" as one FCC chairman famously declared.[11] Rather television now is considered a cultural necessity and a much needed source of news and information.

Like it or not, for many people television is their main source for knowledge about the world. Most people will never travel to another country or even to parts of their own communities. Television news offers reports on what other people are doing, stories about those they rarely encounter, and fantasies about those they will never meet. The problem is that television is anything but a fair and unbiased conveyer of these stories and fantasies. TV and related media do not present a "real" image of the world—certainly not an image of the world that resembles the lives of viewers. Instead television offers an artificially stylized and narrowly drawn image of life, designed specifically to capture and hold audience attention.

Commerce drives television's hyperbolic artificiality. Programming is paid for by people with things to sell. The shows people have become accustomed to seeing are tremendously expensive to produce and they can be financed only by advertisers who want access to the huge audience TV reaches. Although television seems like such a commonplace and ordinary part of American culture, the reality is

that TV production is a highly selective and competitive affair. Broadcasting executives continually hunt for programs and formats that engage viewers quickly, lining audiences up to receive commercial pitches. The intense competition for viewers creates a tendency to favor production formulas that guarantee results. This is why so much television looks alike. Ironically, in the interest of reaching ever larger audiences, television tells an ever diminishing number of stories.

What are the narratives that television and other commercial media convey? Mostly they are stories about human *desire*—for romance, adventure, or success. Or stories of human *difference*—about circumstances, actions, and thoughts that locate characters outside the banality of "normal" everyday life. Both strands of storytelling—desire and difference—play powerful roles in the public imagination. Together the forces of desire and difference, while they are experienced in a similar way by millions of people, create a spectacle that separates viewers from those viewed. Most commonly, the media spectacle generates a "cult of celebrity"—a level of idolatry toward famous personalities that assumes a near-religious intensity. A look back in media history shows how this fascination with wealthy and powerful people developed. The growth of cinema enabled the creation of national celebrities on a level that traveling vaudeville acts had never been able to accomplish. Fed by cinematic publicity in the new medium of the newsreels, early movie audiences for the first time vicariously could "follow" celebrities as the screen idols appeared in public, got married, and worked on new ventures. The first commercial radio station went on the air in the U.S. in 1920. Within a decade the public was obsessed with radio personalities, many of whom adopted their personas to television following World War II.

Each new medium brought with it a fresh array of bigger-than-life figures, ever more removed from the daily lives of audiences. In *On Television*, Clive James argues that true fame was almost unknown before the 20<sup>th</sup> century, because of the lack of global mass media.[12] James asserts that the first true media celebrity was Charles Lindbergh, who made history with his 1927 transatlantic air flight and later received mass public attention due to the kidnapping of his son. James draws a critical difference between fame (the fact of being famous) and celebrity (what happens to fame when it is fed by media

coverage). James has said that "We need to get back to a state where fame, if we must have it, is at least dependent on some kind of achievement."[13] Indeed, the main accomplishment of many of today's celebrities is that they somehow have achieved celebrity.

Most often this comes from being a successful entertainer, journalist, athlete, author, artist, or otherwise gaining media attention for noteworthy work as an attorney, physician, scientist, etc. Other people are famous for being born into a famous family like Barrymore, Hilton, or Kennedy. But it is now possible for the media itself to create fame. This new strand of celebrity disturbs critic Bob Greene because it "doesn't require paying any dues." Greene asserts that before television, people had to accomplish something, possess some type of talent, or create a significant work. With the rise of television—specifically reality television—Greene says that audiences have become the creators, allowing people to "become famous not for doing, but merely for being."[14] Often supported by heavy publicity and exposure in magazines, newspapers, and television "entertainment news" programs, the cult of celebrity focuses attention on the famous, as well as otherwise unexceptional individuals who have become famous for being famous. This latter category includes reality show contestants, debutantes, or wealthy characters like Paris Hilton and Donald Trump.

Media celebrity creates a difference between viewers and those viewed in several important ways: by rendering viewers invisible, powerless, and silent in the media landscape. Considering that it is viewers—as consumers of programs and commercials—who "pay" for television programs with their time, it is indeed remarkable that audiences are so absent from media representation. In most TV comedies and dramas, viewers may be heard in laugh tracks or in the background of shows "filmed before a live studio audience," but they are almost never seen. When viewers are seen, as in certain variety programs or game shows, they typically are depicted as wildly enthusiastic crowds or hapless individuals thrust awkwardly before the gaze of the camera—as in the frenzied atmosphere of *The Bachelor* or *Deal or No Deal*. This image of the helpless spectator has been modified in the cinema vérité styling of long-form reality shows like *Survivor* and *Big Brother*, but such programs really are more akin to

scripted dramas. Audiences of *Survivor* are led to believe that they are observing the wilderness struggles of program participants in a realistic, real-time context. But in actuality, shows like *Survivor* are carefully constructed narratives assembled in the editing room. In scripted programs like *CSI* and *24*, where all of the action is carefully planned and even rehearsed before filming, between 25 and 100 hours of material are recorded for a typical 42 minute "hour-long" episode. In the less predictable realm of reality TV, hours of raw footage can exceed 200 hours per episode. Sometimes, even 200 hours of footage is insufficient to create a compelling narrative, at which point story lines are constructed from otherwise unrelated shots in the editing process.

The media spectacle also contributes to a generalized alienation of viewers by creating an idealized image of celebrity life that vastly differs from the daily existence of audiences. The 1990s program *Lifestyles of the Rich and Famous* most literally engaged this theme in documenting the enormous houses and extravagant leisure pursuits of entertainers, athletes, and business moguls—each episode concluding with host Robin Leach wishing viewers "champagne wishes and caviar dreams." In the 2000s viewers similarly have been taunted with images of wealth in the long-running program *Who Wants to Be a Millionaire?* Indeed, *Slumdog Millionaire* (2008), a movie about an Indian version of the show, swept the 2009 Academy Awards. A recent episode from the program *MTV Cribs* promoted itself as "the most exciting way to peep into your favorite celebrity homes without getting slapped with a restraining order." Not forgetting the youth audience, the popular sit-com *Hannah Montana* portrayed the trials and tribulations of a girl who lives a double life as an average teenage school girl named Miley Stewart (played by Miley Cyrus) by day and a famous pop singer named Hannah Montana at night. As the content of such programs glamorizes the larger-than-life world of celebrities, it suggests that the world inhabited by audiences is just the opposite. If celebrities are wealthy, powerful, and free to enjoy anything their budgets allow, audiences feel impoverished, disempowered, and constrained by limited resources. While this story has a powerful effect on all viewers, the message is especially potent to youthful audiences,

who often already feel constrained by parental authority and age-related legal restraints.

As the content of the mediascape disempowers, its formal structure reinforces the message. Television in particular operates in a one-directional form of address. People may receive its messages, but they cannot talk back. A movie operates the same way. Contrary to popular opinion, so do computers to a large extent. Despite the much-promoted potential of the internet as a two-directional communications medium, entertainment and game sites mostly offer only the illusion of true interactivity. Popular sites like *Pogo.com* and *MSNGames.com* allow visitors to choose among games and to play them, but these "choices" are limited by what the site offers. The illusion of choice in the online game world is but a smaller version of the pseudo-freedom offered in the overall commercial marketplace. Yet the sense of empowerment of interactive media has made computer games the most rapidly expanding sector of today's entertainment industry.

## Virtual Worlds

Reading and visual media both operate by telling stories. Aristotle outlines the basic mechanics of storytelling in his *Poetics* in which he described a set of principles for an "ideal narrative."[15] Most obviously to Aristotle, a story needs a plot with a clearly recognizable beginning, middle, and end. He asserted that a tension was necessary in the middle of the story to engage people and keep them interested in what would happen next. In Aristotle's classical formulation the tension would emerge from a conflict facing a central figure or "hero," which would generate sympathy or fear in the audience. Ultimately the story should conclude with a resolution of the conflict, producing a "katharsis" (a mental cleansing) in the audience from which some new understanding would emerge.

One can recognize this fundamental Aristotelian model of storytelling in all media. Yet it's important to remember that Aristotle formulated his ideas in an era in which stories were only told in spoken or written formats. The linear model of storytelling is a product of an

age when people communicated with one idea following another in a sequence. Pictures and statues existed, of course. But they generally were quite simple in comparison to imagery today, focusing—as in Aristotle's formulation of stories—on singular heroes or well-known events. As discussed earlier in this book, the emergence of the photograph radically changed the way people communicated, suddenly presenting lots of information and detail in a single frame—which got even more complex as moving pictures, and then movies with sound, became available.

The emergence of the photograph, the moving image, and the eventual development of immersive games and computer networks invite consideration of another paradigm of communication: the virtual world. On one hand, it can be said that stories have always created imaginary worlds in the minds of audiences. After all, the process of narrative that Aristotle described was really a mental process of following a story in one's mind and imagining what might happen next. But this "worlding" phenomenon took a dramatic leap with refinements in realistic rendering. The real wonder of renaissance perspective painting and its infatuation with fine detail lay in the way it drew viewers into the picture. The images captured viewers' attention by obliging them to examine the detail. The illusion of depth helped viewers imagine that they were actually entering the picture space.

Some evolutionary psychologists have studied human preferences for detailed images that give viewers a perception of depth in space. Work by Stephen and Rachel Kaplan suggests that people instinctively prefer landscapes, for example, that present both complexity and a coherence of organization of exactly the type that photography offered.[16] The Kaplans further describe the common fondness of viewers for landscapes that provide orientation and invite exploration by the viewer. Appealing landscapes often center attention on a pathway or river leading from the foreground to the background. The inclusion of a focal point or a view of the horizon increases the coherence of the scene, which increases its visual appeal. People are intrigued by deep-space landscapes because such pictures suggest that "one could acquire new information if one were to travel deeper into the scene."[17]

Others have explained the human liking for landscapes further in anthropological terms. Jay Appleton has argued that primitive instincts for refuge motivate the curiosity for images with deep-space linear perspective. Appleton puts forth the hypothesis of "prospect and refuge."[18] Human beings naturally look for a "prospect," or vantage point, from which they can survey a landscape and examine it to assure their safety. At the same time, viewers tend to look for a "refuge" in the form of a high point or enclosure. To Appleton these preferences explain the frequent appearance in early landscape paintings of castles, houses on hillsides, and even mountains and trees.[19]

Three-dimensional (3-D) rendering came remarkably early in the history of photography. Popular fascination with the photographic image and a burgeoning scientific culture in the early industrial era drove all kinds of experiments with optics, viewing devices, chemical processes, and imaging technologies. It really didn't take that much insight to recognize that depth perception comes from seeing the world from different perspectives from each eye. The detailed one point perspective of renaissance painting and photography brought picture-making a long way, but the approximation of lived visual experience was still elusive. Charles Wheatstone generally receives credit for developing the first stereographic images in the 1840s by replicating human vision using two cameras—an inch or so apart—to record a scene. The resulting images would be reproduced side-by-side on cards that a disciplined viewer could look at simultaneously to get an uncanny perception of depth in the image.

But the unacknowledged gift of the stereograph to the "worlding" paradigm came from the viewing devices it generated. To fully experience stereographic depth people used hand-held contraptions that would position their eyes to get the stereoscopic effect—but would also *block out any perception of the world around them.* These early photographic viewing devices were extremely important in giving people an experience of leaving the immediate environment and entering an imaginary space.

The movie-viewing experience lends itself especially well to 3D because the blocking out of viewing distractions is done by the darkened theater. In movies 3D has been a cyclical fad—appearing in the 1920s, the 1950s, 1970s-1980s, and finally again in the 2000s. With each

of these 3D booms audiences have worn special glasses that have been an annoyance to many. But 3D systems have improved dramatically with contemporary technological advances to the clarity and capacity for fine detail in films, as well as the size of the image. IMAX emerged in the 1980s using cameras with 65mm film stock nearly double the size of the industry standard.   In the 2000s high-definition (HD) digital filmmaking technologies moved the bar even higher in terms of resolution, while simultaneously permitting computer-driven special effects to enter the production process as never before. But Digital 3D required special equipment on the exhibition end. In 2005, the Mann's Chinese theatre in Hollywood became the first commercial movie theatre equipped with the Digital 3D format.  Advances in digital technology in the 2000s had one further effect. Prior to this time 3D movies had to be shot with special 3D equipment—two separate cameras in the early days of 3D, and later single-cameras with special lens and filter systems. But when 3D went digital it became possible to retrospectively remaster conventional films into 3D. *Toy Story* (1995), *Toy Story 2* (1999), and *The Polar Express* (2004) were retrospectively rendered in 3D in this way in 2009.

All of these technological advances heightened the capacity of movies to pull viewers into a virtual world in what has been termed an "immersive" experience. To enter the world of the story being told, audience need to "suspend disbelief" and let themselves forget the world outside the picture frame. In the 1970s theorist Christian Metz described this entry into the virtual world as having two components.[20] On one hand, in the darkened space of the movie theater with a large-sized projection and amplified sound, viewers can imagine themselves to be inside the story being told—at times pretending to be one of the characters. On the other hand, the viewer identifies with the perspective of the camera filming the story—and having a masterful overview of the whole thing. In either case—whether viewers see themselves as characters in the story or omniscient onlookers—the imaginary process usually involves a temporary acceptance of the premises of the story.  The movie might present an ideal family, a rugged hero, an embattled nation, etc. To get the full effect of the story one needs to "go with it" to a certain extent.

Now there's nothing intrinsically wrong with this process. Letting go of the outside world is an important part of enjoying a story. But there have been heated arguments about this phenomenon. As people were coming to understand how the viewing of movies operated, films were criticized for leading people astray in the same way media have been challenged throughout history. Some academics were drawn to psychological explanations of movies suggesting that movies encouraged audiences to regress to states of child-like vulnerability—rendering them powerless in the face of powerful media defining the world for them.

As such theorizing was taking place about the vulnerability of audiences, feminists and others noticed that certain kinds of stories were told over and over in movies and other entertainment: men were always in charge, women were ignored or treated as sex objects, racial minorities and gays were often mocked or villainized. Factor in the reality that in the 1970s and 1980s the entertainment industry was largely run by heterosexual white men who chose the stories, wrote the scripts, ran the cameras, edited the films, and then marketed the productions—and a kind of conspiracy was seen. Could it be that the whole business was driven by what men liked to see, especially white straight men?

Thus was born the concept of the "male gaze" in movies. Try this classic experiment the next time you watch a movie or television show. In her classic 1973 essay "Visual Pleasure and Narrative Cinema" British feminist Laura Mulvey proposed that often in movies women are positioned in the frame to be viewed.[21] More than men, women face the camera and are positioned or dressed up to be examined. Even within the scene, women tend to be looked at by men. The whole process operates in a gender-biased manner.

All of this assumes that viewers are not being very critical about what they are seeing. This issue raised its own controversy. Do viewers really regress into a child-like state of passive acceptance of what they are being told in the virtual world? Do they readily accept and agree with the camera's ideology? Certainly they must play along with the story on one level to make the story work in their minds. But viewers are not fools. Certainly not in an era in which they have seen

thousands of TV commercials and other entertainment products that even young children know are trying to manipulate them.

Media consumers "read" movies and television through active intellectual processes much like that of reading a written story or book. The process of interpreting written or visual media has been described as "decoding." Linguist Ferdinand de Saussure described human communication as a process in which thoughts are assigned symbols in a commonly identified system.[22] Ideas are "encoded" into words or pictures by the person sending the message and "decoded" by the receiver. But obviously this process doesn't automatically ensure that the message sent will be the same as the one received. People constantly are being misunderstood or not believed when they exaggerate, as often is the case in advertising.

Subsequent theorizing about the "reading" of virtual worlds has seen the viewing process as a kind of contest. As people are watching a movie they go through a variety of thought processes, sometimes giving into the story and its premises, but also mentally arguing with it, imagining alternative outcomes, or even rejecting its underlying logic. For a long time these ideas of viewer empowerment were not widely accepted. But things changed in the 1980s as media theorists, educators, and other academics began to take seriously the way ordinary people enjoyed entertainment. With so many millions of people watching television and going to the movies, were they all being manipulated? As academics began questioning their assumptions, the entertainment industry itself began providing answers. *Saturday Night Live* premiered in 1975 and became an overnight sensation using satiric skits that mimicked familiar TV commercials and news programs, poking fun at the artificial ways they told stories. The *Saturday Night Live* format evolved around celebrity guest hosts for each episode, who would be featured in comic versions of the movies or TV shows that made them famous.

The appeal of *Saturday Night Live*, generally broadcast after 11 pm on Saturday evenings, came from its appeal to young adult audiences who recognized its satiric humor as a critique of authority on many levels. Sometimes the show made fun of posturing politicians or presumably serious newscasters—or the objectification of women, racial stereotyping, and homophobia prevalent in popular entertainment.

*Saturday Night Live* initiated a genre later adapted in the 2000s by entertainers like Steven Colbert, Bill Maher, and Jon Stewart, which shined a light on the artifice of commercial media. More to the point, the popularity of such programs, especially among younger audiences, gave potent evidence of latent critical sensibilities in the media consuming public.

As audiences have become more critically aware of the ways media work, new technologies have opened the door to previously unexplored worlds. During the past decade, *computer games* and *the internet* have provided novel experiences and new social possibilities that have sent their market-shares skyrocketing. Recent setbacks in the 2009 economic downturn notwithstanding, computer gaming remains the fastest growing sector of the entertainment industry. According to industry sources, sales of computer games remain at approximately $1 billion per month owing to the continuing popularity of products for Microsoft X-Box, Sony PlayStation, and the Nintendo Wii.[23] The only impediment to over-the-counter revenue of such games, which in 2007 averaged $1.7 billion per month, has been the migration of some sales to online sources.

The lure of computer games is no secret. While movies and television pull viewers into the "diegetic space" (the world of the story) by virtue of their imagistic clarity and illusion of perspectival depth, games allow participants to physically control action within the game space. This creates a powerful sensation of actually inhabiting an imaginary world that is truly virtual owing to its creation by computer rendering. Countless stories have been recounted by anxious parents and educational authorities—not to mention gamers themselves—about becoming "lost" in the game-space, losing track of time, and the wonder of exploring or competing in the virtual world.

A turning point in the game industry occurred in 2005, as game players for the first time surpassed 50 percent of the U.S. population.[24] People around the world now spend twice as much each year on computer games ($31 billion) as they do on movies ($14 billion).[25] The Entertainment Software Association asserts that adult game players (39 percent of whom are women) spend 7.5 hours per week engaged in the activity and that 84 percent of people playing computer games are over the age of 18.[26] Some in the media community believe that

the interactive character of computer games makes them a more influential "teacher" of aggressive behavior than movies or television, although such assertions have yet to be proven conclusively by scientific research. Regardless of its effects, computer gaming has become an enormous business—with the budgets of game development and promotion now surpassing that of many feature films. This is hardly surprising in light of the fact that popular games like *Grand Theft Auto IV* (2008) and *Halo 3* (2007) both sold over 15 million copies (retailing at $49.95), putting them on an economic par with the most successful Hollywood movies.

The phenomenon of the virtual world in gaming has been brought to new heights in recent years with the growth in multiplayer roleplaying games, most notably *World of Warcraft*. Such games maximize the virtual world experience by enabling players to assume the role of a character (usually a combatant) within the game-space, who interacts with others—either real world friends or online acquaintances. Entire college dorm-units play *World of Warcraft* and similar games together, as well as networks of gamers brought together by games. At times hundreds of players can inhabit the *Warcraft* game environment—so large that players can travel to towns, inhabit buildings, and roam across expansive terrain. Unlike earlier computer games sold as single-package software units, games like *Warcraft* are paid for via subscription. With over 9 million subscribers *Warcraft* is estimated to hold over 60 percent of the multiplayer online game market.[27] As the name implies, *Warcraft* is a fighting game placing participants in an environment where they potentially hunt, shoot, or blast hundreds of other players. But in the most popular multiplayer game there is no fighting at all.

*The Sims* first appeared in 2000 as a game oddly seeming to lack a goal. Players simply assume an identity and construct a life for themselves in any of a variety of environments (homes, mansions, colleges, vacations, deserted islands) depending on the version of *The Sims* purchased. Initially a game for a single computer, *The Sims* became an online multiplayer experience in 2002. Since then the non-violent Sims has become the largest selling game of them all, with over 1 million copies in circulation.

A research subculture has developed examining the positive aspects of media and game culture. A notable example of this is James Gee's book *What Video Games Have to Teach Us About Literacy and Learning*.[28] In this work Gee takes a cautious look at the neurological processing skills that game technologies help develop. As the book's title indicates, Gee argues that computer games require certain types of learning unique to the game medium. Most obviously this entails a mastery of the game and its rules—which can be quite daunting. Anyone who has picked up the controller of the Sony PlayStation knows that the game's controller has no less than 15 separate buttons and toggles requiring split-second dexterity to operate successfully. Games like *World of Warcraft* oblige players to animate their avatars in highly complex commands. Most uninitiated players find themselves hopelessly vulnerable when they start to play, typically eliminated by experienced players within a minute or so. But this is only the beginning of the learning curve.

Central to the mental work of entering a virtual world—whether through a book, movie, television program, or computer game—is the engagement with an alternative universe. Reading any story means entering a narrative with its own rules, systems of logic, and vocabulary. The familiar Harry Potter books, movies, and games require readers to accept a world in which magical powers exist, operate in unique ways, subscribe to a hierarchy of institutions, professors, and master wizards. In fact, considerable comedy emerges in the interactions between the "magical community" and the world of "muggles" (non-magical beings). Harry's aunt and uncle Dursley are muggles, who are continually befuddled by a magical world they view as "not normal." The magical characters continually ridicule the pompously middle-class Dursleys, who simply are not privy to how the magical world works.

In interactive game environments, players must first assume an identity that conforms to others in the virtual world. To Gee, this entails a "committed learning principle" of gaining fundamental knowledge of the virtual world, as well as an "identity principle" that involves "taking on and playing with identities in such a way that the learner has real choices (in developing a virtual identity) and ample opportunity to meditate on the relationship between new identities

and old ones.[29] Next, players begin the intellectual work of probing the virtual world, formulating hypotheses about how it operates, and testing the ideas. Finally, life in the virtual world requires a tolerance for differences, a willingness to engage those one does not understand, and the ability to form communities with others.[30] It's worth acknowledging that all of these skills have corollaries in the non-virtual world. But they are exercised with an intensity and frequency in virtual worlds that is quite different from other story-telling forms.

Owing to the exponential growth of Twitter and Facebook, much has been said in recent years about internet social networking. These sites make good on predictions made in the early 1990s about the potential of virtual communities—in other words, places where people meet, chat, conduct business, and develop a sense of togetherness. Of course, even in its most generic definitions, community always is a relationship among people as much as a place. Long before the internet existed as an idea, communities operated as "networks" made possible by mail, telephones, automobiles, and mass communications. With this in mind, Raymond Williams wrote that "the process of communication is in fact the process of community."[31]

To Anderson, the very way that people view themselves as members of a group or citizens of a nation hinges an imaginative leap enabled by common association, but reinforced by such entities as news and entertainment media. As Anderson described it, "All communities larger than primordial villages of face-to-face contact (and perhaps even these) are imagined. Communities are to be distinguished, not by their falsity or genuiness, but by the style in which they are imagined."[32] In more recent years, linguistic scholars have described speech communities, interpretive communities, and other types of "virtual communities" like fan clubs as groups enabled by understandings that generate relations of inclusion and exclusion. In other words the idea of virtual communities, so celebrated as a revolutionary concept by internet technophiles, is nothing new. To scholars like Manuel Castells, the virtual community also offers little of consequence aside from the way it throws traditional concepts of community into relief. Castells writes that "the opposition between 'real' and 'imagined' communities is of little analytical use beyond the laudable effort at demystifying ideologies of essentialist nationalism."[33]

In this context, the idea of communities enabled by the internet hardly seems like a great insight. Yet the online manifestation of the "virtual community" has generated a powerful mythos in the popular mind. Why is this so? The simple answer is that apparent technological novelty has once again been promoted successfully as a revolutionary force. In an era of wireless web access and proliferating e-commerce, community is simply another part of life that has become digitized and thereby improved. But on another level, the idea of digital connectedness resonates powerfully at a time when many people feel alienated and estranged from public life. The network begins to appear as a viable option when "real" communities are diminishing and people increasingly feel powerless. Is it any wonder that the tremendous popularity of internet communities is growing at a time when the majority of citizens no longer participate in electoral politics, when corporate mergers and monopoly business practices are at an all time high, and when the idea of something as fundamental as universal health care evokes intense political acrimony? Factor in such historical changes as the weakening of organized labor and religion, the moral bankruptcy of party politics, changes in the traditional family structure, the declining role of the state—and the stage is set for something "new" to capture the public imagination.

An unabashed advocate of the social potentials of these "virtual" encounters, Howard Rheingold wrote in 1993 that life in cyberspace can be virtually identical to life in physical space, except "we leave our bodies behind."[34] Rheingold saw the gap between virtual fiction and physical reality as insignificant: "Not only do I inhabit my virtual communities; to the degree that I carry around their conversations in my head and begin to mix it up with them in real life, my virtual communities also inhabit my life."[35] It goes without saying that the virtual crowd also leaves behind such bodily inconveniences as hunger, poverty, and violence in the pursuit of electronic comradeship.

Yet, this is where things get interesting. Rather than focusing on differences between virtual/non-virtual worlds (or to put it another way, representation and reality) these two spheres can be viewed as mutually informing. Each reflects and shapes the other. In this sense the notion of a virtual community does not need to be regarded so much as an end in itself, but rather as one of many "spaces" where

dialogues can emerge. *Whole Earth Catalogue* founder Stewart Brand once described the virtual meeting place much like the public sphere: "There's always another mind there. It's like having the corner bar, complete with old buddies and delightful newcomers . . . It's a place."[36]

Those who assert that online worlds have little "real" effect often discount the growing significance of the internet as its own world and the subsequent impact that world is having. The internet has become a prodigious medium of commerce–initial overstatements notwithstanding—in the form of such entities as Amazon.com, E-toys, and various software, video, and MP3 music outlets. Such corporations certainly have recognized the power of "community" as a way of developing and organizing cohorts of customers. The interactive capabilities of Amazon's website allow it to analyze information on a customer's purchases to produce a continually changing set of "recommendations" for new purchases. These are accompanied by "Customer Reviews" and lists like "Customers who bought this book also bought books by . . . ." This creates a simulation of a community of readers with similar interests—all generated by a computer. Other retailers promote community via special gatherings announced through e-mail invitations, or print publications that one receives as a supplement to online services, or memberships in "priority" clubs or discount buyers groups. All of this is done in the interest of instilling a sense of affiliation, brand loyalty, or "membership." As Jeremy Rifkin explains, "there's a growing awareness among management and marketing experts alike that establishing so-called 'communities of interest' is the most effective way to capture and hold customer attention and create lifetime relationships."[37]

While this might sound like simply another form of commodification, the transformation of community into a commercial product has serious implications. The way people form communities says a great deal about the way they understand themselves and their world. It also has a great deal to do with the way people communicate and their ability to do so. Rifkin asserts that "because communication is the means by which human beings find common meaning and share the world they create, commodifying all forms of digital communication goes hand-in-hand with commodifying the many relationships

that make up the lived experience—the cultural life—of the individual and the community."[38]

None of this is going to dissuade the many people who have used the popular *eHarmony* matchmaking site. Founded in 2002 by psychologist Neil Clark Warren, *eHarmony* has risen above other dating sites to become a genuine social force. After taking extensive personal histories and collecting preference data, *eHamony* finds matches for people interested in long-term personal relationships. With over 15 million current subscribers, *eHarmony* says that 90 percent of its users eventually get married and that such unions constituted 2 percent of *all* marriages in the U.S. last year.[39] In the world of working adults frustrated by the lack of real-world social networking they perhaps once had in college, most people know someone who has used the service. In fact, several of the marriages I've attended in recent years have been the result of *eHarmony* introductions

The community building capabilities of the internet also have successfully mobilized constituencies to write letters and communicate with legislators as well as orchestrate online "demonstrations" resulting from mass e-mailings to single sites. On another level, the internet's impact is more accurately interpreted as a function of culture than as material presence. This is well recognized by the growing number of corporations who use the internet as an advertising medium, not to mention investors who pay inflated rates for shares in internet companies that make no profits. Like other mass media, the net is becoming a major conduit for the reflection and manufacture of human desire. Finally, the internet enables a form of community building in the growing use of tracking and profiling software to surreptitiously collect information about internet users and to aggregate them into target consumer groups, mailing lists, or simple statistics for analysis. In other words, you belong to online communities regardless of your knowledge or willingness to join.

But there is something even more basic going on here. Shopping online is its own kind of virtual world in which the sense of empowerment people derive from making individual consumer decisions is harnessed by the interactive character of the online medium. People define themselves through the things they buy, and the internet makes the process just that much easier. Not that shopping is the

end of the story. Without a great deal of public fanfare, much of the financial world has become a part of the virtual universe in the past decade. Almost all stock trading now takes place online—so much so, in fact, that Wall Street has become increasingly concerned that powerful computer systems are now able to manipulate stock prices. In a phenomenon known as "flash trading" online investors at large institutions are now capable of executing millions of transactions in a few seconds thanks to the network computerization of the market. Individual investors often find themselves blindsided by shifts in investment value that occur in seemingly instantaneous bursts due to blasts of money shot through the system by flash traders. In 2009, Congress began drafting legislation to limit the power of virtual trading.[40] This is but one aspect of an entire financial system that has gone digital. Certainly the transfer of money between banks has been done by computer networks for quite some time. But the digital era brought much of personal banking and financing online as well, with electronic salary deposits, bill-paying, and home accounting systems. Always an object of abstraction, money has become even more ephemeral in the virtual world. Is it any wonder that a credit crisis might occur as money became ever more make-believe in our digital society?

Online gambling has become one of the most quickly growing virtual worlds in cyberspace. While the operation of gambling sites remains largely illegal within the United States, gambling casinos, card rooms, bingo-parlors, and sports betting sites operated off-shore or by domestic Native American groups continue to grow—with an estimated 600 gambling "portals" currently in operation. Gamblers typically establish accounts with gambling organizations, using either credit cards or bank accounts registered in other nations. Some members of Congress have tried to legalize online gambling by rolling back a 2006 ban on financial institutions handling such transactions.[41] Social conservatives have long opposed internet betting, as have states such as Kentucky and Nevada, which are home to legalized gaming franchises threatened by internet gambling. Others argue that regulated internet gambling could increase tax revenues.

Playing poker online may sound simple. But the idea neatly encapsulates the principles of virtual worlding: *immersion* and *naviga-*

*tion.* Nothing could be so *immersive* as finding oneself at an online poker table, locked in a game, and living with the consequences of one's decisions. For the lifecycle of the game, you are in a quite specific world, with certain rules, players, strategies, and outcomes. At the same time, you are free to do what you want, to *navigate* the situation in any manner you wish—choosing cards and placing, calling, or folding bets. Someone wins and someone loses in real or imaginary terms, but the transaction takes place nevertheless.

From movies and television to online environments and games, new forms of media envelop us. There's just no getting around it. But rather than fretting that media may be encroaching on the written word, it seems healthier to recognize that visual and written materials now simply coexist. Our futures will not be enhanced by clinging to old standards of intellectual value or by replacing them with new ones, but by recognizing that the very idea of standards is the issue. There is no longer one standard of literacy, or intelligence, or humanity for that matter. The challenge ahead lies in exploring the many kinds of reading that exist in our world.

## NOTES

1. Marshall McLuhan and George B. Leonard, The Future of Education: The Class of 1989," *Look Magazine* (Feb. 21, 1967) pp. 23-24.
2. Henry A. Giroux, *Popular Culture, Schooling and Everyday Life* (South Hadley, MA: Bergin & Garvey, 1989) p. ix.
3. Nigel Spivey, *How Art Made the World: A Journey to the Origins of Human Creativity* (New York: Basic Books, 2006) p. 34.
4. John Belton, *American Cinema/American Culture* (New York: McGraw-Hill, 1994), 17.
5. Ella Shohat and Robert Stam, *Unthinking Eurocentrism: Multiculturalism and the Media* (New York: Routledge, 1994), 103.
6. Jan Pieterse, *White on Black: Images of Africa and Blacks in Western Popular Culture* (New Haven: CT, Yale Univ. Press, 1992), 77
7. Max Horkheimer and Theodore Adorno, trans., John Cumming, *The Dialectic of Enlightenment* (New York: Herder and Herder, 1972).
8. Bureau of Labor Statistics, *American Time Use Survey* (Washington, DC: U.S. Department of Labor, 2006).
9. "Poverty Now Comes with a Color TV," *Christian Science Monitor* (2005) http://articles.moneycentral.msn.com (accessed April 21, 2008).
10. Norman Herr, PhD, "Television and Health," *Sourcebook for Teaching Science*. Internet reference. http://www.csun.edu/science/health/docs/tv&health.

html (accessed April 21, 2008).

11. Newton Minnow, "Vast Wasteland Speech," delivered to the National Association of Broadcasters (May 9, 1961), http://janda.org/b20/news%20articles/vast wastland.htm (accessed April 21, 2008).
12. Clive James, *On Television* (New York: Picador, 1991).
13. Clive James, "Save Us from Celebrity," *The Independent* (Oct. 28, 2005), http://www.independent.co.uk (accessed April 27, 2008).
14. Bob Greene, "The New Stardom Doesn't Require Paying Any Dues, " *Jewish World Review* (Sept. 14, 2000), http://en.wikipedia.org/wiki/Celebrity (accessed April 27, 2008).
15. Aristotle, Richard McKeon, ed., *The Basic Works of Aristotle* (New York: Modern Library, 2001)
16. Rachel and Stephen Kaplan, *Cognition and Environment: Functioning in an Uncertain World* (New York: Praeger, 1982).
17. Stephen Kaplan, "Environmental Preference in a Knowledge-Seeking, Knowledge using Organism, in Jerome Barklow, Leda Cosmides, and John Tooby, eds., *The Adapted Mind: Evolutionary Psychology and the Generation of Culture* (New York: Oxford, 1992).
18. Jay Appleton, *The Experience of Landscape* (New York, Wiley, 1975).
19. Denis Dutton, *The Art Instinct: Beauty, Pleasure, and Human Evolution* (New York: Bloomsbury, 2009) p. 21.
20. Christian Metz, trans., Michael Taylor, *Film Language: A Semiotics of Cinema* (New York: Oxford, 1974).
21. Laura Mulvey, "Visual Pleasure and Narrative Cinema," *Screen,* 16, no. 3 (Autumn 1975) pp. 6-18.
22. Ferdinand de Saussure, trans. Wade Baskin, *Course in General Linguistics* (London: Fontana/Colins, 1974)
23. Steven Musil, "Video Games Sales Revenue Plummets 31 Percent," CNET News (July 16, 2009) Internet reference. http://news.cnet.com/8301-10797_3-10289207-235.html. Accessed Aug. 17, 2009.
24. Entertainment Software Association, *Facts and Research: Game Player Data* (2005) www.theesa.com/facts/gamer–data.php. Internet reference. Accessed May 3, 2005.
25. Media Awareness Network, *The Business of Media Violence.* www.media-aware ness.ca. Internet reference. Accessed May 3, 2005.
26. Entertainment Software Association, *Facts and Research: Game Player Data.* http://www.theesa.com/facts/gamer_data.php. Internet reference. Accessed Oct. 5, 2005.
27. Mike Fahey, "World of Warcraft's U.S. Sales Numbers are Massive," *Kodak.* Internet reference. http://kotaku.com. Accessed Aug. 16, 2009.
28. James Gee's *What Video Games Have to Teach Us About Literacy and Learning* (New York: Palgrave, 2003).
29. *What Video Games Have to Teach Us*, p. 67.
30. *What Video Games Have to Teach Us*, p. 90.
31. Benedict Anderson, *Imagined Communities: Reflections on the Origin and Spread of Nationalism* (London: Verso, 1983).
32. *Imagined Communities*, p. 6.

33. Manuel Castells, *The Information Age: Economy, Society, and Culture, Vol. II The Power of Identity* (London: Blackwell, 1997) p. 29.
34. Howard Rheingold, *The Virtual Community: Homesteading on the Electronic Frontier* (Cambridge, MA; MIT, 2000), p. 3.
35. *The Virtual Community*, p. 10.
36. *The Virtual Community*, p. 24.
37. Jeremy Rifkin, *The Age of Access: The New Culture of Hypercapitalism, Where all of Life is a Paid-For Experience* (New York: Tarcher, 2001) p. 108.
38. *The Age of Access*, p. 139.
39. "eHarmony," *The Internet Dating Guide*, Internet reference. http://www. theinternetdatingguide.com/2007/10/eharmony.html. Accessed Aug. 17, 2009.
40. Karey Wutkowski, "U.S. Regulators Propose Ban on 'Flash' Trading" (Sept. 17, 2009) *Reuters*. Internet reference. http://www.reuters.com. Accessed Sept. 18, 2009.
41. Dan Goodwin, "US Lawmakers Renew Fight for Legal Online Gambling," *The Register* (May 26, 2009). Internet reference. http://www.theregister. co.uk /2009/05/26/online_gambling_bill/.Accessed Aug. 16, 2009.

CHAPTER FOUR

# WHEN MACHINES DO THE READING

## Multiple Literacies in a Digital Society

READING TAKES place everywhere in all kinds of unexpected ways. Any discussion of *The End of Reading* requires a discussion of the ways that ordinary people interpret the movies and TV they watch, the radio and music they listen to, the toys and games they play. In the broadest sense it can be said that people "read" the media in quite diverse ways, bringing to the interpretative encounter their various educational histories, cultural backgrounds, levels of literacy, as well as their tastes, biases, and opinions. Forms of culture play out differently in activities like shopping, going to school, traveling, work, and leisure—as well as different media. To a certain extent everyone possesses a degree of critical skill. Educator Douglas Kellner writes that "All people in a media culture are media literate, they are able to read and interpret the multitude of cultural forms with which they daily interact, but their media literacy is often unconscious and unreflective, requiring the cultivation of cognitive skills of analysis, interpretation, and critique."[1] It's often said that the TV generation had a level of media literacy superior to the print generations that preceded it. Today's digital generation is way ahead of its predecessors who grew up without computers or the internet.

Kids like my daughter Emily certainly navigate a much more complex media universe than the baby-boomer generation. While many adults confess that they can become befuddled by the maze of internet, cell phone, GPS, and game technologies that immerse us,

younger people are often unaware that the world ever existed without this multiplicity of media forms. But this new often highly commercialized cultural environment is hardly neutral or even safe. With Kellner, it's worth pondering what degree of criticality inhabits the minds of the new multimedia generation.

No one needs reminding that media like photography, video, film, the internet, and interactive computer games play an enormous role in our lives. Conventional reading of linear narratives is now augmented by immersion and navigation in virtual worlds. The U.S. Department of Labor estimates that that the average adult  spends four hours every day watching TV, two hours listening to the radio, 30 minutes online, and 20 minutes reading.[2] Regardless of one's viewing habits or the time one spends at any one media activity, it's hard to deny the importance of virtual worlds in shaping our understandings of who we are and  how we got here. So accustomed have we become to using media for learning about the world around us that we rarely think about the complexity or persuasive abilities of the messages we receive.

This section proposes a rethinking of common notions of literacy in an age in which the written word has been supplanted by visual and aural technologies. The concept of "literacy" is expanded in discussions of the many ways messages are sent and received in an era of media and computer communications. Discussion then turns to the contradictory ways that reading has been both minimized by some aspects of the digital era, yet made ever more important by others. While commerce and our collective hunger for speed and efficiency continue to change the ways we read and communicate, an imperative is emerging for multiple literacies in a world of diverse interests and in an increasing multicultural society.

When most people hear the term "literacy" the first idea that comes to mind is written proficiency. A literate person is one who knows how to read and write.  In the contemporary world literacy is considered by many a prerequisite for success in school, work, and everyday life. Students who do not learn to read and write properly are compromised in their ability to function fully in society. If a person cannot read, it is difficult to fill out a job application, get a driver's license, or access important news and information only avail-

able in printed materials.   Literacy also plays a crucial role in the maintenance of a healthy democracy. To participate in collective decision-making citizens need to be able to access information, "read" the world around them, and respond in appropriate ways. Contrary to what many people think, low rates of literacy are not only a challenge faced in underdeveloped countries or inner cities. Illiteracy exists in every neighborhood, church group, school and work environment. It's important to recognize that definitions of literacy vary. Also, literacy is relative to the nation or place in which it is measured. When the National Institute for Literacy speaks of literacy in the U.S., it specifies "literacy" in English because it recognizes that non-English speakers may be perfectly functioning members of   society. There is no single definition of literacy. In fact, the term "literacy" now extends far beyond mere spoken or written language.

Although most people take for granted their abilities for deciphering the meanings of photographs, television programs, movies, and other "media," they actually use numerous complex audio/visual "languages" that each have specific rules and grammar. Elizabeth Thoman and Tessa Jolls assert that "If our children are to be able to navigate their lives through this multi-media culture, they need to be fluent in 'reading' and 'writing' the language of images and sounds" just as they have learned to "read" and "write" the language of printed communications.[3]

As mentioned earlier, Howard Gardner has proposed that people possess, not just one form of intelligence, but what he terms "multiple intelligences." Gardner contends that by broadening what counts as competency in communication, "literacies, skills, and disciplines ought to be pursued as tools that allow us to enhance our understanding of important questions, topics, and themes."[4] In this sense, literacy means more than speaking any single language. Of course, most readers become literate by learning to read commonly shared words and symbols in today's world and its antecedents. But they also analyze, compare, evaluate, and interpret multiple representations from a variety of media formats, including spoken language, texts, photographs, moving pictures, and interactive media.

On a basic level, the concept of "media literacy" has evolved to help people understand the different ways that these audio/visual

formats organize and present information. Groups like the National Association for Media Literacy (NAME) and the Center for Media Literacy assert that although everyone possesses a fundamental ability to understand a lecture, a photograph, or a television commercial—clearly we are in an era in which further education can help one grapple with the sensory overload that more complicated forms of media utilize. Basic media literacy education begins by analyzing the fundamental differences in the ways ordinary communication takes place in daily life. Consider how these different forms of media formats deliver their content: *Speaking, Written Language, Sound Recordings, Photography, Motion Pictures, Interactive Media.*

*Speaking* is a linear, time-based form of expression. Words and sentences are uttered in a sequence that accumulates meaning as the speaker continues to talk. In classical Western philosophy, spoken language  was said to operate through the principles of rhetoric and grammar.  In ancient and medieval times, rhetoric (from Greek word *rhêtôr* for orator or teacher) was the art or technique of persuasion through the use of oral language.[5] As such, rhetoric was said to flourish in open and democratic societies with rights of free speech, free assembly, and political enfranchisement for some portion of the population. In conjunction with rhetoric, grammar concerned itself with correct, accurate, pleasing, and effective language use through the study and criticism of literary models. Keeping track of rhetoric and grammar requires considerable concentration, since what is being said typically is not repeated. Listeners must follow the spoken sequence of ideas and construct the story or argument in their own minds. One advantage of conventional face-to-face spoken communication lies in its ability to convey added nuance and meaning through the intonation, facial expressions, pacing, and body language of the speaker.  Also, listening makes demands on one's time. A person can read a book anywhere and anytime.

But conversations or lectures are often fixed in time and space. In today's digital world much communication takes place by electronic means. People don't spend as much time as they once did sharing the same physical space for an exchange of ideas. In the 1800s audiences would sit for prolonged periods to hear oratorical exchanges. Neil Postman writes that the famous presidential debate between Stephan

A. Douglas and Abraham Lincoln on Aug. 21, 1858 lasted for seven hours, with each speaker debating and then responding for 90 minutes at a time.[6] Listeners can exert control over the speed of the communication only if in conversation with the speaker—or in a situation like a class or meeting, which would permit feedback during the discussion. Such instances afford participants in a dialogue to make observations, pose questions, or otherwise interact to change the course of spoken narrative. Listeners must maintain attention to the speaker and make efforts to screen out extraneous sounds or goings on. The telephone facilitates this process in common usage by limiting communication to two conversants. Anyone who has ever joined a conference  call will attest to the complexities of keeping track of the multiple voices in a conference call, which have been stripped of their visual and spatial referents. People on conference calls need to tell others when they arrive or are leaving and continually need to remind each other who they are.

*Written Language* also works in a linear sequence, but not with the spontaneity of speaking. Because the narrative is printed on a page, readers have the ability to determine the pace of reading. At the same time, readers need to remain relatively immobile, concentrated on the text, and undistracted by extraneous design elements, typographic flourishes, or illustrations. In this sense, readers can exert a degree of control over the sequence of ideas they are given. Readers can pause, reread, skip ahead, or take breaks in their reading. But because the narrative is silently appearing on a page, readers have little opportunity to interact or respond to the writer or to gain the type of additional cues that speaking can express. Also unlike speaking, written texts can be shared with others or reengaged at other times. Indeed, the physicality of a printed text is one of its great advantages over spoken language. But this same physicality also tethered messages to the materiality of printed matter. It took the introduction of the telegraph in the mid-1800s to mobilize the world of print by changing the speed by which information traveled.

Prior to the telegraph, information could only move as fast as a ship or train could travel. With the telegraph the huge time lapses that could fall between news and its reception at a distant location were eliminated. But the context from which news emerged was often

lost in the process. As the speed of messages increasingly surpassed the ability of people to travel with them, telegraphed information began to take on a life of its own. Some historians of communication assert that this dematerialization of information ushered in a new age of deception and confusion in communication—while at the same time allowing disembodied information to become commodified in new ways. Messages disconnected from any physical trace or their origin could be decontextualized and manipulated as never before.[7] A person on the west coast could communicate via telegraph with a person on the east coast, but not necessarily with any depth or background knowledge. As Postman writes, "The telegraph may have made the country into 'one neighborhood,' but it was a peculiar one, populated by strangers who knew nothing but the most superficial facts about each other."[8]

*Sound Recordings* offer many of the benefits of written texts in the ways they allow readers/listeners options for reviewing or altering the pace of listening. Recorded information offers obvious benefits to the unsighted or to those without reading ability. Recorded texts also convey additional levels of meaning that come from inflection, intonation, multiple voices, and added elements like music or sound effects. But recordings require equipment that written texts do not. The benefit of sound equipment lies in its ability both to play and record information—and by extension make the recordings available by duplication, amplification, or transmission to multiple listeners or remote audiences in much the same way printing functions for written texts. Recorded music is consumed by individuals, broadcast via radio or the internet, compiled into collections, and in the digital age, shared among users, sampled, manipulated, and re-used in new creative contexts. Sound recordings do this in part by isolating a moment and then removing it from what falls outside the recording. This erases the surrounding information from which the recording derived. Context disappears. At the same time, recordings exploit the viewer's trust in mechanically produced realism. Even though people know that sound recordings can distort reality or create alternative realities via analogue or digital enhancement, people retain a belief in their verisimilitude even if it is a tentative belief. There is no other choice,

*Photography*, as discussed earlier in this book, delivers meaning in a non-sequential fashion, with the entire image available at once. With a photograph a viewer has the ability to navigate the image, choosing where to look and what elements to scrutinize. For this reason the meanings that photographs convey are less stable than sound recordings or written texts. What a photograph "says" to a viewer is in part dependent on how the viewer chooses to "read" the image. Photographic meaning also emerges from such elements of visual language as composition, shape, tone, color, point of view, image size, and cropping—all of which are operating simultaneously. These formal elements are but the beginning of the story, however. The content of the image, juxtaposition of subject matter, and the various interpretations that pictorial elements evoke work together to make photography an extremely dynamic medium. Complicating matters further are the accumulated meanings that come when several photographs are seen together on a page or in sequence or when captions or other texts accompany the images. The multiplicity of these factors explains why people often derive different meanings from photographs or at times can't explain why a photograph is saying what it is saying. Some communications experts assert that the complexities of photographic language enable it to manipulate viewers, as happens in advertising, propaganda, and entertainment contexts.

*Motion Pictures* combine the elements of movement, sequence, sound, and special effects with the delivery of photographic meaning. Individual shots are animated by action taking place within them, but further motion can be added with camera  zooms, pans, tracking techniques. These cinematic forms of movement geometrically extend the complexity of meaning beyond that of a still photograph. The sequencing of shots into a filmic montage adds another dimension. Dialogue, voiceovers, music, and sound effects contribute added layers of meaning. Conventional special effects and the plethora of contemporary digital enhancements, animation footage, and computer generated imagery complicate interpretation still further. But like photographs, moving pictures construct a world of decontextualized fragments. Film and video clips exist without a connection to the world from which they were taken. They can be used for any purpose

to say anything. As such, pieces of moving imagery have no certain history, veracity, or ethics. They are simply fragments of material.

*Interactive Media* use computers or networks to enable the user to initiate communication or respond to it. It is often argued that interactive technologies are more potent than "passively" received media like television and radio because users must actively participate in the experience of searching a text, playing a game, or writing an e-mail message. The nature of this interaction becomes exceedingly complex if audio/visual information and text are negotiated simultaneously with hand controls, steering mechanisms, and accompanied by the perception of rapid movement through space. The interactive character of computer networks has enabled the creation of online communities and new "spaces" of engagement for purposes ranging from game playing to academic research. The two-directional information flow of interactive multimedia also has enabled industry and government to monitor online activity and collect information about users.

As even this brief review of media forms and technologies suggests, the various "languages" embedded in everyday communication, entertainment, and news media are considerably more complicated than many people perceive. Yet most of us take our fundamental "literacy" in these technologies for granted. Should we be concerned about media with such powerful abilities to manipulate information or influence opinion? Postman has argued that as we have evolved from a society based on the spoken or printed word to one based on photography, sound recordings, and moving pictures, we have gradually lost the ability to discern the veracity in what we are interpreting. As Postman states, "Since intelligence is primarily defined as one's capacity to grasp the truth of things, it follows that what a culture means by intelligence is derived from the character of its important forms of communication."[9] Postman explains that "As a culture moves from orality to writing to printing to television, its ideas of truth move with it."[10]

With spoken and typographic media, many people feel more confident about their abilities to discern the truth of statements because they can examine messages in a controlled, word-by-word, manner. Clear rules of syntax in oral and written communication have the ef-

fect of stabilizing meaning. But a photograph "lacks a syntax," according to Postman, which deprived it of a capacity to argue with the world.

Making matters worse, photographs dislocate meaning in both time and space. Susan Sontag writes about this ability of a photographic image to alter the interpretation of a scene, stating that the borders of a photograph "seem arbitrary. Anything can be separate, made discontinuous, from anything else: All that is necessary is to frame the subject differently."[11]

Cautionary voices like Postman's and Sontag's urge consideration of media and digital education in public policy debates, school curriculum discussions, and the programming of public service media. These thinkers assert that in today's world a media/digital literate citizenry is a necessity for a healthy democracy. This type of literacy education begins with an analysis on how images on TV or the Web are built in formal terms. It then moves to discussion of the producers, intentions, contexts, and economic issues behind visual material. These powerful concepts of electronic literacy can be used to enhance people's critical thinking skills about the mass media, to help them to look at television and interactive media in new ways, and to clarify the role that consumers play in the economics of media.

*The Evolution of Media Literacy Education*

If we accept the premise that we live in an era requiring multiple literacies and that learning about the functions of media is a worthy endeavor, one might reasonably assume that media literacy would be taught in schools. Not so. This isn't to say that media have been absent from education—only to point out that schools typically have viewed them more as teaching tools than objects of analysis. If media truly are becoming a new form of literature, they merit closer scrutiny.

Television became a part of education in the U.S. during the decade following the Second World War, but critical viewing was the last thing from the minds of its early proponents. As the first wave of the baby boom hit the classroom in the 1950s, video was recognized as a means of increasing teacher productivity. By simply eliminating the need for duplicate presentations, video was credited with reductions

in labor of up to 70 percent.[12] It was also recognized as a powerful tool for observation and evaluation.[13] Concurrent advances in computer and telecommunications industries prompted more elaborate speculation. While in residence at New York's Fordham University during the late 1960s, Marshall McLuhan attracted a quasi-religious following based on his vision of a global telecommunications network designed on biological (and therefore "natural") principles that would undermine all hierarchical structures. At the core of McLuhan's program lay a concept of media as "information without content" that defined international turmoil as the result of failed communication rather than ideological confrontation.[14]

This idealistic vision of new technology fit perfectly into 1960s educational reformism, while also complimenting U.S. cultural policy. In a domestic atmosphere of desegregation, urban renewal, and other liberal initiatives, efforts were made to eliminate the biases inherent in traditional schooling. As a means of de-emphasizing differences of race, gender, and class, theories of educational formalism were introduced into much instruction to stress the structure of learning over culturally specific content. Educators uncritically seized upon photographic media as tools for directly engaging student experience. They developed concepts of "visual literacy" to compete with what some viewed as oppressive print-oriented paradigms.[15] As one educational textbook of the era explained, many students "demonstrate a lack of proficiency and lack of interest in reading and writing. Can we really expect proficiency when interest is absent? To what purpose do we force students through traditional subjects in traditional curricula?"[16] Within this movement, many teachers adapted photography and video equipment to teach subjects ranging from social studies to English composition.

With the economic downturns of the 1980s and the ascendancy of the Reagan/Bush government came sweeping indictments of liberal programs. Supply-side analysts blamed schools for the nation's inability to compete in world markets, while ironically arguing for reductions in federal education and cultural budgets. Because they often required expensive equipment, media programs were terminated in the name of cost reduction, as renewed emphasis was placed on a "back to basics" curriculum. This did not mean that television disap-

peared from the classroom, only that its more complicated, hands-on, applications were replaced by simple viewing.

The type of media that survived the reform movements of the early 1980s differed greatly from its utopian predecessors. Stripped of any remnant of formalist ideology, video was reduced to its utilitarian function as a labor-saving device. This redefinition of "television as teacher" paralleled distinct shifts in the production and distribution. These were outgrowths of large-scale changes in the film and television industry brought about by the emergence of affordable consumer video cassette equipment. For the viewer, home recording and tape rental allowed hitherto unknown control over what was watched. The same was true in the classroom. For the instructional media industry, the hitherto costly process of copying 16mm films was quickly supplanted by inexpensive high-speed video duplication. The entire concept of educational media products began to change, as films could be mass-produced on a national scale (in effect "published") like books. Market expansion in this type of video was exponential. So profound was the technological change that 16mm film processing labs from coast to coast went out of business over night.

Although the shape of education was changed forever, computers didn't become a serious part of K-12 schooling until the 1990s, with the broad-based distribution of personal computers in the home, the development of network technology, and strategic donations by computer companies. Like cable television, the internet was touted as a means of bringing the outside world into the classroom, while connecting students to resources hitherto unimagined. In its early stages of implementation, school computerization was also regarded as a means of leveling the cultural differences among students—much as "visual literacy" had been promoted. These attitudes fit well within the progressive belief that digital media could deliver a world of great equity and freedom. From this perspective, public education should be seen as an extremely important means of redressing technological inequities, and their inherent relationships with race, gender, geography and social class. Not only can schools serve as places to provide access and instruction to digital media, but they can structure that experience of these media through progressive pedagogies that critically engage technologies and that foster equity and student agency.

Is the current craze for computers-in-the-classroom simply an extension of this historical faith in educational mechanization, or is it something more?

The business interests who have the most to gain in this matter assert that fundamental structural changes and paradigm shifts are occurring that necessitate new technological approaches to schooling. This could be dismissed as simple self-interestedness were it not that high tech corporations increasingly have a role in educational policy discussions. Meanwhile, parents exposed to an endless barrage of effusive media reports and advertising about the "information society" and the need for "digital literacy" are petrified at the idea of their kids missing out. So it's a double whammy. As parents pressure schools to adopt technology, schools are becoming institutional customers for educational products and venues for promotions targeted at students. It's like an entrepreneurial dream come true. Fortunately, there are limits to ways that K-12 schools can tolerate change. Given their role as day-care for underage youth, the fundamental structure of schools and the school day will not change significantly. Since elementary and secondary schools are also primarily regarded as a site for general academic or vocational education, the fundamental balance in curriculum among humanities, science, and math offerings will similarly resist significant change. This stability is further buttressed by the decentralized governance of schools at the level of the local school district and the high degree of political scrutiny that communities afford to educational issues. This raises the crucial issue of computer competency or what has been termed "digital literacy."

Contrary to the popular notion of young people as "naturally" computer-savvy, a need exists to instill critical sensibilities toward digital media much like those offered by television and film oriented media literacy programs. While acknowledging the persuasive properties of images, practitioners of digital literacy emphasize ways that viewers use media in individualized ways. Moreover, because Web surfers and computer game players can recognize the artifice of representation they need not always be fooled by it. The concept of literacy is central in this pedagogy, as explained by Cary Bazalgette, "every medium can be thought of as a language. Every medium has its own way of organizing meaning, and we all learn to 'read' it,

bringing our own understandings to it, and extending our own experience through it."[17]

The digital literacy movement holds political significance. Not only can it help viewers understand ways digital media create meaning, but it also can connect theory and practice—often by attempting to literally explain (or demonstrate) complex theories to young people. This is done by encouraging viewers to look beyond specific texts by asking critical questions like "Who is communicating and why"? "How is it produced?" "Who receives it and what sense do they make of it?" By doing this digital literacy education argues that our abilities to understand how media work can be improved with study and that these skills can be taught to children regardless of age or grade level. One can teach young people to use digital tools for their own ends by actively interpreting how they function and then choosing how to utilize them. Put another way, the movement proposes to begin identifying strategies for contextual reading, thereby suggesting changes to the "institutional structures" that condition spoken and interpretive norms.[18]

## THE TECHNOLOGICAL FIX

*Instrumentalism and Substantivism*
It's ironic that discussions of media literacy and new forms of reading often fail to take on the subject of technology directly. This isn't exactly an accident. Until the recent digital era, technology rarely got the intellectual attention it deserves as a force in changing society. As an area of study, technology largely was ignored through much of Western history. In the aristocratic culture of ancient Greece, the most revered forms of thinking addressed social, political, and theoretical concerns rather than what were considered the everyday banalities of technology.[19] Not unlike contemporary attitudes toward "technical schools" and "technicians," the idea of technology carried a crudely instrumental connotation. The conceptualization of "technology" in today's inclusive and comprehensive understanding of the term did not gain popular currency until after World War I. As the Western enlightenment was unfolding in the 1700s, technical ideas were con-

sidered endeavors in what were termed the "mechanical arts" (material, practical, industrial), as opposed to the "fine arts" (ideal, creative, intellectual).   As Leo Marx writes, "the habit of separating the practical and the fine arts served to ratify a set of overlapping invidious distinctions between things and ideas, the physical and the mental, the mundane and the ideal female and male, making and thinking, the work of enslaved and free men."[20] This is  not to suggest a negative view of technology—simply a resolutely practical one.  As discussions of technology have entered public consciousness in recent years, two schools of thought with deep historical roots battle each other: Technological *instrumentalism* and technological *substantivism*. In some ways, these opposing positions correlate to the "pull" and "push" qualities ascribed to technology earlier in this book. Instrumentalism can be seen in terms of the way human culture pulls technology forward in the interest of  human needs.  The push of technology as an autonomous force often driven by commerce correlates to substantivism.

With the development of the biological and social sciences in 18th and 19th centuries technology came to be viewed as a natural manifestation of the human will to grow and prosper. This idea of technology as an organic and unremittingly positive "extension of man" provided the basis for what has been termed technological instrumentalism. Within this commonsense framework, technology is viewed as a neutral tool that serves as an agent of social progress. Technological instrumentalism flourished in the 19th century with the development of such devices as the steam engine, locomotive, water mill, cotton gin, power loom, telegraph, and numerous other inventions that expanded human capacity and industrial productivity. Between 1870 and 1920 in the U.S., enormous growth occurred in the development of electric power and light companies, telegraph and telephone systems, the chemical industry, transportation systems, and large-scale manufacturing. The mass production and distribution of a commodity like an automobile called into existence a complex constellation of variously skilled workers, suppliers, subcontractors, managers, supervisors, clerks, transporters, dealers, and service people. Railroad systems developed networks of tracks, equipment, conductors, communication networks, and ticket agents. Power grids

were called into being as highways and housing developments sprang up across the nation.

Complementing this thoroughly modern evolution in material goods were similarly scientific methods of management.  In this era the doctrines of Taylorism and Fordism emerged to  enhance worker efficiency and workplace productivity, as employees came to be seen more as components of the larger technological system than as individuals. As labor became fragmented and systemized, new regimes of rationality, efficiency, and order emerged in the edifice of impersonal bureaucracies and hierarchical administrative structures. In an atmosphere of economic growth driven by the imperatives of the modern corporation, the ethos of the day was continual acceleration and accumulation. Over time, technology became invested with "a host of metaphysical properties and potencies, thus making it seem a determinate entity, a disembodied, autonomous, causal agent of social change—of history."[21] The legacy of these early technological systems and their ideological underpinnings of technological instrumentalism are still with us today, manifest in the burgeoning bioscience and information technology sectors that the popular media tell us are fueling the nation's economic recovery.

It is important to acknowledge the range of counterarguments that have arisen throughout the modern era—and especially during the post World War II years—to question, contradict, and negate the unproblematic premises of such utopian visions of technological progress. Historian Andrew Feenberg has used the term technological *substantivism* to describe various strains of opposition to the overriding discourse of technological instrumentalism.[22] Substantive analyses do not see technology as neutral, but instead view it as the embodiment of social values. An early skeptic of instrumentalism, Martin Heidegger wrote that technology invariably creates relationships of control from which people struggle in vain to free themselves. As a substance existing throughout human history, the hidden secret of technology as a controlling force became manifest in the modern era. "It is impossible," Heidegger wrote, "for man to imagine a position outside of technology."[23] Jacques Ellul, among other substantive critics, further elaborated on the distinct relationship of technology to modern society. To Ellul "technology has become autonomous" in its

ability to structure human actions and relationships. Ellul was responding specifically to the way technological systems of the early 20th century became transformed into "technocracies"—or technological bureaucracies—in which technology evolves into a branch of politics.[24]

These generalized notions of technological substantivism assumed a degree of heightened potency and specificity in the years following World War II. With Hiroshima, the nuclear arms race, and the U.S. involvement in the Vietnam War, public anxieties began to erode the unquestioned role of technology as instrument of social good. As a myriad of technologically based domestic products like television were introduced into the home, other voices were beginning to point out the environmental devastation created by unchecked industrial expansion. By the end of the 1960s the student movements of the New Left had given technocracy a name—the "military-industrial complex." Such sentiments deepened in the 1980s with the events of Chernobyl, Bhopal, the *Exxon Valdez*; growing recognition of the phenomena of acid rain, ozone depletion, and global warming; and the social devastation of rust belt communities brought on by the collapse of heaving industry.

Slowly the topic of technology began to emerge as an issue of intellectual concern in a variety of disciplines. In addition to critiques from the antiwar and environmental movements, important analyses of technology emerged from Marxist, feminist, and poststructuralist circles. The Marxist arguments addressed the overarching linkage of technology to markets. As discussed by Andrew Ross, early on technology was "dealt a hand in the power structure of capitalism (which is increasingly dependent on science-based industry), while its efficiency logic came to prevail over scientific management of everyday life."[25] Feminist views of technology grew at first from critiques of science as a patriarchal system practiced by men and for men. Writers like Sandra Harding considered technology in epistemological terms, asking: Whose interests are served by a rationalist philosophy of science that posits the world in universal terms? According to whose logic are "objective" certainties of knowledge established?

*Experiencing Technology*
In the context of reading, one can say that technology extends human capacity, but it does so unevenly. Any discussion of technology's benefits needs to be tempered with the qualification that new things need to be bought--and consequently are more available to those with resources or the good fortune of living where new technology is plentiful. Certainly the internet has changed life in remarkable ways. During the past two decades information technology has been growing in exponential terms—and its effect on both the written world and visual imagery has been nothing short of astonishing. Envisioned in the Cold War era as an emergency communications network, the internet was opened for commercial use in 1988. In the 1990s the Internet evolved from a specialized tool for academics to a popular medium for everyone. Originally accessible to less than 100,000 computers, 20 years later the number of internet users worldwide rose to 1 billion.[26] Dramatic as this sounds, it is important to recognize that internet users represent fewer than 14 percent of the world's 6.8 billion people. With internet access concentrated in the industrial world, a phenomenon has resulted termed the "digital divide."

In global terms, the digital divide begins with something as simple as phone access. In economically strong nations, the percentage of people with telephones—or what demographers term "teledensity"—is unusually high. For example, in the U.S. there are approximately 65 telephone lines per 100 people, as opposed to nations like Afghanistan, Bangladesh, and Kenya, where there is less than one line per 100 people.[27] In South Africa, the African nation with the best phone service, 75 percent of schools have no phone lines and at universities up to 1,000 people share a single connection. It is estimated that that such telephone-poor nations will take 50 years to match the line-density of countries like Germany or Singapore.

The United Nations Development Program (UNDP) states that the United States has more computers than the rest of the world combined. In fact, 55 countries account for 99 percent of global spending on information technology. For poor people, technological progress remains far out of reach.[28] In general terms, one fifth of the world's highest-income nations produce 82 percent of goods purchased and control 68 percent of foreign investment, while the bottom fifth ac-

counts for less than one percent in both categories. Just 10 telecommunication companies control 86 percent of a $262 billion market. This latter statistic carries profound cultural implications in the flow of ideas and values from wealthy nations to poor ones. Few people realize that the biggest export of the United States is no longer weapons systems, computer software, or Coca-Cola—but entertainment. The apparent ubiquity of the World Wide Web in the 2000s suggests that the internet offers a "universal" medium in which differences in nationality, race, ethnicity, and language are subsumed within one global technoculture. The most obvious flaw in this reasoning lies in the fact that the quite non-universal language of English, natively spoken by 6 percent of the world's population, is the language of 82 percent of Web communication.[29]

Once again, *The End of Reading* bumps up against the problematic role of English as a standard for literacy. This is hardly a new story. The idea of English as a universal language was asserted by the British Empire centuries ago to suppress indigenous languages and dialects in India and Africa, much as it continues to be deployed by the U.S. today. The point is that the blind assertion of *any language or medium* as universal denies the origin of that communicative form, the social structures from which it emerged, and any power dynamics attached to it. English is hardly a neutral or historically innocent language. Nor are photography or film. They all share the same ontological roots in Western systems of representation. Moreover, relegating utterances from diverse speakers to an ephemeral realm of universal language also denies the material circumstances (bodies, locations, and times) from which the communication comes. In this sense much utopian speculation about the internet comes dangerously close to promoting a fantasy world quite different from the one in which real differences and inequalities exist. Certainly the internet has increased reading and writing worldwide, even as it has supplanted the printed word in many ways. The internet's apparent insistence on English as the language of choice cannot be blamed on the technology itself, but rather on the dominant role of English as the international language of commerce.

Satellite technology has flourished remarkably in the digital era. It's hard to imagine that the first earth-orbiting vehicle was launched

more than 60 years ago in the form of the 1957 Soviet *Sputnik 1*. From then, the space-race was on, with the U.S. getting an orbiting unit the following year. Cold War paranoia fed fears that the new satellite technology would permit the two superpower nations to spy on each other from space—which they did and continue to do. Indeed satellite images remain a tool of intelligence gathering today in the continual scrutiny of aspiring nuclear powers like North Korea and Iran. But in the meantime, satellite imagery has become public information, as nations around the world and corporations have put satellites in space. Satellite telephone service first became publicly available in the 1980s, soon to be followed by satellite television.

How do satellites affect *The End of Reading*? With voice and imaging communications available on a worldwide basis, some might think the need to read and write has diminished. Certainly conventional letter writing and even bill-paying using paper, derisively termed "snail mail," now primarily exists for documents requiring original signatures. Moreover, the ubiquity of satellite-enabled mobile phones has made voice communication more available than ever before for those able to pay for the service. Most cell phone providers like ATT, Sprint, Verizon offer low-cost unlimited calling plans that encourage people to talk rather than write. But mobile phone voice communication is just the tip of the iceberg.

Immediacy has always been a problem for the telephone. Decades ago, one had to be present to answer a phone call. Then answering machines suddenly came into use in the 1980s to capture missed calls. Mobile phones took off in the 1990s because they allowed users to take the device with them. But with "texting," messaging could be captured and tracked in real-time. Hence, the return of the written word—albeit in an abbreviated and sometimes coded form—in the texting environment. As of 2009, nearly 70 percent of cell phone owners sent at least one text message per day. Alarmingly, 46 percent of teenagers report texting while driving their cars.[30]

The relationship between reading and automobiles doesn't end with the cell phone. The rising popularity of navigation devices using global positioning system (GPS) technology has exploded in recent years. GPS devices get location data from satellites, which they feed into mini-computer databases in cars. In the 2000s all major automo-

bile manufacturers offered GPS options on new cars, as companies like Garmin, Magellan, and Tom-Tom brought accessory GPS units to the market, which also could be used outside of cars. Imagine hiking in a wilderness area with a GPS locator instead of a map. Rather than "reading" a paper map, one follows the arrows or visual indicators on an electronic device. On many systems, reading isn't required at all because the GPS unit speaks.

Many automobiles now have navigation capabilities that talk drivers through directions to a desired location. For example, the General Motors OnStar system consists of four different types of technology: cellular, voice recognition, GPS and vehicle telemetry.[31] All OnStar services come from one or more of these technologies working together. OnStar's cellular service is voice-activated and hands-free. The console contains a built-in microphone and uses the car speakers. To make a call, you say a phone number or a name associated it. The console is connected to an antenna on top of the car. With some OnStar plans, you can also use the cellular service just as you would a regular cell phone plan. OnStar lets users call an advisor, using voice recognition software like that in cell phones. However, one of OnStar's unique features is the ability to Web surf using the Virtual Advisor automated system. For this service, OnStar uses text-to-voice technology called VoiceXML. When you ask for information, such as "weather," the software translates your request into XML (Extensible Markup Language) and matches it to settings in your OnStar profile. Then it translates the information into VoiceXML and reads it to you.

Aside from the purchase of a house, buying a car is the biggest financial expenditure in most people's lives. Is it any wonder that automobiles are the focus of intense technological research and development? Car manufacturers continually lure buyers with claims of enhanced performance, safety, and convenience, as they also work to improve interior and exterior design and functionality with advancements in car body-molding, upholstery, and finishing techniques. On the cutting edge of automotive science are sensor technologies that measure the distance between cars and other objects. Many vehicles now have bumper sensors that use electromagnetic waves to detect imminent collisions and warn drivers. Some cars also

have video cameras for the same purpose. Mostly used for parking, systems are now in development for use while driving, which will stop cars from getting too close to vehicles around them or will warn drivers when they veer from their lanes.

Sensor technologies also have become increasingly important in computer games, as demonstrated by the dramatic rise of the Nintendo Wii system. Unlike X-Box or PlayStation button/toggle systems, the Wii responds to the movement of the controller itself. This was a radical departure for gamers because it introduced an element of physicality into the game experience. Everyone is familiar with the common stereotype of the computer-game playing teenager sitting relatively motionless, controller-in-hand, mesmerized by the game screen. The Wii suddenly had gamers waving their arms and moving their bodies in concert with the game—so much so that Nintendo quickly developed a Wii Sports platform to maximize the physicality of the experience.

## BUSINESS, EFFICIENCY, AND THE FLAT WORLD

It's no great insight that new technologies have been a boon to the business world. As discussed earlier in this book, the financial universe has undergone dramatic changes during the past two decades as transactions of all kinds have been digitized and networked. In this context, the abstract aspect of money as a symbolic medium "representing" value has become further abstracted by the computer. Banks exchange, collect, disburse, and loan money electronically. So called "e-commerce" consists of the buying and selling of products or services over the internet. The amount of trade conducted electronically has grown extraordinarily with widespread internet usage, resulting in such innovations as electronic funds transfer, internet marketing, online transaction processing, electronic data interchange, inventory management systems, and automated data collection systems. Modern electronic commerce typically uses the web at least at some point in the transaction's life cycle, although it can encompass a wider range of technologies such as e-mail as well. A large percentage of digital commerce is conducted entirely electronically for virtual

items such as access to premium content on a website, but most elec-tronic commerce involves the transportation of physical items in some way. Nearly all large retailers have electronic commerce pres-ence on the internet.

Few consumers now remember that commercial enterprise on the internet was strictly prohibited until 1991. Although the internet soon became popular worldwide, it took five years to introduce security protocols and high-speed DSL technology allowing continual con-nection to the internet. By 2000 most large European and American businesses offered their services through the web. Since then e-commerce has become a seemingly natural way for many people to do their shopping and banking. Amazon.com remains one of the dominant merchandisers of this kind. Headquartered in Seattle, Washington, it is America's largest online retailer, with nearly three times the internet sales revenue of the runner up, Staples.com. Launched on the internet in 1995, Amazon was named by its founder Jeff Bezos after the world's largest river. Amazon's initial business plan was unusual in that the company did not expect a profit for four to five years. The strategy was enormously effective, nevertheless. Amazon struggled in the 1990s as other internet companies grew at a wild pace. While Amazon's slow growth provoked stockholder com-plaints, the company proved it resilience when the dot com bubble burst in the late 1990s. As many of its online rivals went out of busi-ness, Amazon continued to prosper—registering its first profit in 2001. Since then other online retailers have prospered as well, led by ProFlowers, L.L. Bean, QVC, Land's End, and Victoria's Secret. As this list indicates, the internet has taken over the catalogue mail-order business of many large companies.

Internet shopping and banking hold great relevance for *The End of Reading*, owing to the ease and intimacy of the online world. On one level, e-commerce simply makes life easier. Amazon's initial focus on book, CD, and DVD sales expanded in the 2000s to encompass practi-cally any commodity whatsoever, due in part to Amazon's seamless linkage to partner retailers. On Amazon one can now buy a baseball glove or a refrigerator with the same ease as a Dean Koontz novel. Amazon has done much in this by simplifying the shopping and buying process with "One-Click" purchasing that allows customers to

skip any review of the transaction. In this and other ways the necessity to read details or think about shopping is minimized—making the process easier and what many would consider more efficient. But the ease of internet shopping also represents yet another way that reading and thinking are diminished in the digital era. Amazon and other e-commerce concerns have been quick to make shopping a largely visual experience, with pictures of products enticing customers and reducing the need to read labels or think as much as they might in a physical retail environment. This makes shopping more "fun" and potentially much more impulsive.

The internet also makes buying things more personal and individualized. Unlike shopping in a store, many people find themselves making online consumer decisions in the privacy of their homes or the even more private space of the computer screen. While some might argue that this isolation of the consumer lessens the influence of pushy salespeople and glitzy store displays, the intimacy of online shopping also capitalizes the basic emotionalism of the consuming process. Here the sense of gratification—or even empowerment—deriving from internet navigation and product purchasing intersect. In both of these phenomena individuals often get a sense of their abilities to act upon the world. Bringing together the internet and shopping experiences holds the potential of heightening sensations of control and self-definition that many people crave in an era in which so much of life seems determined by outside forces.

Many people derive a sense of identity in buying things as a way of expressing themselves. To some, consumer choice represents a use of a skill or an application of knowledge in the interest of efficiency, economy, or self-advancement. To others, consumption can serve as an antidote to feelings of powerlessness and alienation from big government, large corporations, and other institutions that exert power over them. The pleasure one gets in the organization of one's material possessions provides an expressive outlet that many of us take for granted. Selecting a CD or the kind of car one drives affords a reassurance in expressing one's identity by exerting a degree of control over the immediate world. Cultural theorist Paul Willis has written extensively about the expressive potential in the everyday pursuits of consumer behavior.[32] To Willis the "symbolic creativity" found in

these mundane activities plays a central role in the way we engage the world, make sense of it through our interrelations, and stake out a territory we can call our own. Willis writes "symbolic work and creativity mediate, and are simultaneously expanded and developed by, the uses, meanings, and effects of cultural commodities. Cultural commodities are catalyst, not product; a stage in, not the destination of, cultural affairs. Consumerism now has to be understood as an active, not passive, process."[33] According to Willis, people establish a sense of identity by their acts of everyday creativity and consumer choice. He gives consumers a great deal of credit for being able to outsmart advertisers and retailers who work to manipulate taste and control buying habits. In many ways, Willis's formulation of symbolic creativity parallels the beliefs most people hold about the market. Burger King, Pepsi, and The Gap may make convincing arguments about why you should buy their products, but at the end of the day we make our own decisions.

While it's an appealing idea, the symbolic creativity thesis has a number of flaws. The most obvious lies in the way it generalizes the workings of consumer culture. Consumption and the choice of a drink or a pair of jeans may allow people a degree of autonomy some of the time, but just as often consumers are responding to a promotional pitch they've heard. Michel de Certeau has argued that while people exercise some autonomy over what they buy, this control is partial, at best—and not necessarily progressive or even self-serving.[34] Before we get too carried away with optimistic assumptions, any discussion of the way consumers derive pleasure in shopping "should be complemented by a study of what the consumer 'makes' or 'does' with the products purchased."[35] And Certeau doesn't even begin to discuss what happens when the credit card bill arrives.

So there is a contradiction. Do people exercise autonomy and free will in their consumer behavior, or are they tricked and controlled by the marketplace? After all, despite the choice and creativity that people exhibit in their consuming, aren't popular attitudes largely shaped by the marketplace? Consumers may express themselves by the clothes they wear and the cars they drive, but most of the ideas and values they associate with those commodities generally come from the commercial sphere. Or are they? Can it really be concluded that

the very image of a "self" that many people believe they are assembling by accumulating and displaying consumer goods is made up of images they have gotten from advertising? This raises the possibility that perhaps this image-constructed self—received from Old Navy, Nike, Puma, Guess, Banana Republic, Abercrombie and Fitch, Ralph Lauren, and Victoria's Secret, to name but a few—is really an illusion. Could it be that the thing we call the self actually is little more than a selection of images that we have been sold?

Both assertions seem partially true. On one hand, it might be argued that the presumed freedom we experience in selecting what we buy is really little more than an illusion of choice. The commercial marketplace has already chosen the array of goods available to us. It then simply lets us "choose" from what it has made available. On the other hand, one might argue that all of life already is a set of choices from what is available. Although we may be constructing our self from advertising images, it is a creative process nevertheless. Some postmodern theorists have asserted that there really is no such thing as an "authentic" self or even an authentic reality.[36] All of the moments we experience are really little more than representations of a world because each of us understands those moments differently. Choosing a number of advertising images to represent us is just as creative and individual an act as naively believing we can experience reality.

For *The End of Reading*, these debates about consuming beg the question of critical thinking. Whether people are expressing themselves through products or getting tricked into wanting things—they need information. Increasingly in a world of e-commerce and visual culture, such information is either being diminished or rendered more mysterious in the form of images. Many people blame television for the dramatic influence that advertising exerts over us. Indeed, Americans own more television sets than people in any other nation—nearly one set per person.[37] But it is important to stress that commercials alone do not make people buy things. Most people begin to establish purchasing habits in the context of their family upbringing, learning consumer behavior as they grow up. Along the way many of us develop a powerful drive to keep up with the consuming habits of friends, neighbors, co-workers, and fellow students. There

exists a strong social pressure to maintain levels of appearance and to achieve certain visible standards of living.

These factors can create confusion in people's minds between the basic goods required for survival and comfort—and the unnecessary commodities that people think they should have. This creates a confusion between our "needs" and "wants." The fundamental items that people "need" are rather basic: food, clothing, shelter, and transportation. But most people are not satisfied with minimally satisfying these needs. Instead, a desire based on "wants" grows for other things: certain clothing, the latest entertainment, a cool car. It's important to think about this distinction between what people need and what they want.

As a society, we consider people's needs and often organize our communities, laws, and government functions around them. People need roads, education, protection, and a social safety net to help those who fall behind or have problems. But wants are another matter—and they don't just come from anywhere. We live in a society driven by desire. Something is always telling us that what we really want is just beyond our reach. Polling data collected in recent years tells us that 40 percent of adults earning $50,000 to $100,000 a year, and 27 percent of those earning more than $100,000, agree with the statement "I cannot afford to buy everything I really need." One third of the first group and 19 percent of those earning over $100,000 say that they spend all of their money on the basic necessities of life.[38]

One often hears that people get persuaded to desire certain things or behave in certain ways by unscrupulous advertisers and promoters. In other words, they believe society is driven by a huge propaganda system.[39] But that doesn't give people much credit for independent thinking and it assumes that people's only real desires are those they are tricked into having. More recently, a new set of theories has come along that looks at things slightly differently. Perhaps ideology doesn't give people new ideas about what they want, but instead caters to things people really value—like love, friendship, and safety—and convinces them that they can only get them by behaving in certain ways or buying the right things.[40] This is the real genius of modern capitalism. It's gotten people to believe that the road to happiness lies in material possessions and superficial signs of success.

This process of ideology makes the consuming part of identity work. You think you need to have the right car or the right clothes to look good and be admired. And who doesn't want to look good and be admired? There's nothing really wrong with it.

Why do we think this way? Some experts argue that people increasingly are working more and getting less.[41] The American work-week has expanded as public demand for commodities has also grown. People work harder and longer—and they want more for their efforts. The cruelty of contemporary marketing lies in telling you that if you can't afford to buy those things, you're out of luck. And it doesn't stop with small things. Looking good evolved over time in response to dominant groups in western society and what those groups thought was important. In the United States, Britain, and much of Europe this meant white or light skinned people in societies governed by men—heterosexual men. If you scan fashion maga-zines—or any magazines for that matter—you'll see ads promoting a certain kind of beauty. It's a beauty of thin, clear skinned, young white women with enough money to buy clothes, make-up, and great hair. It's a beauty that excludes anyone with a black or brown com-plexion, as well as any woman who is big, or poor, or over 30. In this way the message sent out by the contemporary beauty and fashion industry is racist, classist, ageist, and degrading to anyone who doesn't fit its profile. And most women don't fit its profile.

*The Flat World*
What could be better than a world of seamless markets, instantaneous communication, and a global culture that is increasingly homogene-ous? One of the most widely read proponents of globalization is *New York Times* reporter and columnist Thomas L. Friedman, who in his books the *Lexus and the Olive Tree* (2000), *The World Is Flat* (2007), and *Hot, Flat, and Crowded* (2008) has asserted that the positive manifesta-tions of globalization have been manifest in three domains: *economics, technology,* and *culture*.[42] Freidman's ideas hold relevance for *The End of Reading* because they all depend heavily on written language. He explains that in economic terms, the driving idea behind globalization is free-market capitalism. To Friedman, the more that markets open international economies to free trade and competition, the more effi-

cient and robust those economies become. Globalization has expanded free trade and capitalism across the world, deregulating and privatizing national economies as it has grown. The result has been a transformation of the world from a jumble of isolated local economies into a unified global marketplace. This has resulted in greater efficiencies and a huge overall expansion of the world economics system. According to Friedman, 100 years ago capital expenditures among nations could be measured in the hundreds of millions of dollars and relatively few countries were involved. Today private capital from the developed world to all emerging markets exceeds $205 billion. "This new era of globalization, compared to the one before World War I, is turbocharged," Friedman writes.[43]

Turning to technologies, the new globalization is defined by computerization, miniaturization, digitization, satellite communications, fiber optics, and the Internet. Such technologies present a fundamentally new and unique ethos of globalization. In contrast to a Cold War world typified by separation and division, the defining paradigms of globalization are unity and integration. The symbols of the Cold War were geographical distances and national boundaries, which divided people from each other. The symbol of the new globalization is a World Wide Web, which connects everyone. Today's globalization has been enabled by the falling costs of things like microchips, satellites, and fiber optics. New and inexpensive modes of communication have brought the nations of the world together as never before. These technologies also allow companies to locate different parts of their production, research and marketing in different countries, but still tie them together through computers and teleconferencing as though they were in one place. Moreover, due to the combination of computers and cheap communications, nations everywhere can enter and compete in the global marketplace of electronic commerce, media production, and the information economy.

Globalization also is a huge cultural phenomenon. Friedman argues that this has meant that isolated or formerly "backward" nations are no longer cut off from the ideas and philosophies of developed countries. In part this is an outgrowth of enhanced communications in areas like telecommunications, cable and satellite television, and electronic publishing of goods like CDs and DVDs. But it also results

from the increased movement of people from rural areas to urban areas. At no time in history has it been so easy for people to travel or migrate from one place to another.

Not everyone is happy with globalization. Opponents of globalization say it leads to exploitation of the world's poor and the devastation of the environment. A report by the Alternatives Committee of the International Forum on Globalization asserts that the "unrestricted movement of capital" generates enormous profits for transnational corporations but produces significant economic, social, and political harm for the majority of nations and peoples.[44] This report finds that global well-being is threatened—not fostered—by the conversion of national economies to export-oriented production, the increasing concentration of corporate wealth, and the decreasing regulation of corporate behavior. Moreover, globalization is seen as undermining social and environmental programs within nations, as well as contributing to the "privatization and commodification" of public services, the erosion of "traditional powers and policies of democratic nation-states and local communities," and the "unrestricted exploitation of the planet's resources."[45] Needless to say, opponents to globalization argue that while globalization may enable corporations like Walmart to make $29 DVD players available to customers in nations like the U.S., it does so only through manufacturing practices that underpay workers in poor nations.

If global cultures indeed are diffusing themselves across the surface of a flat world, they are doing so largely in written form. Nations with the world's poorest populations have the lowest literacy rates. Examples include Afghanistan (28 percent literacy), Bangladesh (47 percent), Ethiopia (35 percent), and Pakistan (49 percent).[46] Besides being some of the most poor nations, these countries also have fewer phone lines, internet connections, and computers—effectively cutting off the majority of their populations from the new flat world in any cultural or informational sense.

Whether or not you like the idea of flat world globalization, one premise is inescapable: reading matters. As discussed earlier in *The End of Reading,* the growth of the information society may have shifted public attention from written to visual forms of knowledge, but much internet communication relies heavily on the written word.

What are we to make of all of the ways that technology extends human capacity? Even as new visual technologies of all sorts invite us to use our visual intelligence—e-mail, texting, and netbooks bring us back to the written word. This isn't something we should resist, even if we could. The new age of machine reading is one we should embrace, understand, and learn to master. This clearly is a time for new approaches to literacy and communication—and fresh paradigms for what counts as literacy in education, commerce, and everyday life.

## NOTES

1. Douglas Kellner, "Multiple Literacies and Critical Pedagogy in a Multicultural Society." *Educational Theory*, 48, n. 1 (1998): 111.
2. Bureau of Labor Statistics, "American Time Use Summary," *News* (Washington, DC: U.S. Department of Labor, 2005).
3. Elizabeth Thoman and Tessa Jolls, "Media Literacy: A National Priority for a Changing World." Internet reference. http://www.medialit.org/reading_room/article663.html. Accessed Sept. 18, 2009. This article originally appeared as the "keynote" article for a special issue on media literacy of the *American Behavioral Scientist*, 48, n. 1 (September 2004).
4. Howard Gardner, *Intelligence Reframed: Multiple Intelligences for the 21st Century* (New York: Basic Books, 1999) p. 10.
5. "Trivium," in *Wikipedia*, Jan. 22, 2007. Internet reference. http://en. Wikipedia. org/wiki/Trivium. Accessed Jan. 22, 2007.
6. Neil Postman, *Amusing Ourselves to Death: Public Discourse in the Age of Show Business* (New York: Penguin Books, 1984). p. 44.
7. *Amusing Ourselves to Death*, p. 67.
8. Ibid.
9. *Amusing Ourselves to Death*, p. 25.
10. *Amusing Ourselves to Death*, pp. 24-25.
11. Susan Sontag, *On Photography* (New York: Farrar, Straus, Giroux, 1977) p. 20.
12. Robert M. Diamond, "Single Room Television," in *A Guide to Instructional Media*, ed. Robert M. Diamond (New York: McGraw-Hill, 1964), p. 3.
13. John M. Hofstrand, "Television and Classroom Observation," in *A Guide to Instructional Media*, p. 149.
14. Marshall McLuhan, *Understanding Media: Extensions of Man* (New York: McGraw-Hill, 1964), p. 23.
15. The terms "visual literacy" and "media literacy" have been employed in a variety of differing contexts during the past two decades. The formalist media literacy of the 1970s and 1980s should not be confused with the critical media literacy movement of the 1990s and 2000s. This media literacy education field has grown in depth and complexity, overcoming the academic stigma it suffered unjustly in its early years. Among recent titles of note are: Kathleen Tyner, *Media Literacy: New Agendas in Communication* (London and New York: Routledge, 2009); James

W. Potter, *Media Literacy*, 4ᵗʰ ed. (New York: Sage, 2008); Douglas Kellner, *Media Culture* (New York and London: Taylor and Francis, 2007); Donaldo Macedo and Shirley R. Steinberg, *Media Literacy: A Reader* (London and New York: Peter Lang, 2007).

16. Linda R. Burnett and Frederick Goldman, *Need Johnny Read? Practical Methods to Enrich Humanities Courses Using Films and Film Studies* (Dayton: Pflaum, 1971), p. xv.

17. Cary Bazalgette, as quoted in Ben Moore, "Media Education," in David Lusted, ed., *The Media Studies Book* (London and New York: Routledge, 1991) p. 172.

18. Stanley Fish, *Is There a Text in this Class? The Authority of Interpretive Communities* (Cambridge, Harvard University Press, 1980).

19. Martin Heidegger, *The Question of Technology*, trans. William Lovitt (New York: Harper and Row, 1977).

20. Leo Marx, "The Idea of Technology and Postmodern Pessimism," in Yaron Ezrahi, Everett Mendleson and Howard P. Segal, eds, *Technology, Pessimism, and Postmodernism* (Amherst, MA; Massachusetts, 1994) p. 14.

21. "The Idea of Technology," p. 19.

22. Andrew Feenberg, *Critical Theory of Technology* (New York: Oxford University Press, 1991); Andrew Feenberg and Alastair Hannay eds., *Technology and the Politics of Knowledge* (Bloomington and Indianapolis: Indiana University Press, 1995); Andrew Feenberg, *Questioning Technology* (New York and London: Routledge, 1998).

23. Martin Heidegger, *Being and Time*, trans. John Macquarrie and Edward Robinson (New York: Harper and Row, 1962) p. 41.

24. Jacques Ellul, *The Technological System*, trans. Joachim Neugroschel (New York: Continuum, 1980).

25. Andrew Ross, *Strange Weather: Culture, Science, and Technology in the Age of Limits* (London: Verso, 1991) p. 10.

26. "Global internet users cross 1-bn mark in Dec." *Economic Times* (Jan 23, 2009) http://economictimes.indiatimes.com (accessed Feb 10, 2009).

27. "Making New Technologies Work for Development," *United Nations Development Report* (2001). http://hdr.undp.org (accessed Feb. 10, 2009).

28. *United Nations Development Report* (2001). Ch. 2, 10.

29. *United Nations Development Report* (2001).

30. "Statistics on Texting" (Feb. 21, 2009) Internet reference http://www.articlesbase.com Accessed Aug. 19, 2009.

31. All information about OnStar from Shanna Freeman, "How OnStar Works," *HowStuffWorks*, Internet reference. http://auto.howstuffworks.com /onstar2.htm. Accessed Aug. 20, 2009.

32. Paul Willis, *Common Culture: Symbolic Work at Play in the Everyday Cultures of the Young* (Boulder and San Francisco: Westview Press, 1992) p. 1.

33. *Common Culture*, p. 18.

34. Michel de Certeau, *The Practice of Everyday Life*, trans. Steven Randall (Berkeley: University of California, 1984).

35. *The Practice of Everyday Life*, p. xii.

36. Juliet B. Schor, *Born To Buy* (New York: Scribner, 2004).

37. *Born to Buy*, p. 9

38. Juliet B. Schor, "Towards a New Politics of Consumption" in Juliet B. Schor and Douglas B. Holt, eds., *The Consumer Society Reader* (New York: The New Press, 2000) p. 459.
39. Louis Althusser, "Ideology and Ideological State Apparatuses," *Lenin and Philosophy and Other Essays* (New York: Monthly Review Press, 1971).
40. Hans Magnus Enzenberger, *Critical Essays* (New York: Continuum, 1982).
41. *Born to Buy.*
42. Thomas L. Friedman, *The Lexus and the Olive Tree: Understanding Globalization* (New York: Farrar, Straus, and Giroux, 2000), *The World Is Flat 3.0: A Brief History of the Twenty-first Century* (New York: Picador, 2007), and *Hot, Flat, and Crowded* (New York: Farrar, Straus, and Giroux, 2008),
43. Thomas L. Friedman, Excerpt from *The Lexus and the Olive Tree.* Internet reference. http://www.thomaslfriedman.com/lexusolivetree.htm. Accessed Dec. 16, 2006
44. As cited in David Michael Smith, "The Growing Revolt Against Globalization," Impactpress.com. Internet reference. http://www.impactpress.com/articles/augsep02/globalization8902.html. Accessed Dec. 18, 2006.
45. Ibid.
46. "Literacy," *United Nations Development Report* (New York: UNDP, 2007). Internet reference. http://www.unesco.org/en/literacy/ Accessed Aug. 27, 2009.

CHAPTER FIVE

# THE FUTURE OF READING

## A Unified Field of Vision

*THE END OF READING* began with a story about my eight-year daughter Emily and the challenges she has experienced in reading. In many ways this book has been about Emily and the world she faces in which reading has come into question or at least become more complex. A discovery about Emily recently has occurred, the timing of which—although embarrassing to me as a parent—seems an appropriate way to begin this final chapter. It turns out that the girl needs glasses. Her difficulties and frustrations with extended attempts to plow through daily reading chores derive in large part from her inherited far-sightedness. Staring at books close-up gives her headaches. Watching movies and TV is relaxing. It turns out that Emily is hardly unique in this, however.

About 10 percent of school-aged children have what is termed "eye-teaming" difficulty.[1] At the close distances required for reading, eye-teaming problems make it hard for kids to aim their eyes together correctly for more than short periods of time. This creates visual strain and eventually blurred, scrambled, or double print. Who knew that? While getting glasses for Emily is unlikely to solve her reading difficulties completely, her prescription offers an important object lesson about the critical role of vision in our digital society of virtual worlds. As this book has documented, we live in an era of visual complexity and richness in which many different kinds of "seeing" are required—in which we need many varieties of media literacy.

Adaptive technologies, of which like eyeglasses are one of the most primary kinds, have helped spur many extensions of human capacities.

Adaptive technology is the name for products that help people who cannot use standard versions of products. Primarily this means people with limited vision, hearing, or mobility. Put another way, adaptive technology promotes greater effectiveness for those with disabilities by enabling them to perform tasks that they were formerly unable to accomplish, or had great difficulty doing. The visually impaired use many "speech enabled" devices such as talking watches, calculators, computers, scales, or thermometers. Talking computers use screen reading software (sometimes called as "Text-to-Speech" programs) to have the machine read to blind people. They also use products with Braille feedback, such as watches or writing devices. Most of us are now familiar with closed captioning on television programs for those with hearing impairments. Less known are technologies that do this in reverse, by rendering written messages into spoken language for the speech impaired.

Research in adaptive technologies has been the driving force in developing conveniences now available to the non-impaired general population. Talking wrist watches and computers were not created to amuse the average consumer. They emerged from products developed for the visually impaired, which then found a market in the general population. Such transitions of assistive technologies from specialized to mainstream use can be tracked historically, especially in the case of vision. Few people now would think that eyeglasses were considered a peculiar contrivance a century ago. After all, most of us can imagine a be-spectacled Benjamin Franklin or Teddy Roosevelt with his monocle. Actually, Franklin helped advance the science of eyeglasses by developing the bi-focal lens in the 1760s. Before then, glasses had been in use in a variety of crude forms for 500 years, with demand rising in the 1400s with the development of the printing press. But for most of this early history, glasses were used primarily by artisans, monks, or religious scholars—and thus acquired their aura as an "intellectual" accessory. Astigmatic or "corrective" lenses came unto the scene in 1828, when Briton John McAllister developed them to help his own myopic vision. The production of finely ground

lenses took a leap in the 1850s, when John Emily Bausch set up a tiny optical goods shop in Rochester, NY, in 1853. A little later, Bausch borrowed $60 from his good friend Henry Lomb and the famous Bausch & Lomb brand was born.

Despite their technological improvements, eyeglasses remained an object of general social stigma well into the 1900s. At the beginning of the 20th century, Dr. Norburne Jenkins wrote in *Optical Journal* that "If glasses are all right, they will seldom or never have to be worn in public," adding that "Glasses are very disfiguring to women and girls. Most tolerate them because they are told that wearing them all the time is the only way to keep from having serious eye trouble."[2] This attitude about glasses on women typified popular views that eyewear compromised "natural" appearance. The author Dorothy Parker famously proclaimed in 1926 that "Men don't make passes at girls who wear glasses" and in the 1953 movie *How to Marry a Millionaire* Marilyn Monroe's character preferred walking into walls to being seen in glasses.[3] The wide popularity of contact lenses today (first introduced in the 1940s) testifies to the continued public ambivalence about the appearance of eyewear. Prior to the 1970s the British government classified eyeglasses as "medical appliances," specifically stipulating that subsidized eyewear "should not be styled" in any way.[4] As late as 1991, the American design press was noting with apparent surprise that "eyeglasses have become stylish."[5]

But attitudes toward glasses have changed significantly in the past two decades. Once a minority of the population, the number of people wearing eyeglasses recently has risen to 64 percent, according to the Vision Council of America (VCA).[6] What's going on? A number of factors appear to be converging on the personal vision front. Certainly the aging baby boomer generation has had an impact, since half of people over 50 wear corrective lenses. But also, demands for reading and visual interpretation have never been higher. Every student, professional, and worker in any occupation now must be able use a computer. Entertainment is more screen-oriented. Visual forms of communication like e-mail and texting compete with the telephone. Simply put, people must be able to see clearly. Finally, public attitudes toward eyewear seem to have reversed. Glasses have become a popular fashion item, with novel manufacturing and design tech-

niques, and new public attitudes. Maybe we can thank our friend Harry Potter. Or perhaps John Lennon and Elton John, the latter of who is rumored to possess over 500 pair. But celebrities from Jennifer Aniston and Demi Moore to Bono and Usher now often appear without their contacts. Colored frames, tinted lenses, and other advances have moved glasses from their place as "medical necessity into key fashion accessory."[7] It is now reported that up to 20 percent of some brands of glasses are purchased with clear nonprescription lenses.

The growing popularity of eyewear is part of a new visual culture that places increasing emphasis on seeing. At the same time other assistive technologies help us to experience the world, whether it is real or imaginary. Previously in this book I have discussed the "push" of technology to provide ever-more effective means of extending human capacity, whether for positive (instrumental) or self-advancing (substantive) purposes. Meeting the push of technology is the "pull" of human society for assistance or growth toward what can similarly be positive or negative ends. Like it or not, the push and pull of technology and human desire are moving us into new territory in the digital age. Just as we have become accustomed to eyeglasses, other less obvious technological conveniences remind us to use our seatbelts, scan items at the supermarket checkout, and wake us up in the morning. Technology embraces us often without our knowledge or consent—and it defines our everyday life in ways we continually find ourselves struggling to understand. Because it is always on the move.

But the technological expansion of human capacity is only part of the story of our evolving visual culture. Most of what really counts takes place in our minds. *The End of Reading* has detailed the way speech and written language came into existence in early human culture because people needed ways of giving form to ideas. What sets human beings apart from other creatures is their remarkable ability to think symbolically, to fashion mental representations of things in the world and things not in the world. History has shown that humankind found a variety of ways to give form to these products of mind—through sounds, objects, spoken language, writing, music, and pictures. Examination of early language and mark-making reveals that none of these methods began from a particular preference in the human mind, which would suggest a predisposition

toward reading and writing over other forms of communication. The earliest cave dwellers seem to have made paintings and little tokens long before they started writing. Codified language developed within human culture along with other visual and aural expressive forms—but ultimately became dominant because of its utility and efficiency.

Studies of infant and early childhood development suggest that there is little "hard-wiring" in the human mind beyond crude survival instincts. People acquire behavior, knowledge, and communication from the cultural environment around them. Neuroscientists have looked at what the brain does and come to similar conclusions. The field of education generally does not subscribe to theories of an inherent "language instinct."[8] And within linguistics the idea of "universal grammar" underlying all languages is highly disputed.[9] None of this in any way invalidates the centrality of language in human culture and societal evolution. Clearly the acquisition of language by children provides a vital framework for many kinds of conceptual thinking and the organization of knowledge, not to mention communication itself. But critical to arguments put forth in *The End of Reading* is reality that language—specifically written language—is but one means of articulating oneself and making sense of the world. Other forms exist and hold great importance in human consciousness, but they have been ignored, romanticized, trivialized, or simply discredited by traditions of Western humanism, which have for so long privileged the written word over other forms.

Societies appreciate "art" as a special form of communication, but since the Middle Ages creative expression has been regarded largely as a non-utilitarian extra in life rather than a social necessity. Once regarded as society's leading communicators, artists and musicians became seen in Western culture as entertainers or oddballs—often gifted and admired for their skills, yet relatively marginal in comparison to scientists and business people. Photography and other forms of modern rendering initially fascinated the public with their abilities to capture "reality." But almost immediately these media also aroused suspicion as somehow too easy to enjoy. Skeptics and pious observers saw photographs, movies, and television as potentially deceptive in their expressive power, especially to younger or unsophisticated

audiences. But little could be done to deter a public hungry for new forms of storytelling.

In the 1400s the printing press revolutionized society by making stories available to growing numbers of people. Besides making written literacy more of a necessity in life, printing did something far more significant—yet rarely discussed. It allowed certain stories to be told over and over again from different perspectives and by different voices. This redundancy made a critical difference in the way people experienced ideas. Rather than a single story or narrative from an authoritative voice like a priest or teacher, people could get information from multiple sources and they had expanded abilities to seek out information themselves. In this way important stories became diffused throughout the culture and information became more democratized. Of course, certain central narratives had always functioned this way. Religious tales might be delivered in sermons, shared in conversation, illustrated in stained glass windows, and available in carefully copied texts. But printing and other forms of mechanical reproduction expanded both the number and kinds of stories circulated. This was the beginning of media culture.

Media culture played a major role in the standardization of beliefs and the unification of popular opinion. Some assert that print media made possible the creation of modern nation-states defined, not by locality or physical boundaries, but by common ways of thinking circulated in printed materials. As industrialization gave birth to mass-produced media in the form of newspapers, magazines, movies, radio, and television—the process accelerated and the dissemination of ideas grew exponentially. Redundant ideas began to envelop populations, repeating certain ideas to such a degree that they became ingrained in the public mind in ways that people didn't always realize. Advertising and propaganda began to exert unprecedented influence over societies, creating new surges in consumer desire and political conviction.

For a while people argued about what was happening. In the late 19th and early 20th centuries intellectuals and leaders would claim that certain stories or particular speakers were overly influential. Karl Marx had asserted as early as 1848 that segments of society defined by economic class often lacked perspective about their social location

and were vulnerable to external manipulation. But Marx's thinking was not widely appreciated until the next century. Instead, people concerned about society's direction tended to focus on selected kinds of books, images, or movies—blaming them for crime, violence, sexual promiscuity, and declining morality (not unlike today). It wasn't until the 1930s that coherent theories began to emerge about the broader role of media in shaping ideologies. This thinking was driven by intellectuals who wrote about the ways photography, radio, popular music, and film shaped beliefs and opinion. Theodor Adorno coined the term "culture industry" in reference to an overall system that promoted certain values and ways of thinking.[10] Later the media would be described as a giant "ideological apparatus" manipulating public thinking.[11]

Since those early years of media theorizing, opinion has divided between those who warn of large systems that trick masses of people and those who argue that individuals can make up their own minds with relative independence. But one fact remains undeniable. We live in a world in which we are immersed in media representations, always telling us things, selling us products, and seeking to persuade us. And whether or not we believe what we are told, certain ideas get repeated over and over. In part this is because *media both reflect and influence* widely held views. Part of what attracts us to certain stories or commercial products is our familiarity with them as they complement existing understandings, beliefs, and desires. We are attracted to representations of celebrities or consumer goods because they *reflect* desires already in place to view certain kinds of people or possess particular things. But these representations also *influence* us by restating our desires or adding something new to those that already exist.

The important thing to remember is that these representations now come at us from all directions in many different forms all the time. And we really don't have a vocabulary to describe what is happening. Thousands of words actually can't completely describe a photograph, just as movies can never adequately capture the quality of a story written in words. How about that for *The End of Reading*? The systems don't quite mesh. It's why philosophical reflections on vision have been so disappointing and why theories of language re-

main so disputed. At the end of the day we find ourselves on an endless search for ways to reproduce the workings of the human mind—as our technologies continue their efforts to replicate the operations of human perceptions. For *The End of Reading* this is an important point. Isolated forms of communication like books, CDs, photographs, or movies offer us parts of the overall experience of perception that we experience in daily life. As these forms of media become more complex to incorporate sound, images, and events unfolding over time, the media come ever closer to replicating our *unified field of perception*. The closer media come in achieving this model of mind, the more excited and interested audiences become. This is why the photograph became such a marvel when it came onto the scene in the mid-1800s and why multimedia experiences such as game playing in virtual worlds are even more captivating.

While it's impossible to explain this process completely, a number of observations can be made about the two great eras in the evolution of communication, which were discussed in Chapter One. The first great era was marked by the explosion in communication that occurred with the birth of the printing press approximately 500 years ago, which popularized written storytelling as never before. The second great moment came with the exponential growth of personal computing and network technologies that began in the mid-1990s. The so-called "digital era" took communication beyond *linear storytelling* into the realm of *virtual worlds*.

As discussed in Chapter Four, linear storytelling operates in sequences, with each word following another and stories generally having a beginning, middle, and end. Following the sequence of a story requires relational thinking—meaning that each word or part of the story informs the other elements. The sentence or story line only makes sense if we combine their parts to make a whole idea in our minds. We appreciate that Harry finally zaps Voldemort at the end of *The Deathly Hallows* because we've followed all of the struggles that preceded the event.[12] This same relational thinking—of connecting parts of stories to other parts—informs our appreciation of virtual worlds. We can immediately jump into the action in the computer game version of *Harry Potter and the Half-Blood Prince* (2009) because

we bring with us the knowledge we've gotten from Harry Potter books and movies.

The ability to see and remember connections between ideas and stories lies at the center of all human communication. Why? Because these fundamental kinds of relationships define who we are as people. Families are networks of related people. Mom may live in town and Uncle Bob in Chicago, yet we keep our knowledge of the family alive in our memory. But the family is only one of the networks we carry around in our minds. We also are students, employees, community members, and Facebook friends. In fact, Facebook illustrates another critical point in understanding existence and communication. Our many networks of relationships can intersect and overlap. Many people's Facebook friend list pulls together new acquaintances, old friends, family members, co-workers, not to mention people linked through Facebook itself. These numerous and intersecting relationship networks mirror our many-faceted identities at home, school, work, and elsewhere.

Part of what's made digital communication so captivating lies in its ever-improving ways of replicating networks of relationships and identities. Sometimes this occurs in literally defined networks like Facebook and Twitter. In other instances it takes place in entertainment and news media. In both cases, we have learned to navigate different kinds of worlds that we can understand only through a unified field of perception the continually helps us track, remember, and match experiences from different networks of people and stories.

The commercial marketplace offers one of the clearest models of virtual worlding: *branding*. Commercial brands are bigger than individual products or stories in that they represent a general idea that has been copyrighted. *Spiderman* is more than a story about a nerdly news photographer who puts on a red suit. The *Spiderman* brand encompasses comic books, movies, toys, costumes for kids, and computer games. As one producer put it, in today's media economy companies no longer think in terms of a single product or movie. "Now, you pitch a world—because a world can support multiple characters and multiple stories across multiple media."[13]

The emphasis placed on brands incorporating their own world of related products was made possible by important structural changes

in recent decades in the way the business works. The consolidation of smaller companies into bigger ones has always taken place and anti-monopoly laws have been in effect since the 1930s. But starting in the 1990s, corporate consolidation took off with unprecedented speed. Now, a single large corporation owning a large brand like *Halo* or *Batman* can market its various products through the movie, game, toy, and clothing wings of the corporation. Because large corporations increasingly tend to be multinational in scope, this allows them to maximize efficiency in both manufacturing and selling goods around the world. The consolidation of media companies and their acquisition by large, multinational conglomerates has resulted in operating philosophies and business procedures unlike those of the movie studios, television networks, and publishing houses that people once knew. The huge multinational corporations that have swallowed these discrete media companies have acquired them with little intrinsic interest in storytelling aesthetics or journalistic integrity, but with a big interest—indeed an all-consuming mandate—in satisfying the demands of corporate investors for continuing profits. This has meant that money—not ethics, or taste, or politics—has become the driving force in entertainment and journalism.

Gone are the days of Hollywood moguls with stables of legendary movies stars making pictures on the basis of personal taste and creative instinct. Television is no longer the province of powerful network executives who might champion situation comedies, long-form dramatic series, or Pulitzer Prize-winning news departments. Similarly, publishing is now completely a numbers game, with boutique presses and idiosyncratic novels giving way to million-copy press runs and blockbuster titles designed for maximum exposure on television talk shows and Waldenbooks. Six multinational corporations now control the major U.S. media: Rupert Murdoch's News Corporation (FOX, HarperCollins, *New York Post, Weekly Standard, TV Guide*, DirecTV and 35 TV stations), General Electric (NBC, CNBC, MSNBC, Telemundo, Bravo, Universal Pictures and 28 TV stations), Time Warner (AOL, CNN, Warner Bros., Time and its 130-plus magazines), Disney (ABC, Disney Channel, ESPN, 10 TV and 72 radio stations), Viacom (CBS, MTV, Nickelodeon, Paramount Pictures, Simon & Schuster and 183 U.S. radio stations), and Bertelsmann (Random House and its

more than 120 imprints worldwide, and Gruner + Jahr and its more than 110 magazines in 10 countries).[14]

We now live in an era in which brands and images define our understandings of ourselves and the world around us. That we now inhabit virtual worlds presents a big challenge for educators. The complexity and inter-relatedness of those image-worlds tells educators that schooling based on single forms of communication like basic reading only provide part of what young people need to navigate in the digital age. Making sense of the many visual and sonic components in virtual worlds really does demand multimedia literacy. Reading alone cannot prepare someone to traverse a web site, make a *YouTube* video, or critically engage a barrage of advertising pitches. ABC-Disney president Ann Sweeney cites research conducted in 2006 pointing out that while 40 percent of the baby boomers spend their leisure time watching only television, the same percentage of their children use five to eight technologies (often simultaneously).[15] Despite these changes, reading can't be ignored. Like visual thinking, written literacy is required as well. The key lies in recognizing the importance of many different kinds of competencies for the diverse media environment of today's world. As media scholar Douglas Kellner puts it, we need to move beyond "the simplistic Manichean dichotomy between print and visual literacy, we need to learn to think dialectically, to read text and image, to decipher sight and sound, and to develop forms of computer literacy adequate to meet the exigencies of an increasingly high tech society."[16] To Kellner, multiple literacies do more than simply enable people to decipher electronic stories. Seen in a wider context, multiple literacies also implicitly impress upon readers the existence of many kinds of language and styles of communication. This encourages a respect for diversity and difference in an increasingly global economy and multicultural society.

## NEW LITERACIES AND LITERATURES

*Theories of Multiple Literacy*
Adopting a unified field of vision means recognizing that many communicative competencies are necessary in the global digital era.

How do we think our way through this? Three schools of contempo-
rary thought can guide us on the journey: *postmodernism, cultural
studies*, and *critical pedagogy*.

   *Postmodernism*. One of the great legacies of the Enlightenment era
was the organizing of ideas into categories allowing their careful
study. When the printing press extended reading to ordinary people,
this organized way of thinking was extremely useful in bringing peo-
ple out of an earlier time of superstition and ignorance. And it fos-
tered institutions based on categories as well: manufacturers, mer-
chandisers, educators, entertainment and communication providers.
All of this worked well through the industrial "modern" era. But
things kept getting more complicated as the world became bigger, as
it became more diverse, and as communication technologies im-
proved. By the middle of the 1900s it was clear that the great catego-
ries weren't working in society as well as they once did. Women and
minorities couldn't stay in old-fashioned story lines. Children wanted
adventure and independence. Everyone watched television through
networks that suddenly flooded people with information they never
had imagined. Simple stories and clean categories of thought no
longer seemed to describe the world of multinational corporations
and travel in jet planes. By the 1970s so-called "postmodern" thinkers
like Jean Baudrillard, Jacques Derrida, Michel Foucault, and Richard
Rorty were gaining attention by arguing that prevailing truths in so-
ciety were open to question. People began challenging basic ideas like
the traditional nuclear family and the virtues of military service. The
U.S. would be shocked by its first military failure in Vietnam and
ashamed when President Richard Nixon was impeached for lying
about a burglary scheme. Distrust and insecurity ran rampant.
Authority was challenged everywhere. Something needed to change.

   While the change that followed took many forms in politics, cul-
ture, and society, the wave of postmodern thinking that emerged in
the 1980s and continued to grow opened up new possibilities for all
kinds of thinking. Beyond challenging authority and questioning the
dominance of social institutions, postmodernism said that humanity
was composed of many different voices with a wide variety of opin-
ions and values. While some pointed out that postmodernist thinking
could lead to confusion, as any clear sense of right and wrong could

get lost, the overall benefits of a more open and flexible way of look-ing at life proved more lasting.

As a broad-based philosophical premise about intellectual ideas of all kinds, postmodernism influenced thinking in many fields. Of rele-vance to *The End of Reading*, postmodernism challenged the way "great books" and classic philosophers seemed to dominate scholarly discourse. Besides questioning the idea of selected texts and thinkers sitting above all others, postmodernism pointed out that Western in-tellectual traditions mostly came from European men. How could this particular segment of the world's population dictate what was im-portant for everyone to read and know? By asking this question, postmodernism opened the door for more diversity in what was taught in schools, collected in libraries, and even featured in main-stream media.

*Cultural Studies.* As postmodernism was raising general questions about established ways to thinking, attitudes shifted in the ways peo-ple thought about language, communication, and arts. Old ideas about the great books and classical thought had created notions of "high culture" held up as something for everyone to value and want. In this way, high culture refers to forms of culture that a society cate-gorizes as significant: valuable works of art, venerated literature books, specialized aesthetic knowledge. By its very definition, the production of high culture is deemed beyond the creative capabilities or ordinary people. It is made by specialists or experts—and is appre-ciated by people with education or elevated status. As such, what constitutes high culture generally gets determined by those who that hold authority in a society. As sociologist Howard Becker explains, "High culture consists of work recognized as belonging to an honored category of cultural understandings by people who have the power to make that determination and to have it accepted by others."[17]

It's not hard to imagine how this idea of cultural superiority might cause problems. A system that identifies and validates high culture is hardly harmless or innocent. It supports dominant ethnic and racial groups in a nation and excludes the culture brought by immigrants or newcomers. Within this system, ordinary "everyday" culture often is regarded as something "left over." Anthropologist Pierre Bourdieu wrote that high culture is frequently regarded as

something that engages the mind and serves a non-utilitarian interest.[18] As Bourdieu wrote in *Distinction*, his study of the way class shapes cultural preferences and taste, "there is nothing automatic or natural about the ability to 'appreciate' a Rembrandt or a Picasso. You must be raised to feel comfortable in museums" and have what Bourdieu saw as the "educated bourgeois orientation," associated with leisure, money, and unselfconscious social privilege.[19] By contrast, Bourdieu wrote that "low" or popular culture appeals to the unschooled interests of the body. Regardless of background or schooling, anyone can enjoy raucous humor, rock and roll, or a slice of pizza.

Making matters worse, proponents of high culture asserted that its values should be universally adopted in the interest of social cohesion. In representing the "best" examples of thought and artistic expression, works of high culture set examples for everyone to recognize and emulate. The more a society embraces a common set of high cultural values and standards, the more unified and strong it becomes.[20] Societies that allow people to consume a hodge-podge of different cultural influences and subscribe to varied standards of what is "good" and "bad" culture risk falling into chaos and instability.

Like most dichotomies that attempt to divide the world into either/or categories, the high/low divide is at best an abstraction. In a nation like the United States, which itself is made up of people from many different places and backgrounds, the stratification of culture into high and low registers is a tricky logical maneuver. In practice, neither category is neat or distinct; many items fall into either or both sides—or simply resist classification altogether. In this way the high/low divide is a cultural construction that really represents other hierarchies, imbalances, and prejudices.

"Cultural studies" grew out of this conflict between high and low culture. Emerging first in Great Britain and later in the United States, cultural studies started in the 1960s and 1970s when liberal reform movements made Western nations realize they needed to take economic inequity and social division seriously. In Britain this meant looking at working class people and gang culture. As the field grew, cultural studies quickly expanded to examine gender, race, ethnicity,

and sexual orientation—and eventually issues like immigration status, disability, and age. As cultural studies expanded definitions of what was worthy of study, leading voices struggled to define its mission. Stuart Hall wrote that "Cultural studies is not one thing, it has never been one thing."[21]

For *The End of Reading* cultural studies highlights the importance of human diversity and the acknowledgment of multiple languages and modes of communication. High culture and old traditions are not meaningless or unimportant, for their historical value in the evolution of human thought always will remain part of who we are. But these great ideas and the languages in which they were expressed are but a part of our current global society. Cultural studies argues for a convergence of old and new, written and digital, in a unified field of vision.

*Critical Pedagogy.* No one can dispute the centrality of education in our lives. In a rapidly changing world people of all ages need to continually update their knowledge and their skills. This means looking at traditional knowledge passed down to us through print traditions as well as new forms of knowledge we gather from the electronic universe. Many people associate learning with what takes place in school, which remains perhaps humanity's most important social institution: a place where commonly valued knowledge and intellectual skills are organized and imparted to the young so that they can function in adult society as productive contributors, community members, and self-actualizing beings. But because it is such an important and powerful institution, schooling is vulnerable to getting carried away with itself—to becoming too important and powerful. Institutions of all kinds have this problem. Social critic Max Weber wrote in the 1890s about the self-perpetuating "iron cage" of institutional thinking that could take over an institution like school.[22]

Critical pedagogy sees education in a broader context than the school environment. Pedagogy is the basic art and science of teaching. Critical pedagogy examines how teaching works and where it takes place. If we always are in a process of learning from the world around us, critical pedagogy says that this broader field of learning needs to be taken seriously. Social convention has led us to believe that what really counts as knowledge is what we learn in the classroom. And

we do learn important things in school like reading, math, history, and science. But we are in school for only a fraction of our lives and then only part of the day. What about the lessons we gain from the rest of our lived experience? Critical pedagogy looks at all of the stuff that happens both inside and outside the classroom.

But this is more than a simple matter of looking outside the classroom. If we wander outside the metaphorical school, we stray from the authority of the teacher. We are on our own, without the controlling influence of someone telling us what to do. Departing from this institution frees us from restraint but also leaves us vulnerable to the world outside. This is the essence of intellectual inquiry and a democratic society: the risk and freedom of moving forward—examining, inventing, and navigating a world that we create together. But kids don't care about any of this. What matters to children are the boundaries of restraint and pleasures of discovery and interaction. The politics of childhood are about what you can and cannot do—which is a fundamental aspect of one's sense of self. The ability to act upon the world—to do something—is something children continually test and experiment with. This attitude about acting upon things, what is sometimes called *agency*, is extremely important later in life—and it is the main focus of critical pedagogy.

As discussed in Chapter Two, progressive educators believe that agency grows as children (and adults for that matter) receive encouragement to explore and interact with the world on their own terms. "Child-centered" education lets students collaborate with teachers in an *active* process of learning—rather than placing young people in a role as *passive* recipients of instruction. To progressive educators this means allowing students to explore texts that make sense in their worlds as well as the world of educators. The written works of canonical literature may be important, but both their printed form and dated contents don't always excite students the way new multimedia works do. More to the point, new multimedia worlds like those offered by computer games and online environments create open spaces where young people can navigate, collaborate, and form virtual communities.

The active learning and community building made possible in virtual interactive worlds fits perfectly with what critical pedagogy

theorist Paulo Freire described as "dialogue" in the learning process.[23] Freire believed that dialogue played an essential role in encouraging agency by allowing learners to assume teaching roles in relation to each other. When participants collaborate in on-line environments—from *Club Penguin* to *World of Warcraft*—interact with each other, they practice social behaviors that can have genuine benefits. Media scholar Henry Jenkins describes the unifying of the trend in virtual worlds as "convergence culture," advocating new approaches to learning that maximize the potentials of the new spaces they create. Jenkins writes that "schools are still locked into a model of autonomous learning that contrasts sharply with the kinds of learning that are needed as students are entering the new knowledge cultures."[24] Jenkins adds that "kids are teaching kids what they need to become full participants in convergence culture. More and more educators are coming to value the learning that occurs in these informal and recreation spaces."[25]

*The New Visual Literatures*
Let's face facts. While most of the American population can read, it doesn't spend much time doing it. The U.S. government regularly collects census data on how people use their time. Latest statistics from the 2007 *Time Use Survey* reveal that half of the average Americans' five leisure hours per day are spend watching TV.[26] Despite significant increases in the time people spend online, such activities add up to less than half an hour per day, with Stanford University reporting that 90 percent of internet use is devoted to e-mail.[27] While reading printed materials has increased recently, it still accounts for only about 20 minutes per day, which means that television (network TV, cable, and DVD viewing) consumes seven times more of our time than books, newspapers, and magazines combined. So television remains a force to be reckoned with seriously.

One way of looking at this is to conclude that television has become today's dominant form of literature, especially with the evolution of so-called "quality television" in the past two decades. While such an assertion might raise a few eyebrows, a growing consensus of academic opinion supports the idea that television has moved beyond its historical position as "vast wasteland" and assumed a new legiti-

macy as a prime storyteller of contemporary society.[28] To many schol-
ars, television's new legitimacy emerges from its enhanced ability for
"world building" that entails new forms of audience engagement.[29]
As described by Jeffrey Sconce, "Television, it might be said, has dis-
covered that the cultivation of its story worlds is as crucial an element
in its success as storytelling."[30] While television might lack the big-
screen dazzle of the movie screen or the intimacy of game environ-
ments, it compensates with depth and duration of character devel-
opment, narrative, and audience engagement. This has led some
analysts to argue that the "metaverse" of television, which allows
viewers to inhabit TV's imaginary worlds, allows a depth of immer-
sion and intensity far greater than that currently provided by virtual
reality technologies. As Sconce concludes, "television "remains the
world's most vast, varied, and influential narrative medium."[31]

Television's ascendancy as a serious cultural form has hardly
gone unchallenged. *The End of Reading* has chronicled the many ar-
guments made to discredit visual media as well as the reasoning be-
hind criticism of movies and television in relation to writing and lit-
erature. Devalued in literary culture, television was regarded in the
dramatic arts for decades as the cheap version of film. Movies took
time to produce and were incredibly expensive to make—paying off
in astonishing image and audio quality due to all of the effort put into
lighting, sound, scenery, multiple camera angles, and meticulous ed-
iting—not to mention the recording capabilities of 35mm film stock
itself. Movies also accrued a degree of credibility with the early
growth of serious "art cinema" and the later attention given to movies
in the academic disciplines of cinema and film studies. But the ex-
pense of movie productions limited their supply and thus made them
unsuitable as daily entertainment.

With the mass production of TV sets in 1950s and 1960s, television
supported by commercial advertising suddenly emerged as both a
new industrial form and a new cultural institution. To keep audiences
watching, TV was mass-produced, with dozens of episodes becoming
the norm for shows that could continue telling stories for years. From
long-running prime-time comedies such as *The Honeymooners* and *The
Andy Griffith Show* to evening dramas like *Bonanza* and *Dr. Kildare* to
day time soap-operas including *All My Children* and *Days of Our Lives*,

television broadcast nationally by the ABC, CBS, and NBC networks filled the population's waking hours with formulaic entertainment. Owing to its ubiquity and popular appeal, television became stigmatized in its early decades as less important than film. Serious directors and actors might leave the Broadway stage to work in the motion picture industry. But many professionals saw television as a lower form with weak production standards, poor writing, and a tendency to pander to audiences.

Television really changed in the 1990s. New technologies and the rise of huge multinational corporations broke the grip of ABC, CBS, and NBC. Cable and satellite TV gave viewers hundreds of channel choices, opening national audiences to scores of providers. "Channel surfing" emerged as the use of remote control devices grew, making it much easier for audiences to scan the television schedule to find exactly what they wanted. While most viewers would gravitate to a handful of channels, the battle for those channel choices heated up considerably. Sponsors and producers quickly recognized that the TV audience was changing in the 1990s from one large mass market to numerous *niche markets*. The smaller markets might not contain as many customers, but those customers could be more accurately targeted for marketing. Oprah Winfrey's Oxygen Network remains one of the largest of the cable channel niche networks to emerge in recent years. But the most historically significant niche provider is Home Box Office (HBO).

HBO emerged in the 1980s as a bridge between movies and television. In 1981 HBO launched a 24-hour subscription TV service providing recent motion pictures unavailable on network TV. The new "pay-TV" was scheduled differently than episodic network TV by offering the same movies over and over. Marketing for the service would beckon viewers by saying, "It's not TV. It's HBO." Simply put, HBO ruptured what Raymond Williams famously described as a "flow" of the television schedule. Viewers had been accustomed to turning on the TV to get a flowing sequence of program segments, commercials, news and other material. HBO and later subscription services encouraged viewers to make an "appointment" with their televisions to see something special. Of course, audiences always had adapted to broadcast schedules and vice versa. But cable and satellite

services made thinking about what one wanted to watch more decisive. With the rupture of television's flow, viewer discretion would continue to evolve. In the 1980s VHS and Betamax technologies further changed the way movies and television were marketed and consumed. As media products were published and distributed like books, people began to think of them more like published works as well—buying movies at stores, or borrowing them from libraries, keeping tapes and, later, DVDs, on bookshelves. The marketing of entire seasons of TV shows as boxed sets further contributed to the perception that television could be collected and that the season unit could be seen as an expressive genre like a novel or an anthology.

Soon practices of home recording would become commonplace, first with electronic timers on tape recorders, and later with more sophisticated digital video recorders (DVRs) like TiVo affording viewers even more freedom in deciding when they could watch programs. The growth of high speed internet via DSL lines in the 2000s made possible online viewing of TV shows and movies. Services like Netflix offered programs online or through the mail. This added yet another dimension to the ability to "time shift" viewing. Finally, improvements in consumer equipment made home viewing more like going to the movies. TV screens have gotten bigger, first through enlarged picture tubes and projection systems—but later with plasma and LCD technologies making screens lighter and flatter. Digital and HDTV signals improved image quality, as Blu-ray and competing technologies took them even further. Surround sound and "home theater" systems added depth and dimensionality to audio.

At the same time, Americans were becoming increasingly enamored with portable technologies. First appearing in the 1980s, the Sony Walkman enabled people to take music with them during the day. Mobile phones became popular at the same time, and would shrink in size as they got more powerful and efficient. Using digital storage, Apple's iPod came along in 2001 and became an instant sensation. Within a few years digital music and phone technologies would converge into single devices—notably with Apple's iPhone. Companies like Sony, Palm, and others soon offered similar devices capable of playing music and games, surfing the internet, and ac-

cessing GPS services. Television and movies joined the portable repertoire at this time as well.

*Television as Novel*
All of these technological changes combined to change the way people thought about television. The narrowcasting of cable had produced programming that smaller groups of consumers could appreciate in more personal ways. The control over viewing through channel choice and recording technology gave viewers an investment in programs they could themselves select. By the mid-1990s it had become clear that the era of programming dominance by ABC, CBS, and NBC had ended, with the enormous profusion of cable and subscription television offerings issuing in the "post-network" era. This heightened the demand for more specialized programming—including a growing market for what has been termed "quality television."[32] This genre of carefully scripted and more complex programs had begun to emerge in the late 1980s, with the success of shows *like Hill Street Blues* and *Twin Peaks,* but one HBO series is generally credited as the linchpin of the emerging quality TV genre: HBO's *The Sopranos.* Running from 1999 through 2007, the drama about a New Jersey mob family won more Emmy awards than any other show on cable TV and frequently drew audiences larger than programs competing against it on broadcast networks. As it came to a close, The *New York Times* described *The Sopranos* as "the greatest show on television."[33]

The novel-like *Sopranos,* with carefully drawn characters and an intricate long-form story line, differed from standard prime-time network fare in its serial structure. With most TV dramas, viewers could count on episodes ending with some kind of resolution to the story. But *The Sopranos* took a cue for daytime soap operas in using a more open-ended format. The story would take an entire season to tell. In this way *The Sopranos*—and later HBO series like *Deadwood, Oz, Six Feet Under*, and *The Wire*—adopted the type of serial-format storytelling used in the mid-1800s by Charles Dickens. Like contemporary serial TV dramas, Dickens's *Oliver Twist* and *The Pickwick Papers* appeared in weekly installments in English newspapers. People would read and reflect upon each episode—slowing down the process of consuming the story—to afford it more depth and complexity.

More than a few television producers and writers credit Dickens as an influence, including Carlton Cuse, Tim Kring, David Lindelof, and Joss Whedon.[34] After winning the 2009 Best Actress Emmy for her role in *Damages*, Glenn Close told reporters that shows like hers were 13-hour serials, "like Dickens for the 21st century."[35] The open-ended episodic format really came into its own with ABC's *Lost*, which premiered in 2004. Running for six seasons, *Lost* told the story of castaways on a mysterious island later discovered to have been the scene of a secret project. Like *The Sopranos* and other programs in what has been termed the "long-term television narrative" (LTTVN) genre, *Lost* featured an ensemble cast with numerous central characters and many ongoing storylines that multiplied and gained complexity as the series unfolded.[36]

While in modern Western literature the novel is often considered the most elite and privileged storytelling format, it's also worth pointing out that in its Dickensian serial form novelistic writing epitomized low-brow mass culture. Over time the novel gained intellectual credibility much as HBO-style television has done in recent decades. Bolstering the creative capacities and critical reception of new quality TV offerings has been the emergence of the television producer/writer at auteur. Earlier television was generally produced anonymously, with the few notable exceptions of comedic producers like Carol Burnett and Norman Lear. But today's quality TV programs frequently get promoted at least in part on the basis of their authorship by figures like Jerry Bruckheimer (*Cold Case, CSI*), David Chase (*Northern Exposure, The Sopranos*), David Kelly (*Boston Legal, The Practice*), David Milch (*NYPD Blue, Deadwood*), and Aaron Sorkin (*Studio 60 on the Sunset Strip, The West Wing*). This recognition of the producer/auteur has gone hand-in-hand with new levels of creative control afforded these individuals in shaping their works and a resulting heightening of credibility for their efforts. Writing of the producer/auteur figure, Michel Hilmes states that these names "mean more in terms of genre, quality, style, and audience than the name of the network."[37] She adds that the stamp of the auteur gives programs "a degree of authencity and legitimacy absent from television's earlier decades."

*Storytelling as Game Environment*

As a continually evolving medium, quality television also increasingly shares characteristics with the other dominant entertainment form of the 2000s: the computer game. In this comparison, the open-ended story structure of programs like *The Sopranos* and *Lost* resembles games like *World of Warcraft* and *Halo* by situating viewers in an imaginary world with no beginning or end. Viewers or readers of any narrative must accept the premises of the imaginary world of the story. But the heightened level of fantasy and complexity of the newer quality TV offerings takes this presumption to unprecedented levels. While *The Sopranos* asks that audiences accept the existence of a mafia underworld that obliges its suburbanite cast of central characters to lead a double life, *Lost* takes its story to an island that becomes increasingly mysterious and magical as the narrative unfolds. Acclaimed science fiction series like *Battlestar Galactica* and *Firefly* take audiences to outer space. *Prison Break* and *Oz* explore the hermetic worlds of the penal system. *Mad Men* operates in the psychologically repressed climate of 1950s America. *Heroes* asks audiences to believe in people with superhuman abilities. *Deadwood* takes place in a small mining community during the gold rush. All of these shows draw audiences into an imaginary world like that of a computer game, where knowing the rules and vocabulary of a particular system is a prerequisite for understanding the story. In many offerings, audiences are obliged to master complex vocabularies of names, terms, or imaginary languages. And when audiences are not deciphering phrases in Klingon or Vulcan, they may be confronted with very odd versions of English.

*Deadwood* stands as perhaps the most intriguing example of this linguistic learning, since it is partly based on the actual history of a rural town in South Dakota. *Deadwood* writers made great efforts, not to invent a new language, but to replicate the speech patterns of nineteenth-century American pioneers. *Deadwood's* baroque syntax gave its world an added dimensionality, as did its abstruse and profane vocabulary. To a viewer unacquainted with way *Deadwood* characters spoke, a line like this from Al Swearington might not make much sense: "Our cause is surviving not being allied with Yankton or cogs of the Hearst machine, to show it don't fate us like runts or two-

headed calves or pigs with excess legs to a good fucking grinding-up."[38] All of this contributes to a story that is not so much read as it is experienced as an immersive world.

Lev Manovitch has described this emerging model of storytelling as creating open-ended space—like that of a computer game—rather than the linear narrative. "After the novel, and the cinema privileged narrative as the key form of cultural expression of the modern age, the computer age introduces its correlate—database."[39] As Manovitch explains, "Many new media objects do not tell stories; they don't have beginning or end . . . Instead they are collections of individual items, where every item has the same significance as any other."[40] In such game-based environments, emphasis lies less on an unfolding se-quence of events than it does on the way the "world" presented in the environment operates. All stories take audiences into such an imagi-nary world, but these new game-based narratives ask viewers to do considerably more thinking about how stories might unfold. This shifts attention toward the internal logic or rules of the game. In the prison environment of *Oz*, audiences must accept that violence and murder are "normal" responses to conflict and thus occur quite a bit more frequently that in the outside world. *True Blood* audiences must take on faith a world in which vampires have become an accepted part of society. *Big Love* immerses viewers in the subculture in which polygamy is naturalized.

For The *End of Reading* these open-ended story worlds challenge readers in new ways as they offer deeper forms of engagement in three important ways. First, they engage readers in forms of *process* within the imaginary world. Second, they demand forms of *interac-tivity* as audiences play out possible scenarios in their minds accord-ing to the rules they have learned about the imaginary world. Third, these new story forms more potently engage audiences in forms of *community*—as fans, players, or other cohorts within the imaginary worlds.

*Process.* Embracing process and interactivity are central to the new literacies offered by today's new multimedia literatures. *The Wire* ex-emplifies the focus on process by repeatedly returning the reader to struggles characters face with the many bureaucracies of the city of Baltimore. Each season of *The Wire* takes place in one of Baltimore's

bureaucratic institutions: the police department, the docks, the drug trade, the schools, and city government. In each season *The Wire*'s characters struggle for autonomy in the face of authoritarian hierarchies, competition for power and resources, and intricate sets of rules. *The Wire*'s writer/producer David Simon describes the program as a "televised novel," clearly seeking to link television to the cultural form of literature.[41] Focusing on Baltimore institutions, Simon stresses the importance of process in making a broader statement about the powerlessness of individuals within large social systems. To Simon,

> *The Wire* has resisted the idea that, in postmodern America, individuals triumph over institutions. The institution is always bigger. It doesn't tolerate that degree of individuality on any level for any length of time. These moments of epic characterization are inherently false. They are all rooted in, like, old westerns or something. Guy ride into town, cleans up the town, rides out of town. There's no cleaning it up anymore. There's no riding in, there's no riding out. The town is what it is.[42]

As Simon points out, the new *process*-oriented storytelling can take the conventional narrative's ability of describing an all-encompassing system to a new level. Readers recognize that they themselves live in similar worlds defined by authority, rules, and continual challenges to personal autonomy—as well as opportunities to act upon their worlds.

*Interactivity.* Drawing comparisons between fictional worlds and real worlds is no small matter. It's where the *interactive* character of reading comes into play. Obviously, readers must suspend disbelief and accept the rules of an imaginary world so they can navigate the story. This has been studied and theorized upon by reader response scholars and others who have looked closely at what goes on inside people's heads as they follow stories.[43] Even the most basic storytelling involves a back-and-forth in the mind of the reader, as parts of the story are remembered, favored, anticipated, discounted, forgotten, or contested. In this way every story is interactive. In fact, it is exactly this interactive aspect of storytelling that makes a book or movie interesting. Your engagement in thinking the story through—wanting something to occur or not happen, someone to succeed or fail—is what makes you want to find out more, turn the

page, or keep on watching. In this thought process, you—the reader—participate in the story.

*Community.* As audiences participate in the story they join its imaginary communities. On one level this occurs as a reader identifies with characters and begins to imagine or desire certain outcomes. Readers do not do this by themselves, of course. Cohorts of audiences follow stories in similar ways and make up "fan" communities. Sometimes these fan communities can be more than mobs of people who show up for the opening nights of movies like *Harry Potter* or *Twilight*. Fan communities frequently organize themselves, especially in the internet age, to share ideas, imagine new story lines, or even write about the stories they like. A huge subculture exists around Harry Potter, with websites, podcasts, and online journals devoted to life in Hogwarts and beyond. While this kind of fan discourse might sound trivial on first glance, it represents something important in the way public imagination operates in the digital era. The ability to form communities as fans has become important to people—especially young people—who feel shut out of society's large institutions and pushed around by authority. In fan communities and online worlds, the viewing public finds ways of giving voice to opinions, sharing knowledge, and generally empowering itself. James Paul Gee explored this phenomenon in his book *What Video Games Have to Teach Us About Learning and Literacy*.[44] To Gee, immersive imaginary environments encourage people to learn about new forms of communicating, community building, and acting in the imaginary or real world. Those who discount the new ways that people share their engagement with stories are ignoring a rising tide of cultural bonding and learning. At its worst, the privileging of traditional print paradigms over new multiple literacies is seen by Gee and others as a way of putting down the young and the marginalized who gravitate to these new community forms. But in more general terms, resistance to multiple literacies is simply a nostalgic yearning for the power structures and institutionalized knowledge of the past.

## READERS OR WRITERS?

The idea of a reader's participation in making sense of a story was discussed by literary critic Roland Barthes in his famous essay "The Death of the Author."[45] Barthes received a lot of attention as one of the first scholars to assert that authors didn't get the final say in what a piece of writing meant. Everyone's opinion mattered. While this might sound simply like a theory about writing, it has a lot to do with the expanded definition of reading discussed above. Like multiple literacy, the death of the author implied a challenge to authoritative knowledge of all kinds. The idea implicitly asked, "Whose opinion matters?" and "Whose voice is important?" The answer was that everyone's ideas and speech had value, rather than those of only a few important people.

Abstract as these ideas might seem, they have great relevance in the digital era of virtual worlds. As multiple literacies have thrown into question the primacy of written texts, the internet now allows anyone to be an author, blogger, podcaster, or web-page producer, *YouTube* video maker, or a voice in the endless chatter of Twitter. This certainly has to be good to the extent that the digital universe has taken down economic and institutional barriers to expression. Reports are not hard to find of people who have found social, creative, or financial success on the internet based on the strength of their ideas and determination.

For *The End of Reading* this participatory view of story-building has great significance in suggesting that *readers can be writers*. Not only do readers participate in storytelling through the mental process of making sense of narratives in their minds. Television's newer open-ended formats invite viewers to write their own stories. This writing can take the form of imagined relationships or outcomes. Or, it can be literalized through online writing, web-navigation, or activity in a game space. In this sense, any serious discussion of reading—or the end of reading—must also entail a consideration of writing.

As I write the final words of this book, I've realized something in the process of putting it together. Clearly there will never be such a thing as *the end of reading*. But a transformation has already taken

place to reading *as we know it*. Reading today is so much bigger than the stuff of books and magazines, important as they are. Reading as we know it encompasses an entire universe of media texts and virtual worlds—as far away as the dusty bookshelf and as close as the phone you hold in your hand.

I have learned in writing this book that to be a writer one has to be a reader. Not a reader in the narrow sense of someone who searches through things in a library, but a reader who reads the wider universe of media texts, visual stories, interactive narratives, and virtual worlds. I'm no longer worried about my daughter Emily's journey as she learns to read and navigate the world. Emily sees the world clearly, especially with her glasses, but also because she is learning how to read in many ways. Her computer keyboard demands her understanding and mastery of written language. But the computer screen requires a visual intelligence to navigate the window on the world it provides. Here is where it all comes together. Reading and seeing combined in one unified field of vision. *"The end of reading"* as we know it.

## Notes

1. "Vision and Reading," Children's Vision Information Network. Internet reference. http://www.childrensvision.com/index.htm. Accessed Sept. 1, 2009,
2. Richard D. Drewry, "What Man Devised That He Might See," *History of Glasses*. Internet reference. http://www.teagleoptometry.com/history.htm. Accessed Sept. 1, 2009).
3. Diana Pemberton-Sikes, "The History of Glasses," *The Sideroad*. Internet reference. http://www.sideroad.com/Beauty/history-of-eyeglasses.html. Accessed Sept. 1, 2009.
4. Graham Pullin, *Design Meets Disability* (Cambridge, MA and London: MIT, 2009) p. 16.
5. Akito Busch, "From Stigma to Status: the Specification of Spectacles," *Metropolis* 10, no. 8 (April 1991) 35-37.
6. "Statistics on Eyeglasses and Contact Lenses," Internet reference. http://www.allaboutvision.com/resources/statistics-eyewear.htm. Accessed Sept. 1, 2009.
7. *Design Meets Disability*, p. 21.
8. Steven Pinker, *The Language Instinct* (New York: HarperCollins, 1995).
9. V.J. Cook, Chomsky's *Universal Grammar, An Introduction* (New York: Blackwell, 1989).
10. Theodor W. Adorno, *Essays on Music*, Richard Leppert, ed. Translations by Susan H. Gillespie, trans. (Berkeley: California, 2002).

11. Louis Althusser, "Ideological State Apparatus."
12. J.K. Rowling, *Harry Potter and The Deathly Hallows* (New York: Arthur A. Levine, 2007).
13. Henry Jenkins, *Convergence Culture: Where Old and New Media Collide* (Cambridge, MA: MIT, 2007).
14. Amy Goodman and David Goodman, "Why Media Ownership Matters," *The Seattle Times,* April 3, 2005. http://seattletimes.nwsource.com/html/opinion/2002228040_sundaygoodman03.html. Internet reference. Accessed Aug. 2, 2005.
15. *The Television Will Be Revolutionized.*
16. Douglas Kellner, "Multiple Literacies and Critical Pedagogy in a Multicultural Society." Internet reference. www.gseis.ucla.edu/.../kellner/.../multiple literaciescriticalpedagogy.pdf. Accessed Sept. 4, 2009.
17. Howard Becker, *Doing Things Together* (Chicago: Northwestern University Press, 1986) p. 24.
18. Pierre Bourdieu, *Distinction A Social Critique of the Judgment of Taste* (1984).
19. Ibid.
20. Alexis de Tocqueville, trans., George Lawrence, *Democracy in America* (New York: Harper and Row, 1966).
21. *Cultural Studies,* p. 3.
22. Max Weber: *Political Writings* (Cambridge Texts in the History of Political Thought). Ed. Peter Lassman. Trans. Ronald Speirs. (Cambridge, UK: Cambridge, 1994) p. xvi.
23. Paulo Freire, *Pedagogy of the Oppressed,* 30th Anniversary Edition (New York: Continuum, 2000). Major figures/works in the critical pedagogy tradition include: Henry A. Giroux, *Teachers as Intellectuals: Toward a Critical Pedagogy of Learning* (South Hadley, MA: Bergin & Garvey, 1988); Peter McLaren, *Life in Schools: An Introduction to Critical Pedagogy in the Foundations of Education,* 5th edition (New York: Allyn and Bacon, 2006); Joe E. Kincheloe, *Knowledge and Critical Pedagogy* (New York and London: Peter Lang, 2008).
24 *Convergence Culture,* p. 183.
25. *Convergence Culture,* p. 177.
26. Bureau of Labor Statistics, *American Time Use Survey: 2007* (Washington, DC: U.S. Department of Labor, 2007) Internet reference. http://www.bls.gov. Accessed Sept. 6, 2009.
27. Stanford Center for Internet and Society (CIS), "What Users Do on the Internet" Internet reference. http://www.stanford.edu/group/siqss/Press_Release/Chart9.gif. Accessed Sept 6, 2009.
28. Newton Minnow, "Address to the National Association of Broadcasters" (1961).
29. Jeffrey Sconce, "What If? Charting Television's New Textual Boundaries," in Lynn Spiegel and Jan Olsson, eds., *Television After TV: Essays on a Medium in Transition* (Durham, NC: Duke, 2004). pp. 93-111.
30. "What If?" p. 95.
31. "What If?" p. 111.
32. Janet McCabe and Kim Akass, *Quality TV: Contemporary American Television and Beyond* (London and New York: Tauris, 2007) p. xvii.
33. Bill Carter, "HBO Pushes End of 'The Sopranos' to 2007," *New York Times* (Aug.5, 2005) Internet reference.http://www.nytimes.com /2005 /08/11/arts/ television/11cnd-sopranos.html?_r=1.Accessed Sept 7, 2009.
34. David Lavery, "*Lost* and Long-Term Television Narrative," in Pat Horrigan and Noah Wardip-Fruin, eds., *Third Person: Authoring and Exploring Vast Narratives* (Cambridge, MA and London: MIT Press, 2009) p. 314.
35. Edward Wyatt, "Niche Series (And Dickens) Tightening Emmy Grip," *New York Times* (Sept. 22, 2009) p. C1.

36. *"Lost* and Long-Term Television Narrative."

37. *Quality TV*, p. 9.

38. Regina Corrado, "Childish Things," *Deadwood*. Episode 8, Script # S212 Double Pink, Nov. 18, 2004  (New York: HBO, 2004) p. 28.

39. Lev Manovitch, *Database as a Symbolic Form* (1998). Internet reference. http://cristine.org/borders/Manovich_Essay.htm. Accessed Sept. 9, 2009.

40. *Database as a Symbolic Form.*

41. Jason Mittell, "All in the Game: *The Wire*, Serial Storytelling, and Procedural Logic," in *Third Person*. pp. 429-437.

42. "All in the Game," p. 431.

43. "Reader-response" literary theory focuses on the reader (or "audience") and his or her experience of a literary work, in contrast to other schools and theories that focus attention primarily on the author or the content of the work. Modern reader-response criticism emerged in the 1960s and 1970s in work by Stanley Fish, Wolfgang Iser, Roland Barthes, and others.  Reader-response theory recognizes the reader as an active participant in the making of meaning in a story.

44. James Paul Gee, *What Video Games Have to Teach Us About Leaning and Literacy*. (New York: Palgrave, 2003).

45. Roland Barthes, *Image/Music/Text* (New York: Hill and Wang, 1978).

# INDEX

## Studies in the Postmodern Theory of Education

*General Editors*
*Joe L. Kincheloe & Shirley R. Steinberg*

Counterpoints publishes the most compelling and imaginative books being written in education today. Grounded on the theoretical advances in criticalism, feminism, and postmodernism in the last two decades of the twentieth century, Counterpoints engages the meaning of these innovations in various forms of educational expression. Committed to the proposition that theoretical literature should be accessible to a variety of audiences, the series insists that its authors avoid esoteric and jargonistic languages that transform educational scholarship into an elite discourse for the initiated. Scholarly work matters only to the degree it affects consciousness and practice at multiple sites. Counterpoints' editorial policy is based on these principles and the ability of scholars to break new ground, to open new conversations, to go where educators have never gone before.

For additional information about this series or for the submission of manuscripts, please contact:

Joe L. Kincheloe & Shirley R. Steinberg
c/o Peter Lang Publishing, Inc.
29 Broadway, 18th floor
New York, New York 10006

To order other books in this series, please contact our Customer Service Department:

(800) 770-LANG (within the U.S.)
(212) 647-7706 (outside the U.S.)
(212) 647-7707 FAX

Or browse online by series:
www.peterlang.com